Exhibition Sponsors:

Linda Balahoutis and Jerry Bruckheimer

The Dillenberg/Espinar Collection

Barbara and Jack Hartog

Joel Silver

Patsy and Steven Tisch

Tod M. Volpe

Supported by a grant from the National Endowment for the Arts.

TECO

ART POTTERY OF THE PRAIRIE SCHOOL

Sharon S. Darling

with a contribution by

Richard Zakin

Erie Art Museum

Erie, Pennsylvania

Erie Art Museum

July 8 - October 15, 1989

Chicago Historical Society

November 18 - February 18, 1990

Cataloging in Publication Data

Darling, Sharon S. (1943 -)

Teco: Art Pottery of the Prairie School / by Sharon S. Darling with a contribution by Richard Zakin.

p. cm.

Includes bibliographical references.

ISBN 0-9616623-2-8
1. Terra-cotta — Middle West. 2. Decoration and ornament, Architectural — Middle West.
3. Prairie school (Architecture) — Middle West. 4. Art pottery, American — Middle West.
I. Zakin, Richard. II. Title.
NA3507.D37 1989 89-84291
738.3 ´ 09773 ´ 22 — dc20 CIP

Supported by a grant from the National Endowment for the Arts.

Editor: Fannia Weingartner
Design: Shelle Lichtenwalter Barron
Typography: TypoGraphic Systems

Printed in Hong Kong by Everbest Printing Co., Ltd.
through Four Colour Imports, Ltd.

CONTENTS

ACKNOWLEDGMENTS

A project of the magnitude of this exhibition and catalogue relies on the cooperation of many people. The Erie Art Museum and the authors would like to thank the following for their help.

A special thanks is due George A. Berry III, John Z. Hayward, Jr., Dean Cunat, and Kathleen M. Martinez of TC Industries, Inc., and John L. Husmann for sharing archival materials documenting the production of Teco pottery; Mrs. Ronald M. Byrnes, Major Frederick Gates, Ora Gates, Sarah Gates, and Jessie Benton Evans Gray for providing biographical information relating to William D. Gates and his family; and Mary Claire Hersh, Martin A. Reinhart, and Charles R. Steers for biographies of Teco designers.

Colleagues at museums and institutions who provided reference materials and services included: John Zukowsky, The Art Institute of Chicago; Theresa O'Friel, Kathryn Logan, and Abigail McGuire, The Carnegie Library of Pittsburgh; Phillip M. Johnston, The Carnegie Museum of Art; Ellsworth Brown, Louise Brownell, Robert Goler, Olivia Mahoney, Diane Ryan, Susan Tillett, and Linda Ziemer, Chicago Historical Society; Nancy A. McClelland, Christie's, New York; Henry Hawley and Sara Jane Pearman, Cleveland Museum of Art; Donald P. Hallmark, Dana - Thomas House State Historic Site; David A. Hanks, David A. Hanks & Associates; Elaine Harrington, Frank Lloyd Wright Home and Studio; Janice Tauer Wass, Illinois State Museum; Leslie Green Bowman, Los Angeles County Museum of Art; Nancy Fike, McHenry County Historical Society; Jacquelyn S. Goldman and Katherine Crawley, National Center for the Study of Frank Lloyd Wright; Regina Lee Blaszczyk, National Museum of American History, Smithsonian Institution; Bruce Connolly, Mercedes Hanchett, Carla Freeman, and Sandy Hackett, The Ceramics Library of the New York State College of Ceramics at Alfred; Allan Lathrop, Northwest Architectural Archives; David Ryan, Norwest Corporation, Minneapolis; Claudia Ginanni, Philadelphia Museum of Art; Peter Bush, The State

University of New York - University of Buffalo; David Anderson and Melvyn A. Skvarla, Unity Temple Restoration Foundation; and Dean M. Zimmerman, The Western Reserve Historical Society.

We are most grateful to the lenders who were so gracious to us in conjunction with our research, photography, and travel. Thanks are due as well to Tal Hindson, Charles McMillen and Nancy Nieder for their technical assistance, Michele Bliss of TypoGraphic Systems for extra good work, and to Kathy Merski for photography, good advice, encouragement and support. Art pottery collectors and dealers who were particularly helpful included Jairus Barnes, Robert F. Berman, Nance Darrow, Martin Eidelberg, Paul Evans, Margaret Steenrod Fetzer, Michael Fitzsimmons, Nancy and John Glick, Dorothy Lamoureux, Mary and James McWilliams, Dave Rago, Tom Tomc, and Don Treadway.

Sharon Darling wishes to thank Timothy Samuelson and Diana Stradling for their perceptive and helpful comments on her essay, and Mikell Darling for his research assistance and moral support throughout the entire project.

Special recognition is due Elena DiValerio, Tom Rogowski, Kim Krynock, Mary Snyder, Kirk Steehler, Susan Kemenyffy, Pattie Jo Lamb, Michael Victor, Dan Byler, Virginia Chestek, Jim Colvin, Gary Maas, Carey Thompson, and Linda DeVane Williams of the Erie Art Museum for their work on behalf of the project.

Without the talent and unflagging energy of editor Fannia Weingartner and designer Shelle Barron this catalogue would not have been completed. We also wish to thank the Pennsylvania Council on the Arts and the National Endowment for the Arts for their generous support of the exhibition.

PREFACE

Early in my personal investigations into historical American ceramic art, I was shown one of the Gates Potteries' Teco catalogues. I was amazed. Here was an impressively powerful expression of modernist form in a commercial catalogue dated 1904, and issuing not from one of the cultural centers of Europe, but from the American Midwest. In my conventional view of art history, "modern art" came from Europe to America in 1913 by way of the Armory Show. Yet there it was fully blown a decade earlier, and not even imported, but homegrown in Chicago. At the time, it seemed just one more amazing aspect of the richness of American ceramics, which had come to my attention through the work of Ohr and Mercer, Fulper and Grueby, Rhead and Robineau. As my familiarity with American ceramics developed, it became clear that Teco was as unique as my first impression of it had suggested.

 Teco: Art Pottery of the Prairie School is the Erie Art Museum's second exhibition exploring the forgotten fields of American ceramic art. The first, *Frederick Hurten Rhead: An English Potter in America*, following the career of a peripatetic and multitalented individual, touched on practically every aspect of American ceramics during the first half of the 20th century. *Teco*, by contrast, explores a shortlived experiment — the majority of Teco forms had been designed by 1904 — involving many artists from one locale.

 One is naturally and appropriately drawn to compare the striking forms of Teco with those of contemporaneous Europeans working in the decorative and applied arts — people like Josef Hoffmann, Charles Rennie Mackintosh, Charles F. A. Voysey and Carlo Bugatti. But it is also informative to compare Teco forms with what was being done in painting and sculpture. While William Day Gates and his architect acquaintances were creating works that brilliantly explored pure form, Picasso was re-interpreting El Greco in the morbid realism of his Blue Period; Rodin's naturalism was still the leading style in sculpture; and Bracque and

Brancusi were students at l'Ecole des Beaux-Arts. Cubism, suprematism, construc-tivism, and the other movements of formalist abstraction were still to come. If we set aside the media-based prejudices of conventional art history, Teco clearly demonstrates that modernist abstractionism was not created by painters in Paris; it was very much an international phenomenon and already well established long before *Les Desmoiselles d'Avignon*.

The American Terra Cotta & Ceramic Company was situated in an unlikely location to become a wellspring of avant-garde design. The factory itself was relatively remote (although accessible from Chicago by train); the workers, with few exceptions, had no previous experience in ceramics. Gates, like many of his talented contemporaries, was strongly influenced by the Arts and Crafts movement, as reflected in the factory setting in the Illinois countryside, complete with a man-made lily pond. He doubtless had read William Morris and John Ruskin, and was probably aware of the remarkable work and pronouncements of Christopher Dresser. Like Gustav Stickley and Elbert Hubbard, Gates was a Yankee business-man, and his interpretation of the Arts and Crafts philosophy did not preclude the application of mass-production techniques to what were ostensibly hand-crafted objects. Good design was foremost in Teco. Quality of materials and workmanship were also critical, but a healthy pragmatism favored the use of modern production techniques — piece molds, power glaze sprayers, and coal-fired muffle kilns — already employed in the production of architectural terra cotta.

Curiously and significantly, there were apparently no potters at the Gates Potteries, unless one includes Gates himself or the artisans employed to produce forms during the early years of experimentation. As a result, Teco is unique in American art pottery. It derives less from ceramic traditions than from the field of modern architecture and design at the turn of the century. Obviously any body of work involving such a large number of artists cannot be neatly categorized, and indeed the curvilinear designs of Fernand Moreau and Fritz Albert contrast starkly with the geometric abstractions of Frank Lloyd Wright, William B. Mundie, and that most surprising of Teco designers, William Day Gates. But even the two transplanted Europeans, so apparently immersed in the organic Art Nouveau, integrate an architectural sensibility into their designs, especially evident in Albert's extraordinary use of negative space. The inclusion of one of America's greatest architects in the Teco catalogue is certainly appropriate, since Frank Lloyd Wright shared fully in the Arts and Crafts philosophy as practiced by Gates. The publica-tion of the Unity Temple vase (one of many previously little known forms) is a bonus of this exhibition.

Sharon Darling's contribution to this exhibition and catalogue gives us the benefit of the impressive work she has done in bringing to light the history of several Chicago art industries in previous exhibitions and books, namely, *Chicago Metalsmiths* (1977); *Chicago Ceramics & Glass* (1979); and *Chicago Furniture: Art, Craft, and Industry* (1984). These revealed the high level of sophistication both in style and execution achieved by Chicago-based artisans, artists, and architects — often working in collaboration — at the turn of the century.

Similarly, Richard Zakin's contribution brings us the fruits of his many years as a creator of elegant art pottery, as a teacher, as an art historian, and as a

writer. His guide to the technology involved in the production of Teco pottery and his analysis of Teco glazes add a unique element to this catalogue.

Tod M. Volpe contributed, generally, by helping to create widespread public awareness of Teco and of other Arts and Crafts movement objects; and specifically, by helping to seek out some of the country's finest examples of Teco.

The outcome of this collaboration reveals the combination of artistry and skill, to say nothing of the personal dedication, that produced some of America's most original pottery in forms that continue to delight the eye.

John Vanco

Curator

FOREWORD

Those of us who have long been admirers and advocates of American art pottery cannot help but be delighted to see this exhibition and catalogue come to fruition. After many years of obscurity, the strong and innovative forms of Teco ceramics are finally gaining the recognition they deserve. Teco pieces are taking their rightful place at the forefront of some of the finest collections and architectural settings in the country.

This recognition, long overdue, is supported and reinforced aesthetically and culturally as many creations of the American Arts and Crafts movement capture the public's interest and acceptance, and assume the status they are entitled to hold among objects in the leading design styles of the nineteenth and twentieth centuries.

Although the forms of Teco art pottery had all been developed around the turn of the century, their aesthetic prefigured to an astonishing degree the forms of an era some twenty and more years ahead, a style that once again has a phenomenal hold on our imaginations today. The spirit of Teco pottery is the spirit that animated such flamboyant statements as the Chrysler and Empire State buildings — architectural fantasies that expressed the very essence of modernity.

It is not too fanciful to suggest, I feel, that the upward thrusting forms of Teco anticipated a world that was depicted first in films like *Metropolis*, and then in the futuristic universe of Buck Rogers. But if we reflect on the fact that these popular futuristic images have become in our own time the actuality of the high technology cosmos, then we can get a sense of why Teco pottery appeals to contemporary taste.

In the same way that the architecture of Frank Lloyd Wright, an admirer and designer of Teco pottery, turned out to be far ahead of its time, so Teco pottery heralded forms and aspirations that would come into their own two or three decades later, and would find yet a third generation of appreciators a half century after that.

For me, the most rewarding aspect of this renewed taste for Teco lies in the role this pottery currently plays in homes designed by leading architects of the past and the present. Joel Silver's Storer House in Los Angeles, designed by Frank Lloyd Wright, proudly displays examples of Teco in cabinet and floor spaces. Teco pottery is similarly integrated into the sensitively designed California homes of Linda Balahoutis and Jerry Bruckheimer, and Patsy and Steven Tisch, both houses the work of architect Don Umemoto. The way in which Teco is used in the homes of these very special people reminds us that art and life are one and that the only difference between the material world created by man and the spiritual world created by God is in our minds.

I am deeply grateful for the opportunity I have been given to work on this landmark exhibition with John Vanco, Sharon S. Darling, and Richard Zakin. I have great respect for what is being done at the Erie Art Museum under John Vanco's leadership, and for the scholarship and knowledge of Darling and Zakin, experts in their fields. I know that this exhibition and catalogue are only the beginning of the growing acclaim accorded not only to Teco ceramics but to American art pottery as a whole.

Tod M. Volpe

Los Angeles, California

TECO: ART POTTERY OF THE PRAIRIE SCHOOL

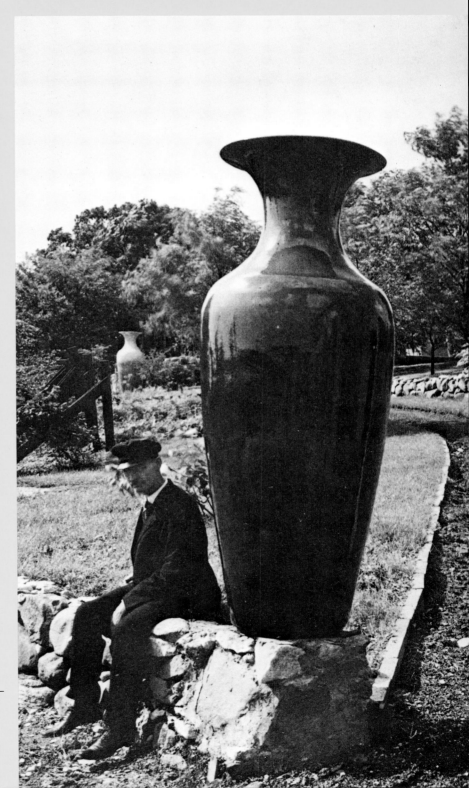

William D. Gates on the factory grounds at Terra Cotta
around 1900.

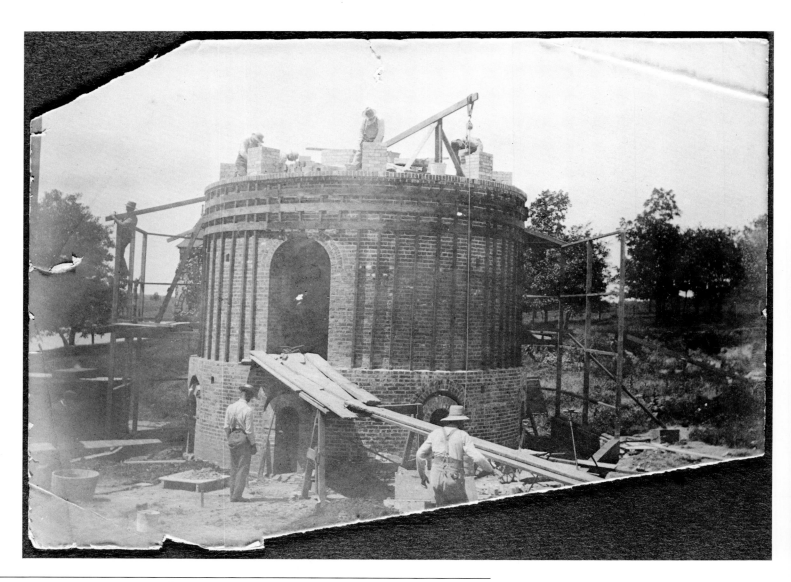

Fig. 1. New muffle kiln under construction at the Spring Valley Tile Works around 1881.

ART POTTERY
OF THE PRAIRIE SCHOOL

If my prophetic eye could have caught a glimmer of all the tedious and baffling experiments; of the trials and failures; of the days and nights of toil and worry — yes, the weeks and years — I should have quit so quickly that the customary "dull thud" would be the only descriptive term to describe the cessation.[1]

W riting to the editor of the *Clay Record* in 1892, the usually genial William Day Gates recalled twelve years of bitter struggle as one of America's pioneer terra cotta manufacturers. Only twenty-four years had passed since the country's first manufactory of architectural terra cotta, the Chicago Terra Cotta Company, had been founded to produce economically fireproof building materials made of clay. The Great Fire of 1871 stimulated the growth of this industry. In a new field where few were expert, Gates had spent a dozen years perfecting techniques for testing clays, concocting glazes, regulating kiln temperatures, and selling the finished products to skeptical architects and builders.

Despite his protestations to the *Clay Record*, Gates thrived on experimentation and challenges. Indeed, in addition to his architectural terra cotta, his "tedious and baffling" experiments would soon lead him to produce the art pottery known as Teco ware, for which he is best remembered today.

Fig. 2. William Day Gates in 1885.

Fig. 3. Gates encouraged local farmers to patronize his new enterprise by offering to grind feed as well as clay.

Gates was a tall, slightly built midwesterner of generous nature, an optimist who liked to make people laugh. A homespun philosopher, he frequently contributed witty conversational essays, called "Button-Hole Talks," to the *Clay-Worker* and other journals. He was in great demand as a banquet speaker because of his fine sense of humor and apparently inexhaustible fund of anecdotes (fig. 2).

Reared in the Crystal Lake area in McHenry County, Illinois, Gates graduated from Wheaton College, and attended the Chicago College of Law. He practiced law in the city until 1886, when he decided to devote all his energies to the production of terra cotta. In 1880 he had purchased some farm land and what was known as the McMillan mill in McHenry County with money he had inherited from his father. One day, walking through his fields, he literally stumbled into a new career when he discovered a large bed of clay on his land. Fashioning a sample into a vase, he fired it in an improvised kiln. The success of this first crude effort encouraged him to experiment further.

Gates's discovery coincided with a period of great expansion in the clay industry. On the one hand the Chicago building boom of the postfire years created a demand for terra cotta building materials. On the other, the flowering of the Arts and Crafts movement, as expressed in the revival of handicrafts like pottery making, encouraged the establishment of small art potteries like the Rookwood Pottery in Cincinnati and the Pauline Pottery in Chicago.[2] Encouraged by these developments, Gates founded the Spring Valley Tile Works on his land in the scenic Illinois countryside forty-five miles northwest of Chicago.

By 1885 an old mill had been refitted to grind clay, and a cluster of kilns were firing an assortment of bricks, as well as drain tile, which was much in demand by local farmers (figs. 1, 3). Ornamental terra cotta building materials, like chimney tops and finials, as well as urns and ornaments for the garden, were in production when Gates renamed the enterprise the Terra Cotta Tile Works later that year. He had decided to drop the reference to Spring Valley and to substitute the name Terra Cotta, which referred both to the products of his company and, increasingly, to the little village that was growing up around the works. At this point he quit his law practice altogether to devote full time to the clay business (figs. 4,5).

In 1887, when fire partially destroyed his factory, Gates rebuilt it and incorporated the company as the American Terra Cotta & Ceramic Company. By then it was clear that Gates's gamble on architectural terra cotta as a viable product would pay off. Terra cotta was now widely used as fireproof coating for cast-iron structural elements and, increasingly, as an economical and lightweight substitute for building cornices, window caps, and other ornaments traditionally made from stone. The parallel development of glaze technology gave the baked clay a porcelain-like surface that was impervious to weather and easy to clean — important attributes in smoky, sooty cities with severe and changeable climates like Chicago. This made terra cotta an ideal material for facing the exteriors of buildings. The plastic quality of terra cotta also made it an ideal medium for architects to express their designs for ornamentation.

From the 1870s through the 1920s, architectural terra cotta enjoyed great success both as cladding for some of the country's most striking skyscrapers — including Chicago's Wrigley Building and Santa Fe Building — and as ornamenta-

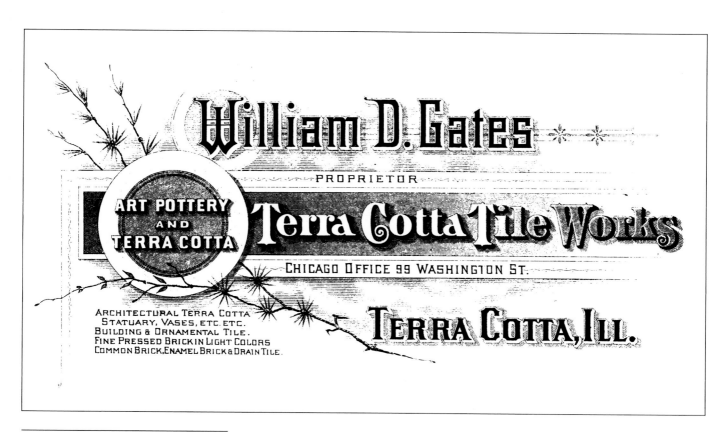

Fig. 4. Gates's 1885 business card listed a variety of products.

Fig. 5. Roof tiles and chimney pots made at the Terra Cotta works in the 1880s.

tion used in combination with brick on a variety of structures, ranging from elaborately façaded movie theaters to simple commercial structures. Gates's company produced architectural terra cotta for many well-known Chicago landmarks, including the Chicago Trust & Savings Building, the A. L. Rothschild Department Store (later Goldblatts), the Woods Theatre, the Chicago & North Western Railway Terminal, and the buildings at Great Lakes Naval Training Center. Since the large manufacturers of terra cotta — including the American Terra Cotta & Ceramic Company and the Northwestern Terra Cotta Company — employed sculptors to execute the architectural ornament they produced, these artists were available to turn their efforts to art pottery. Forming something of an elite group, the sculptors advanced their careers by moving frequently from firm to firm within the industry.

The main part of the labor force at Gates's manufactory, however, was drawn from the surrounding farms and the small towns of Crystal Lake and McHenry. Some of the workers lived in and around the village of Terra Cotta and walked to work; others commuted daily by a special work train that ran from Crystal Lake on a spur of the Lake Geneva branch of the Chicago & North Western Railway. Gates, who lived in Hinsdale, visited the factory about once a week, but worked in the company's main offices in Chicago, where he could meet with architects and contractors and keep abreast of local building developments.

In the summers, Gates and his family lived in an old farmhouse overlooking the factory. On Sundays, Gates led church services in the terra cotta chapel built on the factory grounds by the workers (figs. 6,7).

Entering the terra cotta business in the 1880s put Gates in direct competition with the Northwestern Terra Cotta Company, founded by employees of the Chicago Terra Cotta Company in the late 1870s and incorporated in 1888.

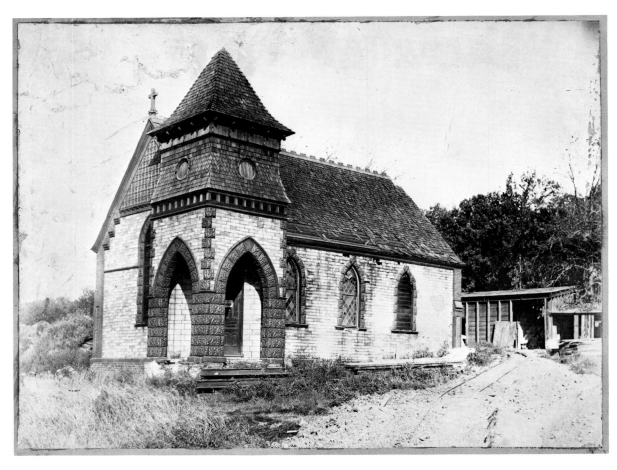

Fig. 6. The terra cotta chapel on the factory grounds of the American Terra Cotta & Ceramic Company around 1900.

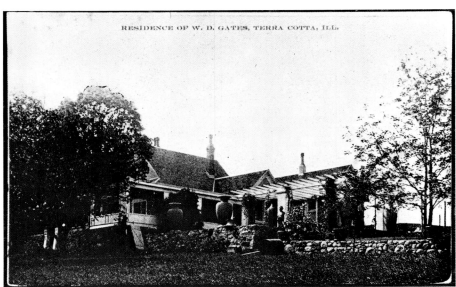

RESIDENCE OF W. D. GATES, TERRA COTTA, ILL.

Fig. 7. William Gates's picturesque residence at Terra Cotta around 1910.

Although similar operations were being launched in the mid-Atlantic states, American and Northwestern would remain the primary suppliers of terra cotta in the Midwest.

For both the Northwestern and American terra cotta companies, a decorative pottery line was a natural outgrowth of the architectural terra cotta business, because small pieces like vases and garden ornaments could be inserted in the gaps left between the large blocks of terra cotta placed in the kiln for firing. Made from similar clays as the architectural terra cotta, these garden urns and statuary pieces were popular with builders and homeowners alike as decorations for the gardens of the elegant residences being built in Chicago and its suburbs.[3]

At Gates's rural factory, lawn ornaments, fountains, plaques, and mantelpieces were crafted by A. LaJeune, a Chicago sculptor who periodically traveled out to the factory by train. A German potter named Gotterman also came from the city to hand-turn vases in various shapes and sizes. These earthenware forms were lightly fired and sold in the biscuit state to Chicago women, who glazed and decorated them to create fanciful "art pottery" emulating the wares being made at the Pauline Pottery. In addition to selling the biscuit forms, Gates's factory, and possibly Gates himself, decorated such forms with elaborate, three-dimensional flowers (fig. 8). A local journalist, visiting the factory in 1887, described these vases in glowing terms:

> In the potteries there are displayed a large number of
> shapes of the most beautiful vases, ornamented with roses
> and other flowers, in a manner that is astonishing, so
> perfectly does each petal and leaf stand out in the clay.[4]

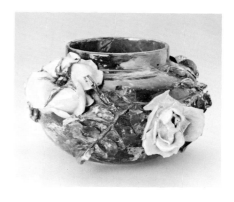

Fig. 8. Jardiniere ornamented with applied roses and leaves made around 1887. It is glazed in tones of brown, green, and tan. *Collection: TC Industries, Inc.*

These vases, like the terra cotta building materials, were at first made of local clays. By 1892, however, clays from the original beds were among many others being used for the company's products. Similarly, the original buildings had been supplemented by a complex of structures housing draftsmen, sculptors, chemists, mold-makers, and decorators, as well as special departments devoted to the preparation, pressing, drying, and firing of the clay.

In 1897 this efficient operation drew praise from Professor Edward Orton, Jr., then the country's leading ceramic chemist. Three years earlier Orton had founded a School of Clayworking at Ohio State University. The emergence of large numbers of factories to produce ceramic tableware, plumbing fixtures, and building materials challenged the skills of traditional potters and encouraged the establishment of schools dedicated to the technical training of ceramic engineers. Orton had met Gates through their shared interest in clay, and, in 1897, the professor visited the American Terra Cotta & Ceramic Company works. Sharing his impressions with readers of the *Clay-Worker*, he noted that the company's work force was "agog with excitement" over the production of two huge vases, each seven feet tall and weighing a thousand pounds, that had been designed, formed, glazed, and fired by Gates himself.[5]

Already in production were enormous red, buff, and gray garden urns five feet in height. Like the taller, more delicate vases, these urns had been cast in molds and featured interior walls webbed with thick clay partitions similar to those used to strengthen the hollow blocks of terra cotta. Ideally suited for outdoor

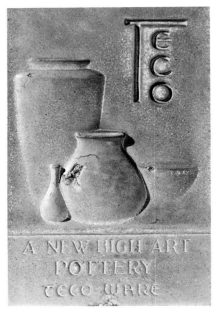

Fig. 9. Green glazed plaques from the gateposts at the entrance to the factory at Terra Cotta, Illinois. *Collection: TC Industries, Inc.*

use, these sturdy urns were put to use as flower containers in many of Chicago's public parks (fig. 10).

Such a difficult feat required familiarity with the principles of glaze chemistry, as well as the working of clay. The glaze had to be adjusted chemically so that it had a similar degree of contraction and expansion as the body of the pot in order to minimize "crazing" during firing. Success in this area was directly attributable to the talents of Elmer E. Gorton, a recent graduate of Orton's classes at Ohio State, who had charge of the chemistry lab at the factory. Assisting him were Gates's two older sons, Paul and Ellis, who had graduated from the same institution.

Gates enthusiastically supported efforts like Orton's, which led to the founding of the American Ceramic Society in 1899. Its purpose was to develop and apply scientific principles to an industry that had changed but little since ancient times. The skills of his young ceramic chemists, combined with the growing market for art pottery, encouraged Gates to develop what had previously been a pleasurable avocation into a subsidiary line of his terra cotta business. In June 1899, the company announced plans to construct a new two-story brick laboratory, noting that:

> The company has been experimenting, in a small way, over the manufacture of pottery ware, and the new laboratory is considered to be a step further along that line. It is thought by the company that a profitable business may be developed in pottery production, and that the manufacture of this ware will give employment to their men during the dull seasons in the building trade.[6]

The new venture would be known as the Gates Potteries and its product would be called Teco ware. Derived from the "Te" in Terra and the "Co" in Cotta, the name was to be "pronounced as though spelled Tea-Ko,"[7] according to promotional literature. "We needed a distinctive name," said Gates, "So I invented this."[8]

A special trademark featuring an elongated "T" was adopted to identify the pottery. At the entrance to the factory, a handsome ceramic plaque proclaimed the arrival of "a new high art pottery" (fig. 9). Teco ware was to be an entirely new type of decorative pottery, an art product quite unlike the utilitarian ceramic wares being mass produced in many potteries and clearly superior in design and execution to the art pottery being decorated by china painters or being made by hand in manual arts classes.

During the winter of 1899-1900 Teco evolved into three distinct types of pottery, each with a different glaze and clay body. Gates and his chemists concentrated on developing glazes compatible with various clays suitable for firing in the kilns alongside architectural terra cotta. First they used clays in subdued red tones, then in browns, then in buffs. They even developed an experimental high fire porcelain body. A demand for terra cotta with mottled or marbled surfaces led to their trying to obtain similar glaze effects on pottery. Merely by chance one vase emerged with an attractive metallic luster. Efforts to duplicate the odd combination of conditions that had created the shiny surface eventually resulted in the production of a brown glaze speckled with tiny flecks of gold. Applied to small vases with

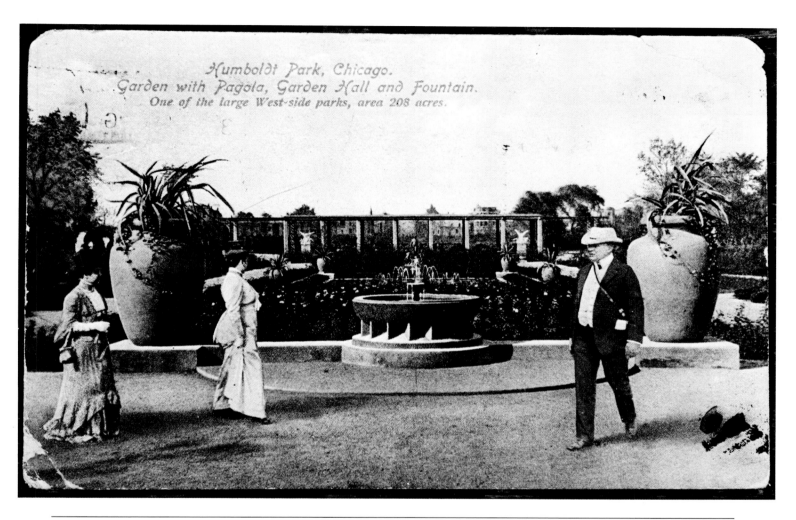

Fig. 10. Green Teco urns set among the elaborate plantings that made Chicago's Humboldt Park a popular tourist attraction. Hugh M. G. Garden, one of the architects who contributed designs for Teco pottery, designed the park's bathhouse in collaboration with Jens Jensen, the noted landscape architect.

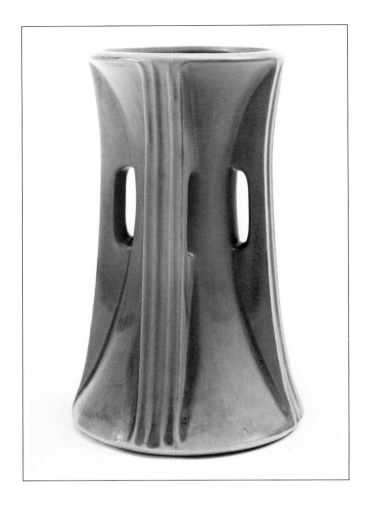

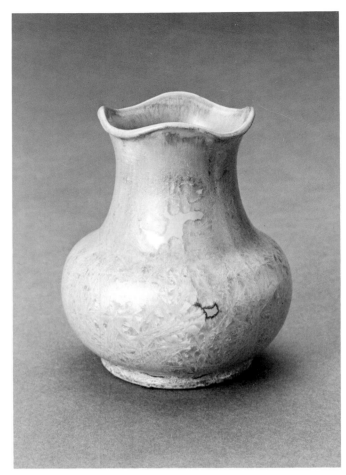

Fig. 11. (left) The matte green Teco glaze ranged in color from yellow green to dark moss green. The architectonic shape of vase no. 416 is attributed to William Gates. h: 18″ *Collection: Norwest Corporation, Minneapolis*

Fig. 12. (right) One of the few surviving examples of Teco Crystal is this blue/gray vase, a gift from a company draftsman to his wife. h: 4¾″ *Collection: Leonora J. Bierdeman*

delicate bodies made of porcelain clay, the glossy metallic glaze yielded handsome effects that flowed from deep brown to gold.

Not long after, another experiment resulted in pottery whose surface was covered with iridescent crystals arranged in fern shapes and clusters resembling frost on a windowpane. After countless hours, this crystalline effect was also replicated. This formula was also applied to porcelain clay bodies, and again various colors and patterns appeared during firing. No two pieces of Teco Crystal, as the ware was named, were alike. Gates was elated, for his pottery was the first in America to succeed in duplicating the large crystals evident on French pottery displayed at the 1893 Chicago World's Columbian Exposition. But the process was too unpredictable, and thus too expensive, to produce on a commercial basis. So the finest examples of Teco Crystal were displayed in Gates's office and proudly shown to visitors interested in the progress of the pottery[9] (fig. 12).

Similarly, the vogue for matte glazes (first displayed on French ceramics at the 1893 World's Fair) and for the color green (considered the tone most restful to the eye and most soothing to the nerves) inspired the chemists to work in that direction.[10] Soon they produced a glossless crystalline glaze in a cool, silvery green. Varying from pale to deep moss green, the color resembled the tones assumed by bronze after long exposure to the weather. In addition, it was an excellent "fit" over a dense buff body that could be fired at a low temperature in the factory's kilns (fig. 11).

This waxy green glaze, nicknamed "Teco green," would become the hallmark of the pottery. Gates explained:

> Mat glazes have found most favor at the works, since these
> have been found to give the best crystalline effect, not
> glossy or refractive, but pleasing and velvety to the eye and
> to the touch . . . the best finished effects have been scien-
> tifically produced, and our formulas have been so perfected
> that our products are no longer subject to experiment.
> They are positive and certain, and be they surface
> crystalline or metallic or glossless finish, when we have
> produced one piece we have practical assurance that we
> can duplicate it.[11]

Although the glaze was suggestive of one being made in Boston by William Grueby's pottery, Gates declared any similarity "a matter of accident, and not of deliberate imitation."[12]

Gates's experiments with clays and glazes kept pace with his invention of new pottery shapes. His aim was to produce ware whose beauty would derive from line and color rather than elaborate decoration. It would conform to the highest artistic standards, yet be sold at modest prices.

Over the years, Gates had become a reasonably skillful amateur potter. He began by throwing shapes (fig. 13). A few classic forms reflected his interest in ancient history; others were precise geometric designs supported by trusses, buttresses, and piers that, intentionally or not, reflected his involvement in the building trade (fig. 11). But he was acutely aware of the talent required to create original shapes and of the skills required to execute them. "In regard to the pottery business," he told colleagues at the time, "it is almost impossible to invent a new shape. You may try to invent a new combination of those flowing lines, but show it to an older potter and he will say: 'Oh, yes, that is Assyrian or Roman' — and it is not of any use to say anything."[13] For assistance in devising new forms, he turned to local architects and artists with whom he had become friendly in the course of doing business.

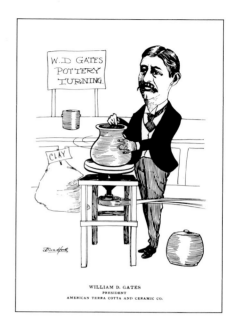

WILLIAM D. GATES
PRESIDENT
AMERICAN TERRA COTTA AND CERAMIC CO.

Fig. 13. "Clay products is his line, terra cotta his specialty; but pottery, Teco ware in particular, is with him an obsession, and he can't get away from it, and doesn't want to any more than you can get away from Gates or want to, after he has once got hold of you for one of his 'buttonhole talks,'" declared the *Clay-Worker* in 1908. A Chicago newspaper cartoonist captured Gates's enthusiasm in 1904.

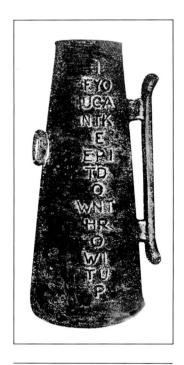

Fig. 14. The souvenir stein Gates presented to the Chicago Architectural Club was over twenty inches tall. The inscription reads, "If you can't keep it down, throw it up."

Gates was an active supporter of the Chicago Architectural Club, an organization of architects and draftsmen which sponsored talks, design competitions, and annual exhibits at The Art Institute of Chicago each spring.[14] Thus it is not surprising that Gates should turn to fellow club members for suggestions regarding the design of his new pottery. He had shown his large terra cotta garden vases in the Club's annual exhibitions in 1894 and 1895. Teco ware made its debut as an "exhibit of art pottery" in the club's 1900 exhibition.[15] Already Gates had amended and revised his forms following the friendly advice of some of Chicago's best-known architects, several of whom had sketched new forms for him and his modelers to execute. Gates must have been delighted to see the emergence of new forms so wholly compatible with modern architecture. The architects, in turn, were honored to have their ideas translated into this new art form.[16]

To show his appreciation for its contributions, Gates presented the Chicago Architectural Club with a giant dark green Teco stein bearing the monogram of the club (fig. 14). The piece, an elongated cylinder to which a handle had been added, was illustrated in the January 1902 *Clay-Worker*, whose editors pointed out:

> The stein is something over twenty inches high, and is of the same general color effect as the famous Teco ware now being manufactured by the American Terra Cotta and Ceramic Company, and which is, we think, destined to become as noted and popular as the Rookwood or any other of the really great American ceramic products.[17]

The highly original forms devised by Gates and his friends had been put into production at the Gates Potteries during 1900 and 1901. Within a year this group had designed as many as 150 shapes, and by 1904 it had created nearly 300. Supplemented by designs for garden pottery, these pieces would constitute a line of pottery so varied in shape that no one item could be called representative of the company's output. This variety, combined with the ware's pleasant green tones and modest price, immediately drew attention to it.

In the spirit of the Arts and Crafts movement and his own practical inclinations, Gates created shapes that were not merely decorative but would serve some

Fig. 15. Teco "triplicate vase" no. 330, designed by Frank Lloyd Wright, on display in the Chicago Architectural Club's exhibition in 1907.

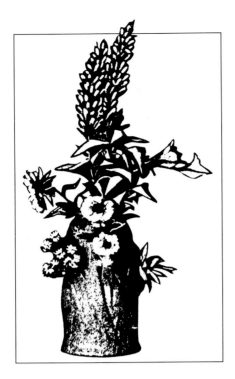

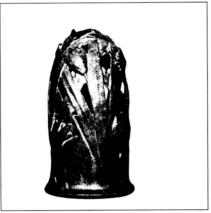

Fig. 16. Vase no. 151, designed by William J. Dodd, was shown holding a casual floral arrangement in the Gates Potteries' 1906 catalogue.

useful purpose, whether household or horticultural. He created shapes that were clearly recognizable as vases, pitchers, or bulb pots and had strong bases that prevented tipping or spilling. Forms fitted the hand, and protruding or perpendicular parts, while often not obtrusive enough to be called handles, suggested the ease with which the pieces could be moved or lifted.

Teco mugs and pitchers made fine flower holders; low bowls, made popular by the fad for Japanese flower arrangements, could double as bulb pots or ashtrays; and large vases served equally well as lamp bases. This versatility was clearly demonstrated in 1902 when a dozen Teco vases suitable for use as lamp bases were shown at the first Annual Exhibition of Applied Arts held at The Art Institute of Chicago.[18] Similarly, the practical Gates fitted several large vases with interlocking lids and promoted them as "absolutely indestructible" crematory urns.[19] The sanitary and economical Teco urns with their striking modern designs were well suited to the spirit of the cremation movement, part of a socially "progressive," rationalist trend that had been gaining popularity since the 1880s.

In 1903 Gates displayed a selection of vases designed by Chicago Architectural Club members at the club's annual exhibition.[20] Several pieces were the work of the well-known team of William LeBaron Jenney and William B. Mundie, who ten years earlier had designed an innovative all-terra cotta residence for Gates in suburban Hinsdale, and one in Chicago for the company's treasurer, Nathan Herzog.[21] Jenney (celebrated for his pioneering use of skeletal framing in Chicago's first "skyscraper," the Home Insurance Building) contributed a Teco vase featuring a conventionalized floral motif in low relief (no. 154). Mundie, Jenney's partner, created such a variety of Teco ware that the following year Gates's exhibit consisted entirely of his work. Most of Mundie's designs were jardinieres or vases in simple shapes featuring intersecting circles and rectangles. On a few, leaf-like forms softened the mouths of otherwise stark geometric forms.

One of Jenney's former apprentices, William J. Dodd, designed an intriguing series of vases with tapering semidetached leaves and delicate cutwork patterns (nos. 84-90) reminiscent of aquatic plants in the factory pond. One vase (no. 151) was directly inspired by the exotic water lilies so popular at the time. The long stems of flowers could be thrust through the interstices of the overlapping leaves, which had been designed especially to support the heavy heads of the pond lilies (fig. 16).

Hugh M. G. Garden, later known for his splendid commercial architectural designs, contributed several vases, including one which combined graceful rounded contours with an openwork leaf design (no. 106) and another whose simple barrel form was banded by parallel lines (no. 252). A vase by N. Max Dunning, secretary of the Architectural Club, featured square corner posts that echoed the sturdiness of geometric Arts and Crafts furniture being designed at the time (no. 265). Other handsome vases were designed by architects Jeremiah K. Cady, John I. Dorr, Harold Hals, Holmes Smith, Melville P. White, and Frank Lloyd Wright.

Although not a member of the Chicago Architectural Club, Frank Lloyd Wright frequently displayed his work in the club's exhibitions. An example of Teco pottery known to have been designed by Wright in 1902 is an intricate thirty-two-inch "triplicate vase" whose slender vertical shafts anticipated the skyscraper

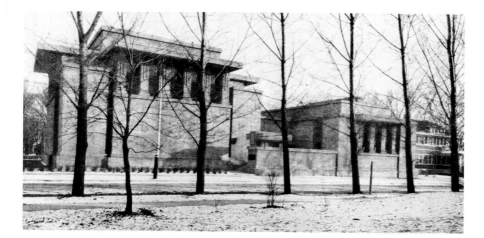

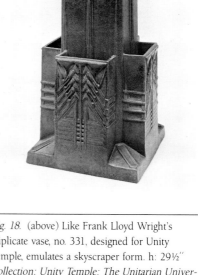

Fig. 17. (left) Unity Temple, Oak Park, Illinois, designed by Frank Lloyd Wright in 1906.

Fig. 18. (above) Like Frank Lloyd Wright's triplicate vase, no. 331, designed for Unity Temple, emulates a skyscraper form. h: 29½" *Collection: Unity Temple: The Unitarian Universalist Church in Oak Park*

Fig. 19. (left) At least two large Teco vases were displayed in the 1907 exhibition, *Frank Lloyd Wright's Work*, sponsored by the Chicago Architectural Club at The Art Institute of Chicago. The one illustrated here may have been no. 328, an unidentified shape which precedes three designed by Wright.

forms of the following decade (no. 330). The vase, holding dried weeds, was displayed among other examples of Wright's work shown in the Chicago Architectural Club's exhibit of 1907[22] (figs. 15,19,23).

By this time Gates's workers had cast in terra cotta glazed creamy-white the *Flower in a Crannied Wall* statuette and *The Moon Children* fountain, both modeled by Chicago sculptor Richard W. Bock for the entrance hall of the Susan Lawrence Dana residence in Springfield, Illinois.[23] For the same house Gates's potters were executing a large Teco stand ornamented with the abstracted sumac motif that Wright used as a unifying motif throughout the house[24] (fig. 23). A third sculptural cubic vase, whose form recalled the geometric clerestory piers on the cast concrete exterior of Wright's Unity Temple in Oak Park, was also made by the pottery around 1906 (figs. 17,18, colorplate 16).

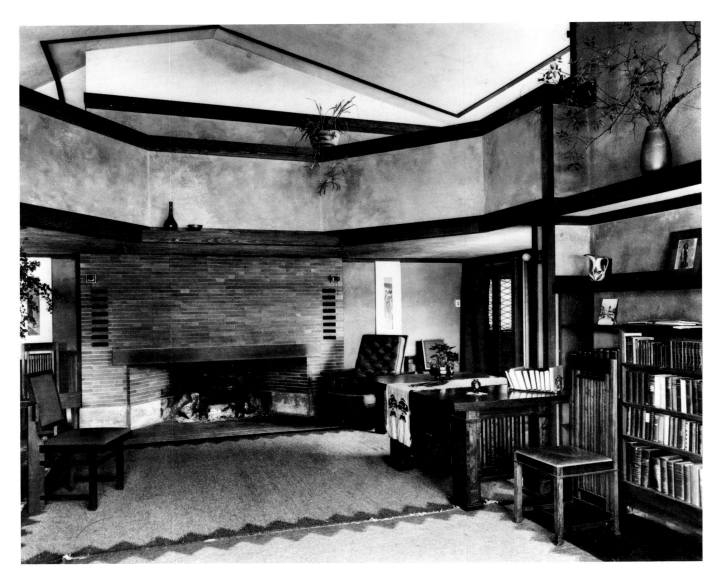

Fig. 20. Teco vase no. 252, designed by architect Hugh M. G. Garden, complemented the interior of Isabel Roberts's dramatic living room.

Fig. 21. Prairie style house designed by Frank Lloyd Wright for Isabel Roberts, his office manager, in 1908.

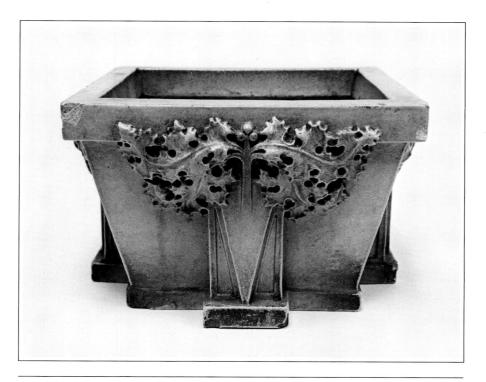

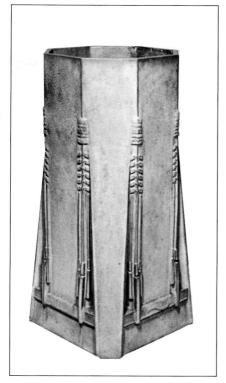

Fig. 22. Teco green planter from the National Farmers Bank of Owatonna, Minnesota, designed by Louis H. Sullivan around 1907. h: 8¼″ *Collection: Norwest Corporation, Minneapolis.*

It is not known whether these three large Teco pieces were modeled by Bock or by Gates's modelers, or how many castings of each vase were made. Only the "triplicate vase," which was illustrated in a 1906 Teco catalogue, is known to have been offered for sale to the public.

By 1903 Frank Lloyd Wright and several of the other architects designing Teco pottery were identified with Chicago's progressive Prairie School of architecture, whose particular concern was residential design. Rejecting the historical revival styles that had characterized American architecture during most of the nineteenth century, members of the Prairie School had begun to develop new forms that they considered more appropriate to the time.

Inspired by Louis H. Sullivan's message of simplification, and encouraged by Frank Lloyd Wright's success, members of the movement created suburban residences characterized by open interiors and horizontal silhouettes that hugged the midwestern prairie. Calling attention to the beauty inherent in natural materials such as wood, stone, and clay, they advocated the use of simple rectilinear forms, plain surfaces, and finely executed decorative detail. Such ornament as appeared in their structures often consisted of a flat geometric composition or an abstracted plant or floral motif which emerged gracefully from within the material through carving or modeling (figs. 20-22).[25]

The product of a unique collaboration between architect and potter, Teco ware became the ceramic expression of the Prairie School. This special relationship was acknowledged in 1908 by Chicago architect Thomas Eddy Tallmadge, who, reviewing the work of the Prairie architects, wrote: "In the realm of pottery Chicago architects have delved deep, and have encouraged by their demands and their designs the local development of the craft."[26]

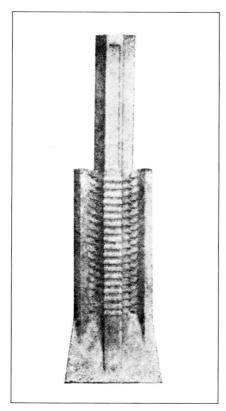

Fig. 23. Teco pottery designed by Chicago architect Frank Lloyd Wright: (top) no. 329 from the Susan Lawrence Dana house, Springfield, Illinois; (below) triplicate vase no. 330 illustrated in the Gates Potteries' 1906 catalogue. It was priced at $30.

Fig. 24. The rooms of The Cliff Dwellers Club were furnished with Teco vases and smoking accessories designed by architects W. K. Fellows, Hugh M. G. Garden, and Howard Van Doren Shaw, all members of this arts club for men. (below) On the tables, flower tubs no. 376, designed by William K. Fellows, double as ash trays. Jardiniere no. 158, designed by Howard Van Doren Shaw, holds a potted palm.

DESIGN AND PRODUCTION

While not all Teco ware was designed by architects or artists, each piece embodied the same philosophy of design. Silhouettes revealed graceful lines and soft curves. Occasionally a flower or leaf appeared in low relief on the body of the form, or incised lines embellished a rim. But most pieces had smooth surfaces glazed with the soft "Teco green" that harmonized so well with plants or flowers of any hue.

Like many who were educated in the late nineteenth century, Gates held a quasi-scientific view of art as an extension of the principles of nature expressed in "organic design." In spite of his claim about the impossibility of innovation, he succeeded in creating simple and original forms inspired by plants or flowers. Among the most unusual were cones, vasiforms, and cylinders modified by horizontal or vertical stalks, and fluid organic forms modeled after local flora and fauna. Others were derived from classical forms favored by ancient or preindustrial cultures like those of Japan, China, Persia, or the American Indian. While some shapes were identified specifically as a "classical Grecian vase" or a "Roman salad bowl," others were based on traditional ceramic forms.

The similarity between the shapes developed by Gates and those created by other designers reflects the popularity of the concept of organic design among his contemporaries. In addition to this common aesthetic, Gates and the architects who designed Teco ware shared important social and professional associations. Most were members of the Chicago Architectural Club or, after 1907, the Cliff Dwellers. Nearly all were the same age and were connected in one way or another with professions related to building. Many were architects who had been trained in the offices either of William LeBaron Jenney or of Louis H. Sullivan, both of whose commercial work is part of what came to be called the Chicago School of architecture. Their practical approach to design gave Teco ware a decidedly masculine character that set it apart from most of the art pottery of its day.

Unlike the delicate and highly ornamental forms produced by many art potteries for use in the parlor, boudoir, or dining room, Teco's architectonic forms with their chaste decoration were ideally suited for "men only" spaces like smoking rooms, athletic clubs, and hunting lodges. Thus it is no surprise that Teco ashtrays and steins are often found impressed with the logos of clubs like the Chicago Athletic or Cliff Dwellers. Around 1909, when the Cliff Dwellers moved

into a new penthouse overlooking Michigan Avenue, the clubrooms were furnished with Teco vases, smoking sets, and planters donated by Gates. An active member, he frequently dined at the club, which claimed many of Chicago's best-known writers, artists, architects, and musicians among it members (fig. 24).

Gates's artistic temperament and generous nature also drew him into the Arts and Crafts movement with its focus on design reform as a means to social betterment. Arts and Crafts proponents set out to combat what they saw as the appalling consequences of the Industrial Revolution — dehumanization of the worker and a resulting decline in the quality of goods. Gathering force in England in the latter half of the nineteenth century, the movement soon spread to Europe and the United States.

The rapid organization of arts and crafts societies in major American cities drew together artists, craftsworkers, industrialists, and social workers. While the motivations of the various societies differed as much as the styles of their products, all the societies embraced the Arts and Crafts philosophy. Their credo was simplicity in design and the creation of products that embodied the skill and individuality of the craftsman.[27] When the Chicago Arts and Crafts Society was founded at Hull-House in 1897, it claimed 140 charter members, including crafts-workers, artists, social workers, professors, political reformers, and numerous architects (this linking of aesthetic, social, and political interests, reminiscent of its English origins, would remain characteristic of the Chicago movement). Although not listed as a charter member, Gates later served as the Society's president.[28]

In the United States, as in Europe, pottery proved to be one of the most popular of the revived crafts. The immediate product of the hand functioning as a tool, pottery frequently retained the imprint of the potter's palm and fingers. Objects of lasting beauty could be fashioned using no more than common clay. Requiring few tools and inexpensive equipment, pottery making became a popular hobby as well as a source of livelihood for many men and women. Among the women known to have designed Teco pottery were a Mrs. F. R. Fuller (about whom nothing further is known),[29] and Blanche Ostertag, a popular Chicago painter and illustrator. The latter worked as a free-lance decorative designer in Chicago at the turn of the century and is known to have collaborated with Orlando Giannini and Frank Lloyd Wright on glass mosaic fireplace mantels for the Joseph Husser house in Chicago in 1899. Ostertag's sketches and paintings were frequently exhibited at The Art Institute of Chicago in the late 1890s and she was a member of the artistic circle that included many of the Prairie School architects.[30]

The revival of handicrafts seemed a means to revitalize the life and spirit both of the individual and of society as a whole. It was believed that those who took pride and pleasure in the work of their hands would eventually create a better, more moral society. As Gates often said, "Clayworking led not only to the making of clay wares, but to the making of men as well."[31]

Although Chicago's Arts and Crafts advocates emphasized the creation of an indigenous American art, they did not work in isolation, and eagerly sought knowledge of the international modern art movement. In 1898, for example, the first exhibition sponsored by the Chicago Arts and Crafts Society displayed innovative pieces made by the French artist/potter Auguste Delaherche, items

Fig. 25. Catalogues issued by the Gates Potteries helped spread the philosophy of the Arts and Crafts movement throughout America.

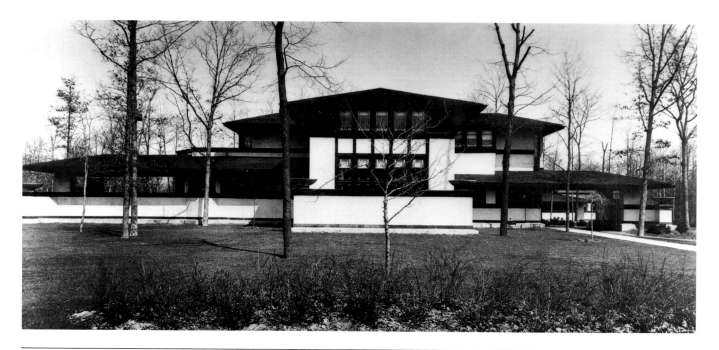

Fig. 26. Designed by Frank Lloyd Wright in 1902, the Ward W. Willits house in Highland Park, Illinois, was one of the earliest and most successful "prairie" houses.

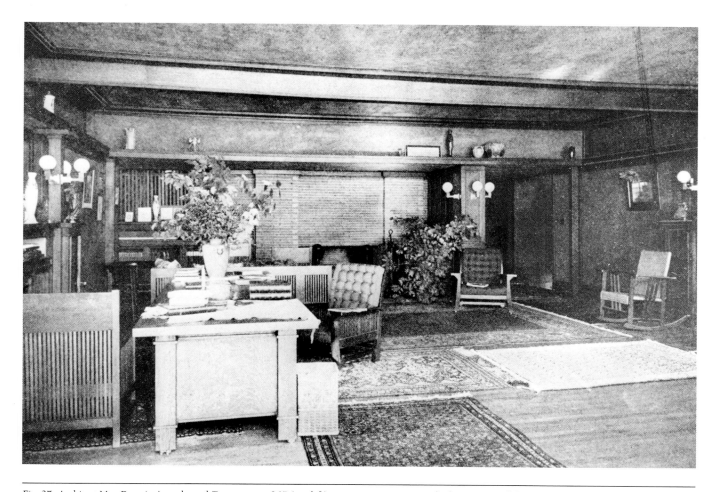

Fig. 27. Architect Max Dunning's sculptural Teco vase no. 265 (top left) was among ceramics in the living room of the Ward Willits house, Highland Park, Illinois, around 1902.

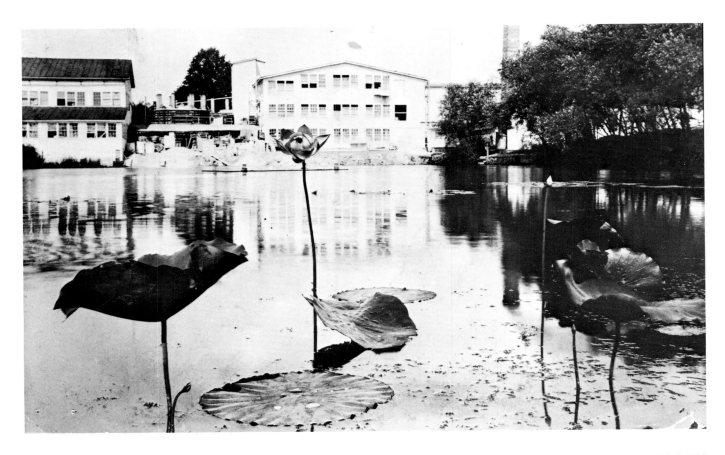

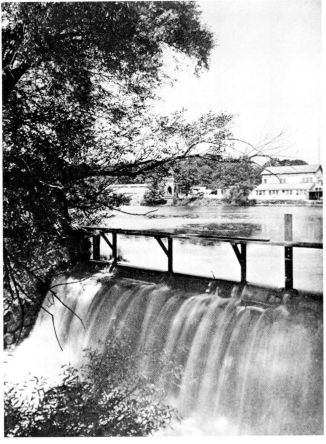

Fig. 28. A view of the factory from across the lily pond around 1903, when new kilns were under construction. Writing in the *Clay-Worker*, Edward Orton, Jr., described the advantages of the site in 1897: "The modeler's room at Terra Cotta overlooks on one side a lovely little lake, whose placid waters are framed in willows and rushes and covered with lily pads. On the other a wooded, park-like slope, covered from spring til fall with the flowers of the season, stretches away to the west. If he lacks inspiration for a difficult design, two minutes' walk will put him in the heart of nature, out of sight or sound of men, where he can drink in beauty and refresh his mind."

Fig. 29. "In the early 1880s I started experimenting and remodeling an old mill at what is now known as Terra Cotta only to learn that while it might be a dam by a mill site, it was not a terra cotta factory by a dam site," wrote Gates in the *Clay-Worker* in March 1928.

from the Rookwood Pottery in Cincinnati and the Dedham Pottery in Massachusetts, and antique Chinese and Japanese ceramics as well. Indeed, the exhibit, much discussed in the local arts press, may have encouraged Gates to begin producing art pottery commercially, since there were no other art potteries in the area, the Pauline Pottery having gone out of business.[32]

Periodicals like *International Studio, Fine Arts Journal,* and *Dekorative Kunst* also carried news of the latest trends in British, Austrian, and German decorative design to Chicago's artistic community. G. Broes Van Dort Co., purveyor of "architectural and art industrial books" at 218 LaSalle Street, was one of several dealers who specialized in supplying books and periodicals to the city's architects and designers. From this shop, Gates purchased the *Dekorative Vorbilder*, a series of folios illustrating modern European designs for ornament and graphics published annually by Julius Hoffmann of Stuttgart, Germany.[33] A number of the elegant symmetrical designs shown in the Hoffmann portfolios were later traced by Gates's modelers to be copied for terra cotta ornament.

William Gates, described in one Teco booklet as a "painter, designer, raconteur, student . . . also chemist and modeler in clay," was typical of many who were drawn to the Arts and Crafts movement by its unique blend of aesthetics and morality.[34] Like the English founder of the movement, William Morris, he was a "hands on" participant dedicated in his efforts to unite industry and art. "A psychologist would say that in Teco he found the best and truest expression of himself," a friend of Gates wrote. This appeared to be true, despite Gates's protests that he just liked to "putter about pottery."[35]

As a philosophical and artistic expression, Teco pottery became intertwined with Gates's personal identity. "It is not the symbol of a money-hungry manufacturer, or merchant or exploiter," proclaimed one of the promotional pieces, continuing, "It is an ideal formulated and rendered tangible. Materially it is made of clay, but in reality it is the realization of the dreams, the patience, the industry, the research, the scholarship and love of art of William Day Gates."[36]

The thriving Arts and Crafts movement and the innovative Prairie School provided Gates with both a philosophy of design and a clientele for his pottery (fig. 25). "The strictly modern and truly American home offers many a niche for Teco pieces in its broad, low ceilinged living room with its bungalow type of architecture," one journalist pointed out. "It seems an almost essential part of the arts and crafts interior of modern dwellings, so perfectly is its spirit attuned to the spirit of the times."[37] Whether gracing the interior of a luxurious Prairie style residence or a bungalow built from mail-order plans, Teco symbolized a commitment to the ideals of the Arts and Crafts movement. Thus it was not by chance that Teco ware appeared in the pages of *The Craftsman* and *House Beautiful* as well as in houses designed by Frank Lloyd Wright and his followers (figs. 20,21,26,27).

Like William Morris in England, and Elbert Hubbard, founder of the Roycrofters craft cooperative in East Aurora, New York, Gates believed in the importance of providing healthful and attractive surroundings for his workers (figs. 28,29). He landscaped the factory grounds with flowers and a lily pond, and took a personal interest in the welfare of his employees. Their idyllic pastoral surroundings were a far cry from the noise and soot of the modern factories near industrial

**VISIT THIS INTERESTING FACTORY
WHERE TECO POTTERY IS MADE**

Fig. 30. The factory of the American Terra Cotta & Ceramic Company was located in the countryside northwest of Chicago.

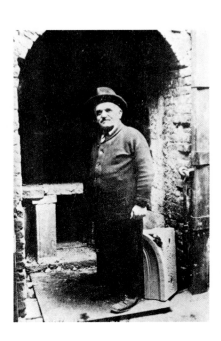

Fig. 31. "Old-timers" at Terra Cotta included foreman pressors Fred Rose, left, and Fred Shuman, right, and Otto Schwarz, center, who had charge of the slipping room and of kiln loading and unloading.

Chicago, whose streetscapes the company's clay products were rapidly transforming.

Visitors to the pottery rarely failed to comment on the natural beauty of the site and the dedication of its workmen. Susan Frackleton, herself a well-known art potter, described the scene in 1905:

> The potteries are beautifully situated in a picturesque valley, amid delightful surroundings of wood, field and lake. Mr. Gates firmly believes that beautiful surroundings tend to inspire beautiful thoughts. One must have enthusiasm for his work to give it individuality and charm, hence the beautiful lily-ponds built and stocked with rare aquatic plants near the clear, little lake, and the profusion of flowers cultivated round about. . . .There is none of the usual factory squalor, nothing dejected and hideous to look upon; no children at work; no half-paid, pinched-faced women; none but men who have the air of being fitted to accomplish what lies before them during the day and of doing the day's work with poise and sincerity.[38]

Although he fired a worker who tried to unionize his employees, Gates was sympathetic to some aspects of the socialism promoted by more radical members of the Arts and Crafts movement. He encouraged his workers to establish a cooperative meat market, and sold them the domestic coal he was able to purchase in bulk at cost price.

He wanted to keep the prices for his art pottery low so that it could be bought by ordinary people. In order to do that, he applied the same mass-production methods he had used successfully in making architectural terra cotta to the production of the art pottery. Each piece was sculpted in clay, then cast in molds

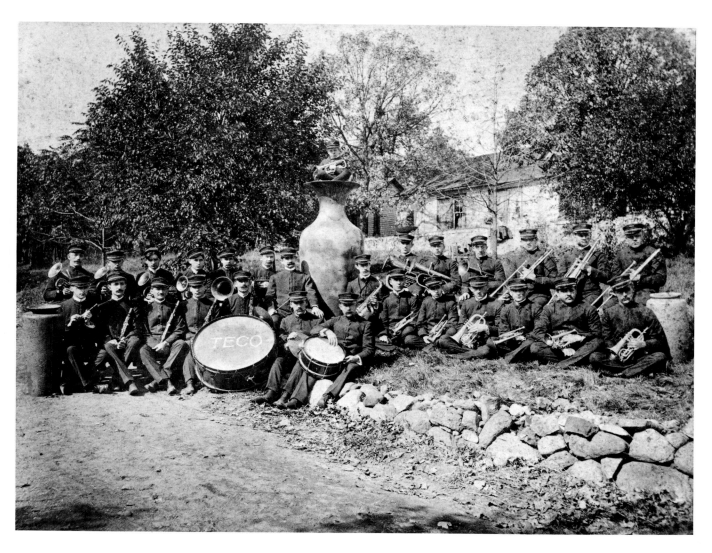

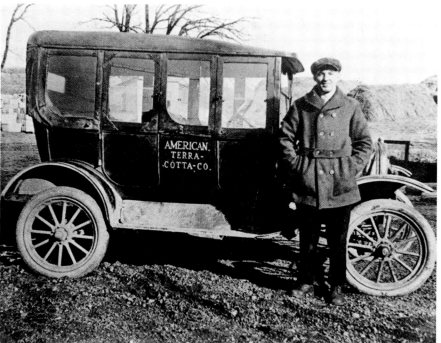

Fig. 32. Members of the Teco Military Band pose in their new uniforms on the factory grounds in 1903.

Fig. 33. Visitors arriving by train were driven from Crystal Lake to the Factory by Eric Utech in his "trusty flivver."

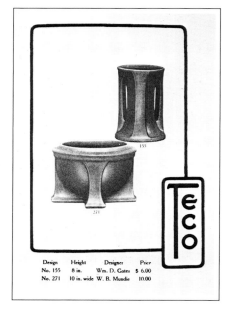

for accurate duplication. Once each piece was taken from the mold, glaze was applied with a sprayer to assure fast and even application. The simple shapes and fluid lines of Teco ware allowed the liquid glaze to skim over the smooth surface.

Such techniques enabled Gates to produce far greater quantities of ware at a lesser cost than would have been possible by using hand building or throwing. While not entirely handmade by a single craftsman, the pottery was still the end product of a time-consuming process requiring much handwork and skilled labor, and thus philosophically conformed to the Arts and Crafts creed.

Designs were identified by pattern number, with shapes that were similar in form or developed by one designer often numbered in sequence. Lamp designs were numbered 1 through 49. Items numbered between 50 and 80 were small classic shapes, primarily vases, designed by Gates. Probably the earliest Teco designs, they reflect two consistent trends characteristic of this ware. One is the tendency to make the same shape in various sizes; the second is the development of generational design variations achieved by manipulating the molds.

Several Teco shapes appear in two, three, or even five sizes. For example, design no. 60, a plain cylindrical vase with a rounded lip, eventually appears in five sizes, ranging from 6 to 26 inches, identified by the letters A, B, C, D, and E before the number. This classic shape also appears frequently with experimental glazes and in a variety of colors. It can be used, as well, to illustrate the second technique, that of mold manipulation, when it reappears as no. "B60 Orn (ornamental)" with its body ornamented with daffodils in low relief.

The manipulation of molds to create a new shape also resulted in vases numbered 72, 73, and 74. Number 72 is a tall plain cylinder tapered toward a narrow mouth. Number 73 is the same shape broader in body with a wider mouth. With the addition of a long vertical handle, the shape became the stein presented to the Chicago Architectural Club (no. unknown). Number 74 was created by applying a broad band of lacy geometric decoration to the body of no. 73. Probably a special order, shape no. 74 seems not to have appeared in any of Gates's catalogues (colorplate 27).

Other new shapes were formed by adding a base, a lip, or duplicate handles. For example, no. 435, a cylindrical vase with vasiform body and two upright piers,

Fig. 34. Garden planter no. A271 was an oversize version (28″ wide) of jardiniere no. 271 (10″ wide), designed by architect William B. Mundie.

Fig. 35. Unglazed jardinieres at the factory. The vase on the right, no. 86, was designed by architect William J. Dodd.

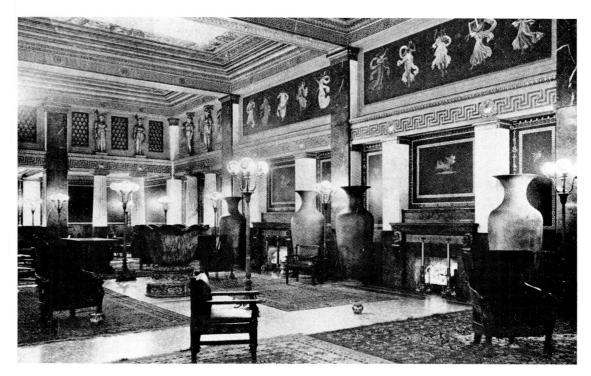

Fig. 36. Teco vases in the Pompeian Room at the Auditorium Annex (later the Congress Hotel), in 1909.

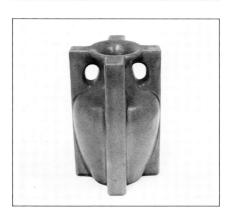

Fig. 37. Molds were used creatively and economically at the Gates Potteries. William D. Gates added a second pair of handles to no. 435 (top) to create shape no. A435 (bottom). h: 7″ *Collection: Robert A. Furhoff (435); John and Nancy Glick (A435)*

is transformed into vase no. A435 with a decidedly rectangular form through the addition of a duplicate pair of molded uprights (fig. 37). Pieces created in this way were identified by the letter A in front of their number. Such techniques produced many innovative shapes while taking full advantage of the fact that many mold sections are interchangeable.

Teco pottery was at the height of its production in January 1903 when Gates acquired the interest of Nathan Herzog, treasurer of the firm. In the reorganization that followed, Paul Gates was elevated to secretary and Ellis Gates became treasurer. Once again the plant's facilities were updated and expanded, and a new four-story factory building was begun and completed in 1904.

At the time, Chicago was in the midst of a building boom and the American Terra Cotta & Ceramic Company's business reflected the region's prosperity. "Another record-breaking season for terra cotta," reported the local newspaper, noting that the firm was "doing an enormous business in pottery ware."[39] Thousands of dollars' worth of vases, seven feet tall and glazed in Teco green, graced the elegant Pompeian Room in Chicago's new Auditorium Annex Hotel (fig. 36). Gigantic urns, jardinieres, and planters made their appearance in public and private gardens as proponents of the "City Beautiful" movement encouraged the spread of handsome municipal parks and streetscapes to cities and towns across America. Orders for pottery flowed in from all parts of the country as Teco ware was placed on consignment with leading ceramics dealers and department stores. Reflecting this success, the company ordered crisp green uniforms with black trim to outfit the new Teco Military Band organized by its employees (fig. 32).

Throughout 1903 additional workmen had been hired at the factory to fill the large orders for architectural terra cotta. And in the potteries others were at work making special Teco pottery and art ware for the company's display at the upcoming St. Louis World's Fair.

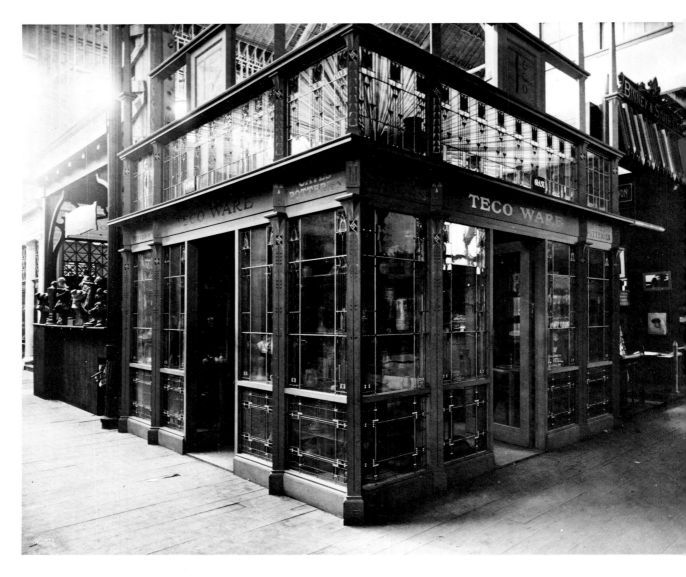

Fig. 39. Teco landscape tile painted by Hardesty G. Maratta around 1904.

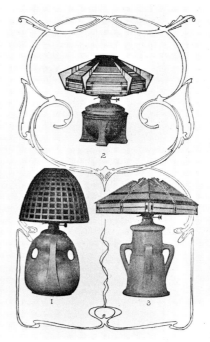

Fig. 40. Teco lamps illustrated in the 1904 *Teco Art Pottery* catalogue.

ST. LOUIS WORLD'S FAIR

Fig. 38. The Teco pavilion at the
St. Louis World's Fair, 1904.

At the 1904 exposition, Gates exhibited an impressive array of both architectural terra cotta and pottery products. In the Palace of Varied Industries, Teco pottery was displayed to great advantage in a stunning art-glass pavilion (fig. 38). The interior was lit by Teco lamps with shades of Japanese grass cloth or leaded glass especially designed to enhance the shapes of the pottery. Most dramatic were the leaded glass shades in soft tones of green and amber fabricated by the Chicago stained glass studio of Giannini & Hilgart. Orlando Giannini, a multitalented artist, also had contributed several designs for Teco pottery. With his partner, German glass worker Fritz Hilgart, he frequently executed art-glass windows and lighting fixtures for Frank Lloyd Wright and other Prairie School architects. It is likely that Gates commissioned Giannini & Hilgart to make the intricate glass pavilion as well as the lampshades.

Also displayed were metallic glazed porcelains and a selection of Teco Crystal. Although he had been one of the first to introduce an Americanized version of the elusive frost-like glaze, Gates chose not to capitalize on his discovery. With a generosity rare in the competitive ceramics industry, he presented the formula for the crystalline glaze to the American Ceramic Society (which he had helped form in 1899) when he became its president in 1905.[40]

In the Mining Building, enormous Teco garden vases were exhibited alongside planters, jars, and tubs. In addition, Gates displayed a landscape painting executed on terra cotta by Chicago artist Hardesty Gillmore Maratta (fig. 39). Its muted blue-green color had been obtained by spraying the design in slip (liquefied clay with color added) on a damp clay panel impressed with the imprint of canvas. This was a particularly challenging feat since the true color of the slip did not appear until after firing, requiring the artist to remember exactly what shades he had used and in what place they had been applied. The novel effect of the landscape panel won a gold medal for Gates, as did his elegant exhibit of Teco ware.[41]

Visitors to the Fair were encouraged to take home a new promotional pamphlet, *Teco Art Pottery*, illustrating lamps and pottery available by mail (fig. 40). The small booklet showed three lamp designs and fifty-eight pottery shapes identified by numbers ranging from 1 to 294. Similar booklets followed in 1905 and 1906, illustrating additional shapes, identified by their numbers and naming their designers. These were supplemented by a *Garden Pottery* catalogue which offered more than forty additional shapes. This broad selection provided something for every taste.

More than half of the shapes appearing in these catalogues were the work of Gates, Chicago architects, or decorative designers like Orlando Giannini or Blanche Ostertag. However, an impressive number were the work of Fritz Albert, head modeler at the terra cotta factory, or his colleague Fernand Moreau.

ALBERT AND MOREAU

Fig. 41. Garden sculpture no. 346, *Conception of Pan*, designed and executed by Fritz Albert.

Trained as a sculptor in Berlin, Fritz Albert had come to Chicago to execute work for the German government at the 1893 World's Columbian Exposition. After studying for a while in Rome, Albert returned to Chicago and went to work at the American Terra Cotta & Ceramic Company. Here he enjoyed the plant's rural setting and often explored the surrounding fields and woods in search of unusual plants and flowers. Reticent and soft-spoken, he pronounced his surname "Alber" in the French manner, reflecting the ambiguous national status of his birthplace, the Alsace-Lorraine region, which was French when he was born but became German after the Franco-Prussian War of 1870.[42]

Albert worked both as a designer of Teco ware and as the sculptor of many of its forms. Some of his shapes inspired by Pompeian vases or Grecian pitchers showed his classical training in art, while garden plinths of Pan and stands ornamented with smiling satyrs reflected his strong interest in history and mythology. More prevalent, however, were the sculptural forms that revealed his love of nature. On one unusual vase (no. 192), three-dimensional iris leaves swirl from base to rim, attached only at their tips. This design required that the slender leaves each be cut from clay and applied one by one to the basic vasiform shape. In contrast, the cool cylindrical form of no. 310 dissolves into a crisp twist of leaves at its base. Here Albert would have used his carving skills to remove clay from the base to create the delicate intertwined leaves on each vase.

Albert also designed a variety of garden pieces. He created a selection of wall pockets ornamented with slender iris leaves, as well as hanging pots and low bowls ideal for holding vines or flowering bulbs. The company's *Garden Pottery* catalogue illustrated several large garden planters and urns resembling olive jars, as well as sculpture created by Albert in gray terra cotta. One of his best-known garden sculptures, the *Conception of Pan* (no. 346), which showed a strong Germanic influence, overlooked the factory's garden. In the 1906 Teco catalogue the sculpture was priced at a hefty $450, reflecting the amount of time and talent required to cast and fire such a complicated piece (fig. 41).

In 1904 Albert was joined in the modeling room by French sculptor Fernand Moreau (fig. 42). Trained in Paris, Moreau had operated his own studio in Washington, D.C., before moving to Chicago at the time of the 1893 World's Fair. When he joined Gates, Moreau was teaching evening classes in clay modeling at The Art Institute of Chicago. While working for Gates, he designed several exuberant pieces whose undulating curves reflected his familiarity with French Art

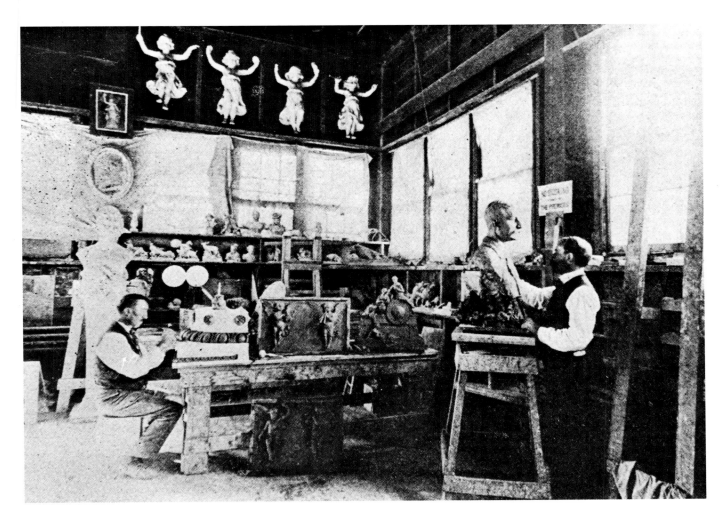

Nouveau. On several vases, strong stalk-like leaves push upward, bursting into bloom or spreading their leaves as they reach for the light. In contrast, vase no. 127 is a sleek bullet form upheld by stark stylized leaves.

Despite its distance from the city, the American Terra Cotta & Ceramic Company frequently hosted architects from Chicago and other cities in the Midwest. These would visit the factory to approve the execution of their designs for ornament after they had been rendered by the modelers in three-dimensional clay. The spacious rural modeling studio was clearly a fascinating place. In the words of one visitor:

> Every appliance for study and work is furnished. Here the plants are brought "root and branch" from which the beautiful lines of the new art are constructed; here are models and drawings of the human figure, the basis of design of the great vase. . . .A dried gourd suggests good forms and the lotus blooms add both form and the fragrance of their beauty to the subtle creative magic in the air.[43]

One wonders which designer or modeler Gates's publicist had in mind when he claimed: "Every piece of TECO pottery, with its soft, cool green tones represents the *imprisoned inspiration* of the artist who dreamed it."[44]

GARDEN POTTERY

Fig. 43. One of two Teco planters designed by George Grant Elmslie for the Edison Shop, Chicago, in 1914.

Pieces intended for use in the garden were among the earliest and most enduring products of the Gates Potteries. Many were designed by Gates himself, including numerous jardinieres with modern lines as well as an assortment of classical urns that harmonized with such popular architectural styles as Colonial and Italian. In 1913 journalist Jonathan Rawson commented:

> No modern designer of garden ornaments has as yet found
> it possible to break away entirely from classical models.
> The Teco potters certainly have not done so, but in nearly
> every instance they have, according to their usual custom,
> added their own distinctive touch.[45]

Gates created pots for holding flowering plants and potted trees; pedestals to support bird baths, sun dials or jardinieres; and frogs and other small sculptures for fountains and conservatories. Of the forty identified garden pieces, twenty-three are designs by Gates and seventeen were the work of others. Three of Gates's sons — Paul, Neil, and Ellis — contributed designs for garden pottery, as did Fritz Albert and Kristian Schneider, a free-lance architectural modeler who joined the staff in 1909.

Most innovative, however, are the shapes created by local architects who turned to the Gates Potteries for stands and jardinieres to complement the radically modern interiors and exteriors of their structures.[46] Although few Teco garden pieces have survived the ravages of weather and changing taste, contemporary photographs record the existence of several handsome pieces created by Prairie School architects. Illustrated in *The Western Architect*, for example, are distinctive green glazed Teco urns, one designed by George Grant Elmslie (fig. 45) for the residence of his brother-in-law W. G. A. Millar in Bellevue (on the outskirts of Pittsburgh) in 1907 (fig. 46), and the other created for the Edison Shop (a phonograph distributor in Chicago) by Elmslie while he was in partnership with William Gray Purcell and George Feick, Jr. (fig. 43). Both urns were low, semicircular planters, whose sculpted bodies were banded by intertwined floral and geometric motifs. In the same issue that featured the work of their architectural firm were photos of their terra cotta ornament executed by the American Terra Cotta & Ceramic Company. On top of the dining room table designed by Elmslie for his wife

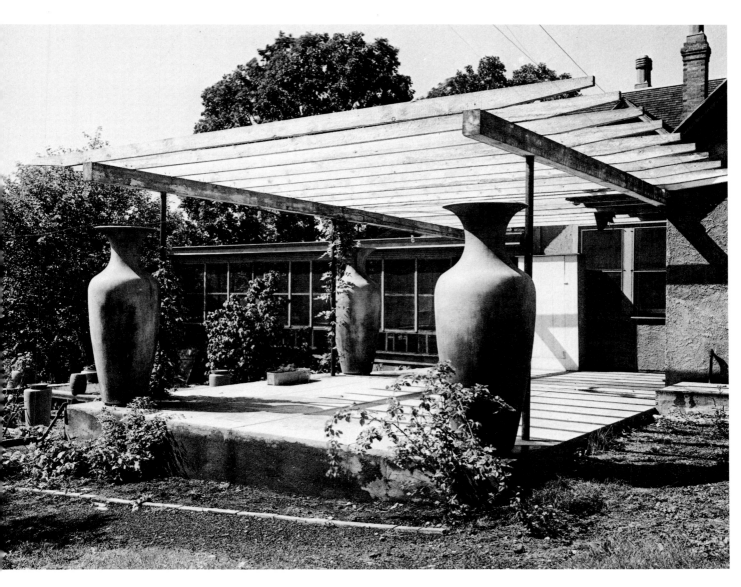

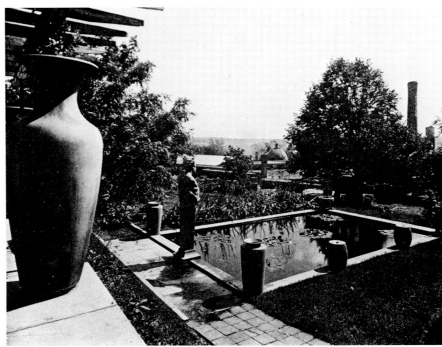

Fig. 44. Views of the garden at Gates's residence overlooking the factory. *Conception of Pan*, by Fritz Albert, stands by the reflecting pool.

Bonnie stood a simple Teco vase (no. 226), serving as a centerpiece for four brass candlesticks by Chicago metalsmith Robert R. Jarvie (fig. 47).[47]

Other Chicago architects, impressed by the durability of Teco and its heavy weatherproof glaze, created designs for outdoor use that were eventually offered for sale in the company's *Garden Pottery* catalogue. Architect Howard Van Doren Shaw, known for the large country homes he designed along Lake Michigan's north shore, created a tapered jardiniere suitable for holding a potted tree (no. 158) that was among the pieces exhibited at the St. Louis World's Fair. Such planters were later put to use in the Cliff Dwellers Club, of which both Gates and Shaw were members (fig. 24).

Similarly, architect N. L. Clark contributed a series of classical urns and wall pockets for hanging vines (nos. 110, 178, 295, 296, 388). A round pedestal encircled by raised leaves was the work of Holmes Smith (no. 222). William K. Fellows devised a round flower tub supported by four flat piers (no. 376); his partner George C. Nimmons turned a similar design into a rectangular planter (no. 413). An impressive thirty-inch-tall Egyptian-style vase (no. 111) with a raised acanthus leaf motif was the work of George R. Dean.

Fig. 45. George Grant Elmslie around 1912.

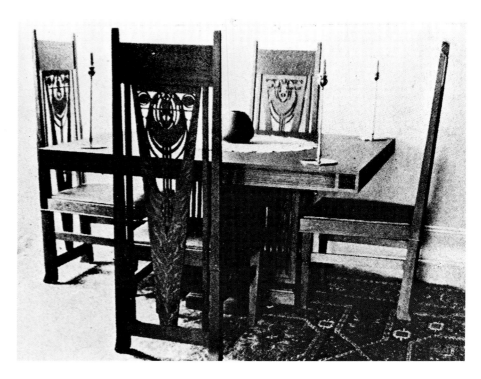

Fig. 47. Teco pottery vase no. 226, designed by William D. Gates, serves as a centerpiece for the dining room furniture designed by Elmslie for his wife Bonnie in 1910.

Fig. 46. Green Teco jardiniere designed by Elmslie for the terrace of the W. G. A. Millar house near Pittsburgh, Pennsylvania, in 1907.

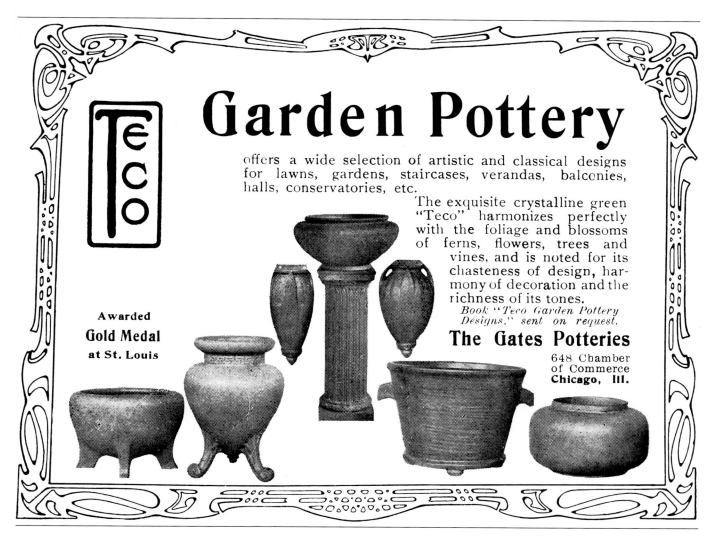

Fig. 48. Advertisement for garden pottery from *The Sketch Book*, July 1906.

Orders for Teco garden pottery could be filled from stock in gray terra cotta. Other colors, like buff and red, could be had on five weeks' notice. Pieces glazed with the familiar grayed green or other colors cost 25 percent more than those with gray terra cotta bodies. In addition to vases, the garden line included sundials, pedestals, fountain frogs, bird baths, and benches. A simple container could be purchased for $5, with larger and more ornate jardinieres averaging $15.

Most expensive by far were Gates's original seven-foot-tall vases, whose pricetag of $1,200 was prohibitive for all but the very well-to-do. Gates's giant ornamental vases remained unique in the marketplace, for few potteries possessed the skills and large kilns required to make and fire such huge pieces. They were still advertised for sale in 1906. Several tall vases adorned the factory site, while a picturesque collection of urns, flower boxes, jardinieres, and sculpture embellished Gates's own garden on a hilltop overlooking the factory (fig. 44).

MARKETING TECO WARE

Fig. 49. Paper labels identified the shape numbers and designers of Teco pottery.

While many Chicagoans worked diligently to effect reforms in architecture and design, Gates worked with missionary zeal to place a piece of Teco pottery in every American home. "It is my earnest desire," he wrote in one brochure, "to put in each and every home a vase of my make. . .that I can so feel that I have, in this way, done something lasting, and have contributed to the homes and the happiness of my generation."[48] Like many involved in the manufacture of Arts and Crafts products, Gates gave equal credit to artist and craftsman. Each piece of Teco ware bore a paper label with the names of the designer and the pottery, as well as the model number and the price of the piece (figs. 49-51).

Many of the smaller pieces of Teco pottery were so modestly priced that the average American worker could afford to own at least one piece. A simple round five-inch vase averaged $1.50. A pansy bowl could be had for 50 cents. Most vases were priced between $2 and $5, while those of lamp-base proportions sold for $7 to $20. While not cheap, these prices were still within the reach of, say, a typical female school teacher, who, according to the *Crystal Lake Herald*, earned $39 per month in 1907. "One small Teco vase, costing perhaps but a dollar, will do more to give that touch of elegance and artistic refinement to the home than any other one thing," Gates's advertisements pointed out.[49]

By 1907, when Teco was featured in a special exhibition at Marshall Field & Company, Chicago's leading department store, 514 different designs were in production. Twenty-five different lamp designs were offered for sale. Five-piece smoking sets (no. OSM) with a covered humidor on a heavy round tray made handsome gifts for men; five-piece dresser sets that included ring holders, powder boxes, and trays for hairpins and combs made appropriate accessories for women (no. EXY).

Teco pottery was sold exclusively through one dealer per city. Fifty different "selections," each of which averaged sixteen pieces in varying price ranges, were offered on consignment to dealers, who paid the Gates Potteries as the pieces were sold (fig. 52). "Teco ware is marketed fair and sold on the square," Gates reassured his customers. "Selections are rigid and prices are uniform both to the dealer and consumer."[50] Defective pieces and "seconds" were not sold. However, some survived because they were salvaged by the workers.

Fig. 51. The Teco trademark was impressed at least once on the base of each piece of pottery. *Collection: John and Nancy Glick*

Fig. 50. (left) The base of vase no. A399 retains its original paper label and exhibits two characteristics common to Teco pottery: the light yellow clay body is stamped twice with the company logo, and glaze which pooled under the outer rim has been ground flat. *Collection: Chicago Historical Society*

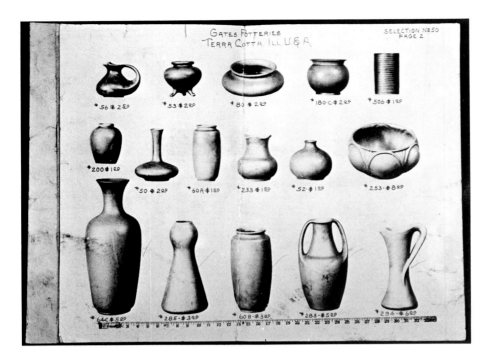

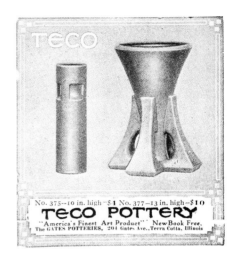

Fig. 52. (left) Cards illustrating "selections" of Teco ware allowed dealers to choose pieces in a variety of shapes and price ranges.

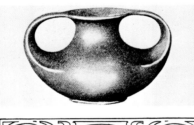

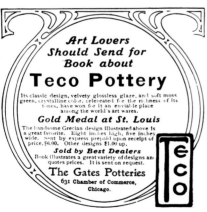

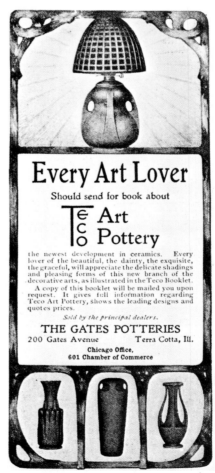

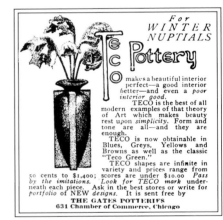

Fig. 53. Advertisements for the Gates Potteries appealed to middle-class Americans who sought to achieve the ideal Arts and Crafts interior. But Teco pottery was also sold by dealers as far away as Berlin, Germany, and St. Petersburg, Russia.

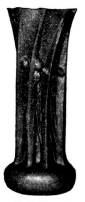

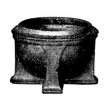

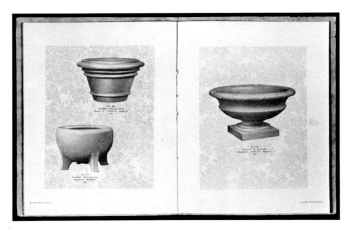

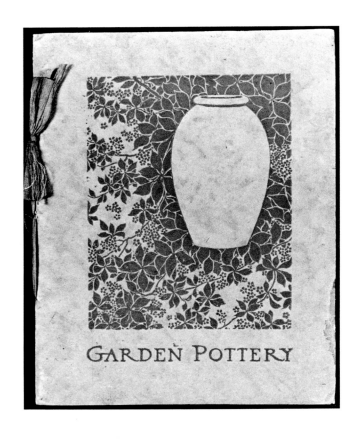

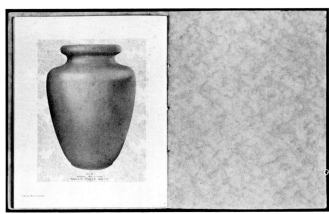

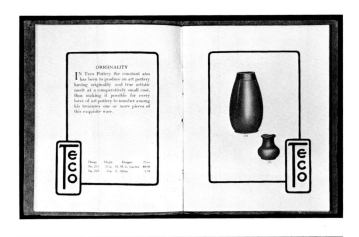

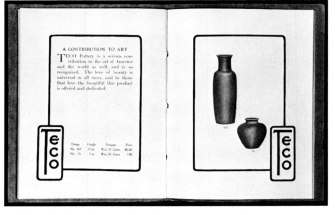

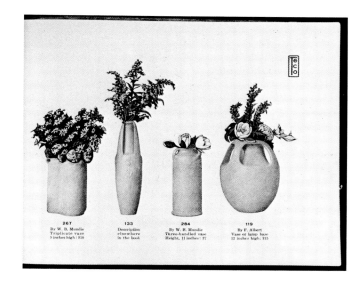

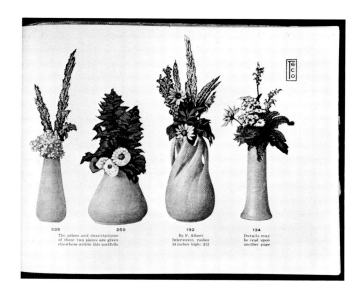

Fig. 54. Catalogues issued by the Gates Potteries: (facing page top) *Garden Pottery,* c. 1906; (facing page bottom) *Teco,* c. 1910; (this page) *Teco Pottery America,* 1906. *Collections: Mrs. Ronald M. Byrnes, Chicago Historical Society, Erie Art Museum*

KRISTIAN SCHNEIDER

Fig. 55. Kristian E. Schneider headed the American Terra Cotta & Ceramic Company's modeling shop from 1909 until 1930.

Fritz Albert left Gates's employ around 1906 to join the Northwestern Terra Cotta Company in Chicago. Fernand Moreau followed a few years later. In 1909, after three years of executing designs for Gates on a contract basis, a talented Norwegian-born sculptor, Kristian Schneider, became the company's chief modeler (fig. 55). Schneider had been foreman in Northwestern's modeling shop for ten years before forming a partnership with another sculptor to work as a free-lance modeler. As adept with wood as with clay, he had made many of the models for terra cotta, cast iron, and plaster ornament used in buildings designed by Louis H. Sullivan and later by his chief draftsman, George Grant Elmslie. Sullivan was so impressed with Schneider's work that, whenever possible, he strongly recommended the American Terra Cotta & Ceramic Company.[51]

Schneider had been at Gates's firm since 1907, modeling the ornament for the National Farmers Bank of Owatonna, Minnesota, the first of a series of small midwestern banks designed by Sullivan between 1907 and 1919. Like earlier commissions, these banks were profusely ornamented with rich terra cotta in Sullivan's highly individualized style. Recognized as a masterpiece at the time, the Owatonna bank's exterior and interior displayed a symphony of luxurious terra cotta foliage glazed in Teco green highlighted with oranges and golds[52] (figs. 56, 57, colorplate 38).

As a result of their business association, Sullivan and Gates developed a strong personal friendship that lasted until the architect's death. During Sullivan's

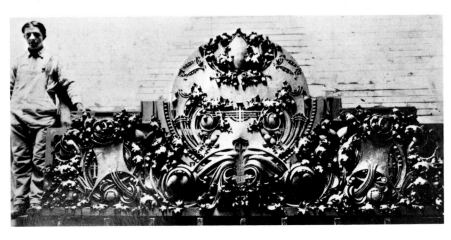

Fig. 56. Modeler B. Nelson with a cartouche made for the National Farmers Bank of Owatonna, Minnesota.

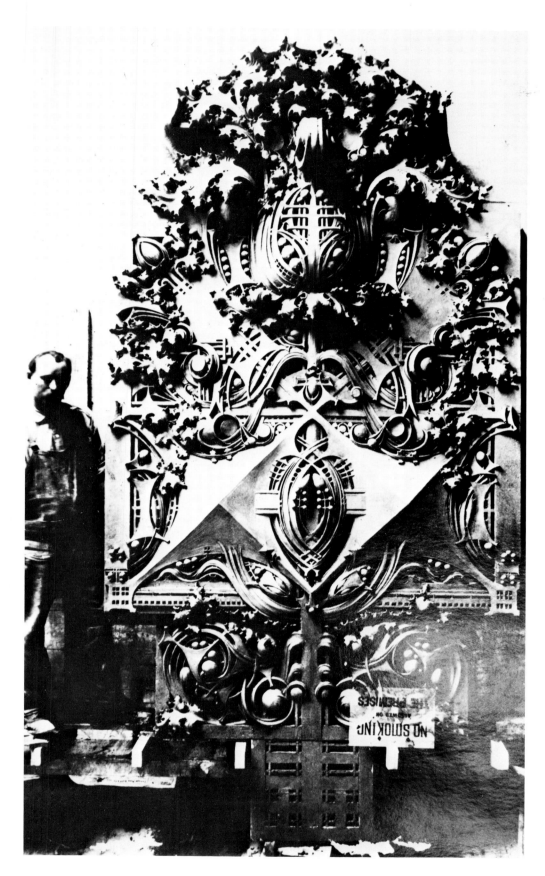

Fig. 57. Kristian Schneider stands next to terra cotta ornament executed for the facade of the National Farmers Bank of Owatonna, Minnesota, around 1907.

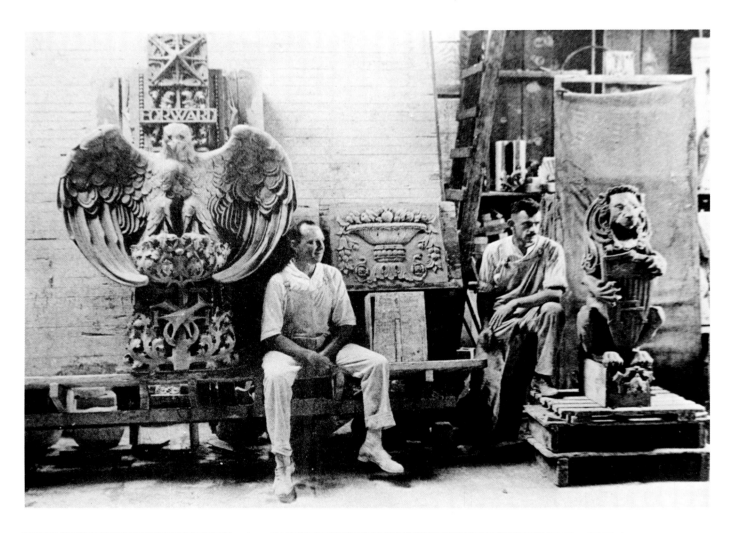

Fig. 58. B. Nelson, left, and W. C. Heidel, right, pose with samples of architectural terra cotta in the modeling room.

Fig. 59. Major Gates, left, with modeler Kristian Schneider, right, at the factory in 1921.

Fig. 60. Architectural terra cotta (left, bottom right) designed by Purcell, Feick & Elmslie. Cabinet photographs of plaster models were sent to architects for approval prior to the mold making process.

Fig. 61. Economical "stock" terra cotta ornament in Sullivanesque designs enhanced the facades of many small banks and commercial structures in the 1920s.

last years, when he was in poor health and had few commissions, Gates remained a loyal friend. In the words of one of Sullivan's biographers:

> Gates was a long, lean angular Yankee whose deepest qualities were kindness and humor. He was a man whose absorption in commerce did not dull his sense of justice. To enable Sullivan still to say he had an "office," Gates and his colleague Albert Sheffield — a dark square-built man who was secretary to the firm and as amiable as his supervisor — invited the champion of terra cotta (Sullivan) to move his desk and table into a corner of a large room in the quarters of the company. . . .[53]

Until his death in 1924, Sullivan enjoyed this free office space in the spacious Victorian mansion at 1701 Prairie Avenue which the firm had purchased in 1921 for use as its Chicago headquarters.[54]

Kristian Schneider remained American's chief modeler for two decades, executing ornament for the company's architectural commissions as well as garden pottery. He also designed and created a variety of bas relief plaques, including panels depicting the life of Abraham Lincoln for the University of Illinois and one featuring the classical figure of a woman, still extant on the exterior of the Woods Theatre in Chicago. "He is equally at home in any style of ornament or decoration, but particularly so in what is known as 'Sullivanesque,'" explained *Common Clay* in 1920.[55] And, indeed, it is for the exquisite ornament modeled for Louis H. Sullivan and George G. Elmslie that Schneider is known today (figs. 60,61).

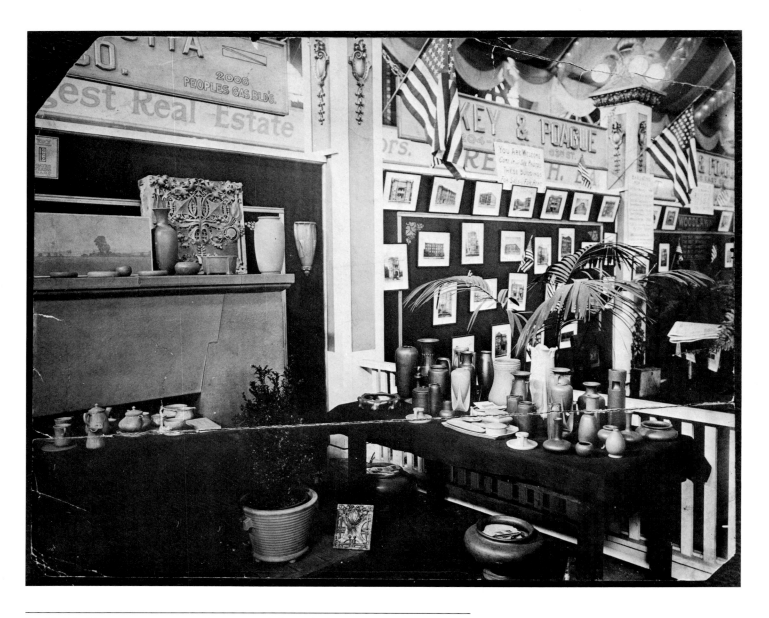

Fig. 62. Colorful Teco vases, tea ware, garden pottery, and tiles on display at the Clay Products Exposition in Chicago in 1912.

NEW SHAPES, NEW COLORS

Experimentation with multicolored glazes for the Owatonna bank and similar commissions may have inspired Gates to experiment with colored glazes for his art pottery. After 1909, the year the bank was completed, the familiar "Teco green" glaze was supplemented by new autumn-inspired colors: mellow golds, warm browns and buffs, silvery grays, and dusky shades of rose. A few pieces, turned out in smaller quantities, featured Persian blues and metallic purples, burnt oranges, and even a bright canary yellow. A selection of these brightly hued Teco designs was reproduced in color in a handsome booklet designed and printed by one of Chicago's art presses.[56] The bold new colors immediately found favor among tastemakers tired of the soft browns, greens, and blues of the Arts and Crafts movement. The new colors "have been just as beautifully blended and painstakingly perfected as the original green," commented one writer, noting that "the new shapes of the past year have been of a particularly practical and useful nature."[57]

One of the motivations for increasing the range of colors was to regain customers who were being lured away by lower-priced green pottery in shapes resembling Teco ware. As in other art industries, manufacturers of high quality handcrafted ceramic products were losing their share of the market to firms which mass-produced imitations of Arts and Crafts wares. Gates's original concepts were being coopted by entrepreneurs more interested in profit than craftsmanship. *"Pass by the imitations,"* pleaded a 1911 advertisement, *"Look for TECO mark under each piece."*[58] "Insist on *genuine* TECO," urged another advertisement, encouraging readers to send for the free booklet illustrating the new shapes and colors.[59]

Although Gates greatly expanded the range of colors, only a few new vase shapes were added and these were simple forms designed by him. Additions to the line consisted of tea services and chocolate sets with paneled bodies glazed in pearly gray, greenish brown, or pinkish tan (fig. 63). When these were shown for the first time in the Chicago Architectural Club Exhibition in 1911, journalist Evelyn Marie Stuart commented favorably, calling the tea set "a decided innovation whose charm entitles it to a place of its own." She found the unusual tea ware "calling up visions of its beauty in combination with mission arts and crafts, bamboo tray, wicker or rustic tea tables, and the curious handwrought effects in

silver and linen which one sees offered for sale in the studios and art shops of the handicraft workers."[60] This comment must have pleased Gates, for it showed that he had not strayed from his original goal of creating products that combined the artistic with the practical.

In most instances, the new colors were merely applied to the most popular shapes. However, the new colored glazes were also sprayed over the green glaze of unsold pieces, which were then refired to make them more attractive to potential buyers. Such pieces are easily recognizable by the green glaze visible on their inner surface or by the crinkled effect that sometimes developed during the second firing.

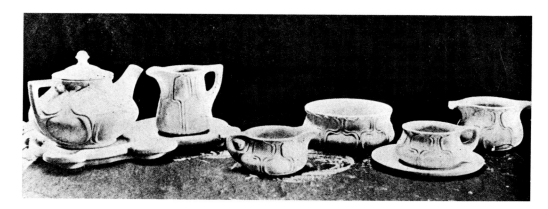

Fig. 63. Teco tea wares have been found in a variety of colors, including green, gray, buff, and tan. A gray tea set was exhibited in the Chicago Architectural Club Exhibition in 1911.

Also new were Teco tiles with matte glazes in tones of green, brown, blue, gray, and dull orange. These were promoted for use in fireplace facings. They were particularly handsome when used in conjunction with rectangular landscape panels, which were inset below the mantel, with the smaller square tiles creating the surround. "A rather flat, simple composition of gently undulating hills, clumps of trees and a clouded sky, in soft dark green and gray colorings, or in shades of blue and gray, or brown and buff, is the usual choice for these landscape tiles," a journalist wrote in 1911.[61] Although some of the landscapes were executed on one large rectangular tile, others were composed of a series of tile panels placed side by side (fig. 64).

In Gates's own home, a large landscape tile in sepia and buff was set into a mantel of cream terra cotta brick. Similarly, the factory office was decorated with handsome tile pictures depicting the plant's early history. But the most spectacular installation could be seen in the "Teco Inn" in the Hotel Radisson in Minneapolis, Minnesota. Here the walls and floor of the restaurant were surfaced entirely in multicolored Teco tiles and large landscape panels. Illustrating scenic views of the "Great Northwest," they had been executed by Chicago artist Charles Francis Brown.[62]

More ornate in character were the architectural faience tiles featuring carved effects in relief. Conventionalized foliage, fruits, and flowers, as well as geometric compositions and pictorial motifs were highlighted by bright touches of color. Green Teco tile pieces, with sculpted compositions in low relief, were suggested as appropriate touches of ornamentation in masonry or tile walls. Scenes of marine life and classical groups of figures were among the designs developed by using several of the square tiles to create a larger rectangle or square. Other tiles, intended to be used alone, featured single figures or floral compositions.

Fig. 64. A large bas-relief of Teco tiles was inset in the wall of the factory office, which housed the clerical staff and company draftsmen.

Around this time, the old McMillan farmhouse across the road from the factory office was converted into a display room and sales office for Teco products. Garden pieces of various shapes and sizes sat upon the porch and lawn attracting the attention of passersby. Inside, Teco pottery, tiles, and wall panels in a range of colors made an eye-catching display. "The poetry of flower and leaf is caught in a thousand ways in the Gates potteries," declared one visitor to the rural showroom.[63]

In 1912 Teco tiles, tableware, and pottery were exhibited in Chicago in the first Clay Products Exposition sponsored by the ceramics industry (fig. 62). After that Gates made no further innovations in the line. Although Teco ware remained in production, only the simpler forms requiring little hand finishing were turned out. Increasingly, large orders for architectural terra cotta left workers with little time to devote to the less profitable pottery making. Of equal importance was Gates's decision to retire from active management of the American Terra Cotta & Ceramic Company after thirty-three years of dedication to the enterprise.

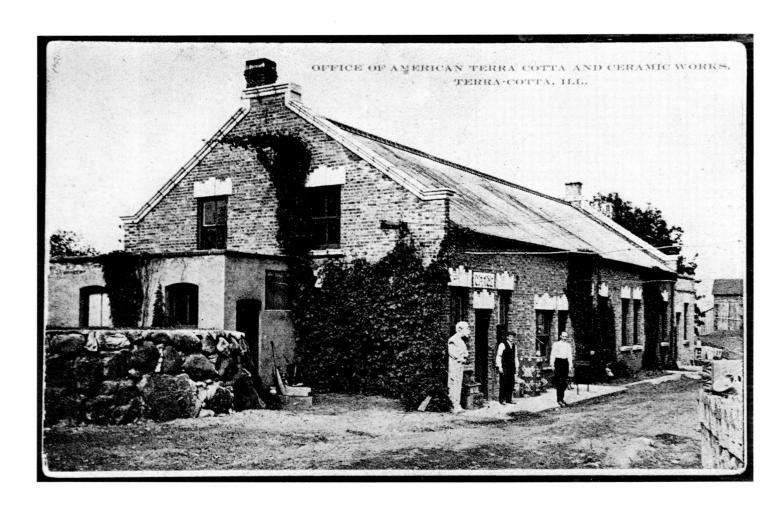

Fig. 65. The factory office at Terra Cotta around 1910.

DIVERSIFICATION AND MODERNIZATION

In March 1913 Gates turned the day-to-day management of the company over to Harry J. Lucas, the new president and general manager, while he assumed the title of chairman. Lucas, a former vice-president of the New York Architectural Terra Cotta Company, had been managing the newly organized National Terra Cotta Society, the trade association for which Gates served as secretary.[64] John G. Crowe, with the firm since 1893, became vice-president and treasurer, while Neil H. Gates was appointed secretary. Major, Gates's youngest son, became assistant general manager. When Lucas resigned a few months later, John Crowe was elected president of the firm.

Almost immediately the new management undertook an ambitious expansion program, adding more space to the main four-story factory, constructing more kilns, and increasing the work force until it totaled close to 300. The drafting department, previously located in the Chicago office, was moved to Terra Cotta in order to consolidate the staff and make the operation more efficient.[65]

Gates, meanwhile, did not remain idle. He indulged his love of travel, continued to buttonhole readers of the *Clay-Worker*, and strove to put the National Terra Cotta Society on a sound footing. But his retirement ended abruptly in the summer of 1915, when he was called upon to avert a major financial crisis at the American Terra Cotta & Ceramic Company.

Although business had been good and there was a backlog of orders for terra cotta, a strike by Chicago's union carpenters had paralyzed the building trade, leaving thousands of dollars' worth of clay products undelivered at the factory, and thus, unpaid for. By July the company was unable to meet its weekly payroll and John Crowe, the firm's president, resigned. Gates succeeded in saving the company, but only by threatening to move the operation to another city unless the citizens of Crystal Lake aided the ailing firm by purchasing stock in the company. By October the plant was again running full time, but this event signaled the onset of the financial problems that would continue to plague the undercapitalized firm through the 1920s.[66]

The possible loss of the area's major employer focused attention on the manufacturing concern that for many years had been taken for granted. A report of a trip

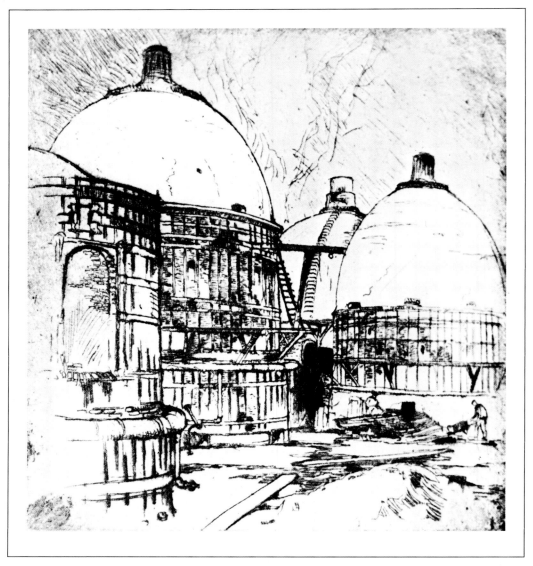

Fig. 66. Chicago architect Thomas E. Tallmadge made this etching of some of the kilns at Terra Cotta. Architects frequently visited the factory to check the progress of architectural terra cotta and pottery being executed for their commissions.

through the plant featured in the local newspaper confirms that Teco pottery was still in production when this enthusiastic article was published in January 1920:

> In the pottery one may see rows upon rows of those wonderfully artistic Teco vases, wall pockets, candlesticks, and lamps. Many of them are modeled along the beautiful simplicity of the Grecian or Egyptian lines, and all of them have the individual touch of the artist. And their coloring is even more subtle, more appealing than their lines. The soft, dull green with which everyone is familiar, the less common but equally distinctive gray, an unusual brilliant yellow, and that rare and unsurpassable blue — the blue of Persian rugs and tapestries — the blue that is so exquisite that one wonders how human genius can conjure it from chemicals.[67]

With Gates back at the helm, the company weathered a number of ups and downs in the demands for architectural terra cotta. In 1917, when America entered World War I, art pottery production ceased at the plant while workmen produced clay hand grenades for soldiers to use in practice training sessions. After the war

ended in 1918, it became clear that art pottery production would never again be a lucrative business.

Paul Gates, who had assisted in the development of Teco ware and remained involved in its production, died in September 1920, following a long illness. His brother Ellis had left the firm before the war. Neither Neil nor Major, the younger sons, shared their father's interest in art pottery. Major, a ceramic engineer, focused on improving architectural terra cotta production, introducing several labor-saving inventions that included a pressing machine and a tunnel kiln. His pulsichrometer, a pump that sprayed several colors of glaze simultaneously in a pulsing pattern to produce a mottled surface resembling stone, was widely used by terra cotta manufacturers after he perfected it in 1920.

William Gates, meanwhile, began to diversify and modernize the company to take advantage of the revived market for architectural clay products. In 1918 he acquired the Indianapolis Terra Cotta Company; the following year he opened a branch office in Minneapolis, Minnesota (fig. 67). By 1920 facilities at Terra Cotta had expanded to include twenty-five buildings and twenty kilns. To transport the growing number of workers, the daily "work train" from Crystal Lake was supplemented by two modern buses. To accommodate the buses and the managers' automobiles, the farmhouse that had served as the pottery showroom was converted into a garage.[68]

Fig. 67. *Common Clay* carried this photograph of B. Scott Goodwin, manager of the Minneapolis office of the American Terra Cotta & Ceramic Company. The accompanying article noted "So much of our work has been built in the Minneapolis district that about a year ago we opened an office in that city. . .This action is strictly in line with our doctrine of service to the customer."

The revival of building in Chicago and the Midwest was accompanied by an increase in competition in the terra cotta industry. In addition to its old rival, the Northwestern Terra Cotta Company, American Terra Cotta now had to bid as well against the Midland Terra Cotta Company, founded in Chicago in 1910. But there was plenty of business for all as architects and builders continued to specify practical and economical terra cotta for the skyscrapers, movie palaces, public buildings, banks, and commercial structures under construction across America. Interiors, too, glistened with smooth ceramic surfaces, as clay products were

TO A TECO VASE

Born of common clay, wrenched from heart of earth,
 Unshapened mass of sodden heavy grey,
Giving no promise at thy sordid birth,
 Of the great glory of thy future way.

Kneaded by heavy brawn, pounded by bitter power,
 Moulded by strength unknown to thee,
Shaped by cunning hands, in thy first hour,
 Trembling thou faced eternity.

Came then the fearful fire, the birthpain's woe,
 The wrenching racking tortures of new life,
Emerging victor o'er thy hidden foe,
 In glorious beauty, born of strife.

Born of the same clay, pounded by circumstance,
 Moulded by Gods unknown to me,
Shaped by strange hands and fired by fitful chance,
 Thou art so like myself, my heart goes out to thee.

Mayhap, when life's full fires have passed away,
 And time and chance have done with me,
I, too, may have my glorious day,
 Complete, convincing, like to thee.

TECO, THE POTTERY
WHICH IS SOLD ONLY
TO ITS FRIENDS AND
LOVERS. ITS FRIENDS
BECOME ITS LOVERS
AND REMAIN FOR-
EVER CONSTANT.

PAGE XII

Fig. 68. Albert H. Sheffield's tribute to Teco pottery was published in the *Clay-Worker* in January 1914 and later in *Common Clay*.

Fig. 69. Cover of *Common Clay*, published by the American Terra Cotta & Ceramic Company.

increasingly used for surfacing lobbies, kitchens, hallways, and even subways and tunnels.

Increased competition and an expanding market required Gates and his salesmen to reach more customers in a greater area. To keep in touch with clients and compensate for the firm's remote location, Gates and Albert H. Sheffield, head of the Chicago office, developed a handsome publication called *Common Clay* (fig. 69). Short, readable articles shared technical information, factory achievements, Gates's "Button-Hole" philosophy, even a poem by Sheffield entitled "Ode to a Teco Vase," with architects, contractors, and other potential customers (fig. 68). The first issue, published in July 1920, showed a view of the factory garden with the caption:

> "Teco — that choice pottery still charms. . . . We make it
> only for our friends and its lovers. It isn't on the market in
> the ordinary sense of the term. We burn it every once in a
> while when we get to the stage when we just must."[69]

Such stages became rarer and rarer, however, as enterprising employees explored more profitable clay applications. In the pottery, attention focused on developing ceramic battery covers for the emerging automobile and radio industries. Kristian Schneider and other modelers experimented with paperweights, bookends and other novelties. "The book-ends are the most popular of all and are varied," reported the local newspaper in December 1920, noting that "the company

is making a Christmas present to each employee of a set of these book-ends, and the men feel that they could not have anything more desirable."[70] Paperweights in the form of seated pelicans, apes, and frogs, called "grotesques," were sent as holiday gifts to customers of the firm.

Pleasant responses to the novelties and requests from ceramics dealers eager for new merchandise must have encouraged Gates and his workers to revive Teco pottery production. In January 1921 the company announced:

> Preparations for the revival of the Teco pottery ware are going along well, and things look as though this summer the pottery department will once again present a busy appearance. There have been many inquiries for this ware, and the way the demand is now picking up would seem to indicate that there will be a good sale for these objects of art during the coming year.[71]

By September quite a large quantity of Teco ware and garden pottery had been made and consignments were once again being shipped to department stores and dealers. That year many residents of small towns got their first glimpse of Teco pottery in a traveling exhibit of American pottery organized by the General Federation of Women's Clubs. "The dull tones of the ware make a pleasing setting for all kinds of flowers and, as a spot of color alone, are decidedly decorative," wrote Lillian Crowley, describing Teco ware in an article in *International Studio* that stressed the educational benefits to be derived from exhibiting art in rural areas.[72]

Although no longer advertised, Teco ware continued to be sold through the network of dealers established before World War I. Garden pottery and tiles were exhibited and sold through the same channels used to market architectural terra cotta. As late as 1928 a reporter visiting the factory spotted "landscape tile, teco vases, fountains, garden vases, decanters, pitchers, lawn pedestals, jardinieres, urns, and other pottery articles" as well as bookends and ashtrays in the pottery. "The love of things beautiful on the part of W. D. Gates is largely responsible for the great popularity of this form of art," he commented.[73]

By 1928 Gates's "love of things beautiful" had been expressed in the interior of his new Crystal Lake residence, aptly named "Trail's End." Approaching the house from the road, visitors saw a handsomely landscaped garden inhabited by an assortment of terra cotta creatures. Teco vases and urns filled with flowering plants and vines surrounded a fountain and reflecting pool, whose overflow meandered under a bridge faced with colorful Teco tiles. Inside the house, Gates had blended a unique collection of sample tiles and terra cotta to form the walls and floor of the living and dining areas. Pieces of Teco pottery — some common, some rare — sat on the mantels, tables, and floor (fig. 70).

Gates's construction of "Trail's End" symbolized his decreasing involvement in company affairs as well as his advancing age. For the past several years he had relied upon his sons Neil and Major to run the factory, while sales were the responsibility of Fritz Wagner, Jr., the company's vice-president. Now in his mid-seventies, Gates remained active in professional organizations, although many of his friends had retired from the field. His half century of dedication was recognized by the

Fig. 70. William D. Gates in his living room at "Trail's End" in June 1928. The Teco humidor was designed by architect Hugh M. G. Garden; the slender wall sconces were the work of artist Orlando Giannini. The fireplace was faced with Teco tiles and inset with landscape tiles painted by Hardesty G. Maratta. Colorful sample tiles covered the floor.

American Institute of Architects in 1928 when it presented him its rarely awarded Craftsmanship Medal for "distinguished achievement in ceramic arts."

But having reached this pinnacle of recognition, Gates was to see the terra cotta enterprise he had worked so hard to build crumble in the course of the next two years. Only four months after the stock market crash of October 1929, the Indianapolis branch of the company closed down. The main plant at Terra Cotta operated only a few months longer before it too became a victim of the Great Depression. Building came to a halt; soon one out of every four in the nation's labor force was without a job.

By 1930 arrangements had been made to transfer ownership of the American Terra Cotta & Ceramic Company to the family of George A. Berry, Jr., Gates's attorney for many years. Under new ownership, with Fritz Wagner, Jr., as

president, the company reorganized and resumed terra cotta production on a small scale.

With little money and in ill health, Gates entertained himself at "Trail's End" with his memories. He painted murals depicting his favorite places — Naples, Pompeii, Capri — and wrote reminiscences of Crystal Lake history for the local *Herald*. Although most of his articles were light-hearted, his final message, published in November 1934, was wistful. "God blessed me with half a Century of activity in hustling to get in work for the factory and then hustling to get it made," he wrote. He went on to say:

> I enjoyed it thoroughly but apparently lacked judgment and didn't have adhesive fingers, the money just slipped through them. I did retain friendships that remain. Now I am old — past 82 — most of the old friends have finished their course and, to me, their places are vacant. A new generation has succeeded them, a generation that does not know me and that I know not. Times have changed and I am just "A has been."[74]

William Day Gates died two months later, on January 31, 1935, mourned by family, friends, and townsfolk from Crystal Lake and McHenry, many of whom had been his loyal employees. But his best-known creation, Teco pottery, was to live on, if in name only, for several years more.

Teco Potteries
American Terra Cotta Corp. ★ CRYSTAL LAKE, ILL.

TECO POTTERIES
TERRA COTTA, ILLINOIS

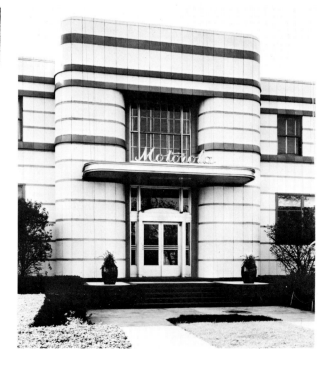

Fig. 73. A pair of highly glazed olive jars made by the Teco Potteries at the main entrance to the Galvin Manufacturing Corporation's new "Motorola" radio manufacturing plant on Augusta Boulevard, Chicago, in 1937. The building's streamlined terra cotta exterior was executed by the renamed American Terra Cotta Corporation.

THE TECO POTTERIES

Fig. 74. Trademarks of the Teco Potteries.

At the American Terra Cotta Corporation, as the company had been renamed, employees resumed making garden pottery as well as architectural terra cotta as the firm struggled through the Great Depression. By 1935 many of the most skilled workmen, including Kristian Schneider, had left to find work in other companies. Few pieces of Teco ware remained at the factory, most having been lost in a fire that destroyed a wooden shed used to store the unsold pottery.[75]

But once again pottery making filled periods of inactivity between orders for terra cotta. New molds were made to duplicate some of the best-selling garden forms. Other shapes were added under the direction of Duane F. Albery. A former assistant chemist at the American Terra Cotta & Ceramic Company, from 1911 through 1914, Albery had operated his own art pottery in Evanston for several years. Returning to Terra Cotta, he took charge of the daily operations until 1939, when Arthur Jenner replaced him as plant superintendent.

A colorful brochure issued around 1937 illustrated the selection of garden pottery and furniture available from the Teco Potteries, as the operation was now called. The ten shapes illustrated included vases, oil jars, strawberry jars, a fountain frog, a bird bath, and a garden bench. Customers could choose from a wide assortment of such colorful glazes as robin's egg blue, light yellow, brown and white mottled, and Teco green.[76] The word TECO was impressed in a rectangle on the base of most pieces (fig. 74).

George A. Berry III, then a young worker at the factory, recalled selling the pottery off the porch of the old farmhouse that had once housed the Teco salesroom and more recently the garage. According to Berry, garden pottery was produced until 1941, when, following the outbreak of World War II, the factory's 400-foot continuous tunnel kiln, which had replaced many of the old periodic kilns in 1936, was converted for use in annealing, normalizing, and stress relieving steel products for the military.[77] After the war, the manufacture of structural clay products continued on a small scale through 1966. Six years later, in 1972, three branch businesses involved in the commercial heat-treating business and the production of ground engaging tools for construction equipment were merged and incorporated as TC Industries, Inc., which continues to operate on the site of William Gates's original factory and pottery.

THE TECHNOLOGY OF TECO ART POTTERY

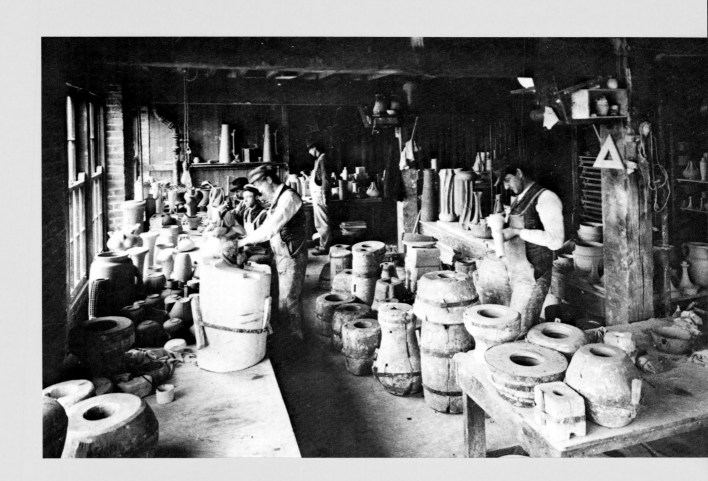

The mold shop at Gates Potteries around 1905.

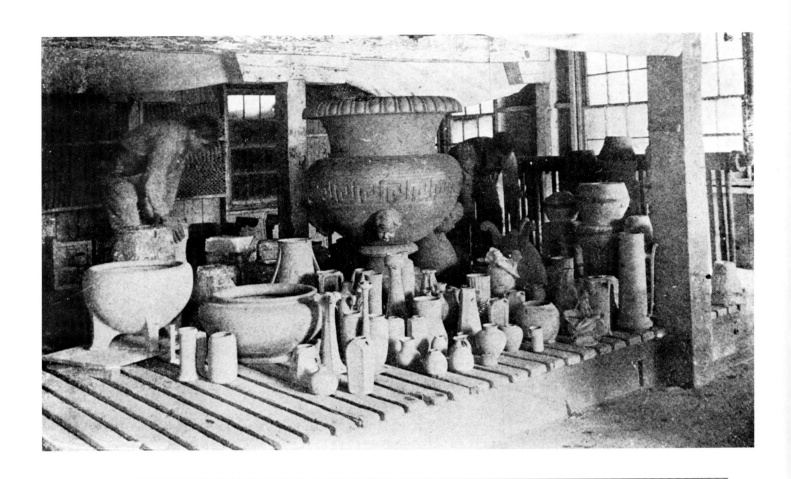

Fig. 75. Teco pottery and vases on the drying racks in 1905. After the forms were completed they were thoroughly air dried prior to being loaded into the kiln.

A rt pottery is a kind of ceramics that is very serious in intent. Nonutilitarian, it fills people's perceived need to enrich their lives with special and precious possessions. The word American in the phrase "American art pottery" is highly appropriate because this work constituted the first concerted effort to create a type of ceramics that was both sophisticated and truly American. It is identified with an era when Americans felt their country to be coming of age: the period from the late 1870s to the early 1930s.

The movement began in the late 1870s and over the next fifty years was to make significant contributions to world ceramics. While the movement was marked by much diversity and change throughout the course of its life, we can discern characteristics that remained constant: in the way its practitioners sought to achieve independence from their European sources, in their striving for technical mastery, and in their febrile technical and aesthetic inventiveness.

From its very beginning American art pottery was generally made by groups of potters working together in small and medium-sized studio-factories where work was organized around the principle of the division of labor. This allowed workers to become expert in specific jobs and was especially useful for tasks requiring the specialized skills of decorators, mold makers, and kiln-firing supervisors. Training could be accomplished quickly, for proficiency in a narrow area can be attained easily.

Among the best-known predecessors of the makers of Teco pottery were the Rookwood Pottery of Cincinnati, Ohio, founded by Maria Longworth Nichols in 1880, and the Grueby Pottery Company founded in 1894 in Boston, Massachusetts, by William Grueby. Rookwood work is characterized by low-fire, slip-painted imagery covered with a clear lead glaze. Grueby reacted against the Rookwood slip-painted style: the work of his studio is characterized by heavy sculptural forms ornamented with stylized vegetal imagery and an earthy green glaze.

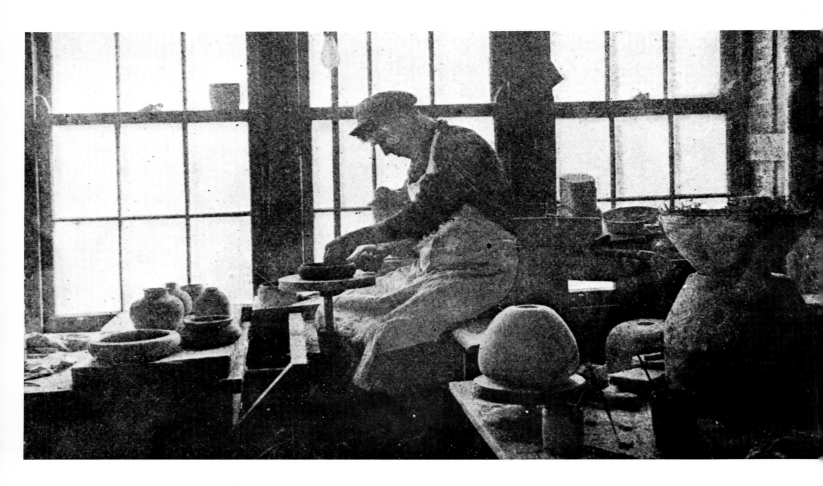

Fig. 76. Hand throwing a Teco shape. The process of producing a Teco pot begins by throwing a form on a potter's wheel. The thrower would be working from drawings provided by the designers. It is likely that many of the earliest forms were thrown by Gates himself.

TECO FORMS

While the imagery of the American art potters has often been discussed, their vessel forms and the evolution of these forms is a subject that for the most part has been neglected. When the movement began form was not an important consideration, and while the artists who were soon hired to decorate the pieces were trained, this was not the case with those who created the forms. Form decisions seem to have been made by artisans who showed great skill on the potter's wheel but had no art training whatsoever. At their worst the forms tended to be fussy, at their best they were modest and did not draw attention from the imagery.

Rookwood's forms in the early days of the movement tended to be fussy and weak, but by the 1880s they were simpler and stronger, though still not very imaginative. By the end of the century potters in many of the studios were employing new and much more interesting forms. William Grueby was, perhaps, the prime innovator in form design during this period, for his strongly colored monochromatic glazes and highly modeled relief imagery were applied to innovative, strong, bulb-like shapes.

Teco forms also mark a break with the past: like Grueby pottery, Teco pieces rely on imagery created in the form, rather than on imagery that is applied to the surface of the piece. However, Teco's shapes were created in the spirit of the forms used by architects associated with the Prairie School. This is especially noticeable in the special treatment of the lip and foot areas of these pieces and in the way handles were used as design elements.

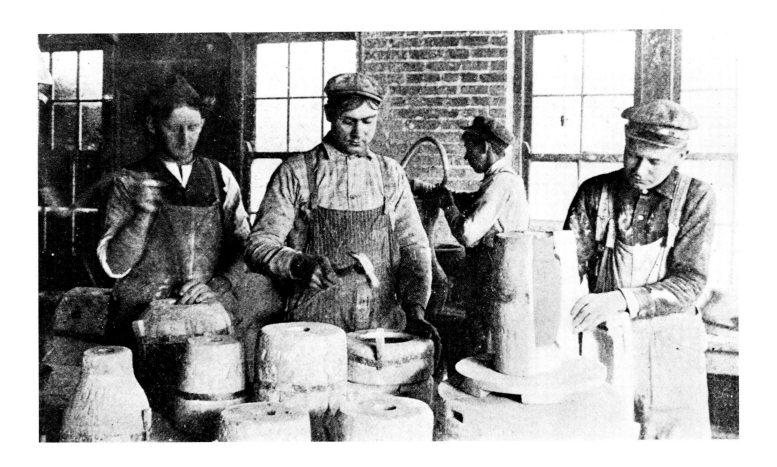

Fig. 77. The casting room at the pottery around 1905. Workers are removing bands and disassembling molds to remove the completed Teco vases. This would be the culmination of a three- or four-hour process that included filling the mold with clay slip, emptying the mold of excess slip, allowing the slip to set, and, finally, removing the partially dry piece from the mold.

METHODS OF PRODUCTION

The methods used for the production of American art pottery strongly influenced the character of the work, and as they evolved the work changed in character. In the beginning many labor-intensive hand-work production methods were used. As the movement evolved the studios moved toward more efficient production methods and relied as much as possible on mass-production techniques.

Teco's methods of production were extremely innovative. The Teco potters used pure mass-production methods; the forms were produced using slip-cast mold techniques and the glazes were applied using a spray gun. In this way William Day Gates was able to keep the prices for his pottery low and yet employ complex, subtle forms and imagery. The example of Teco is extremely important because it shows us that economical production methods could be used to create highly serious and ambitious work.

As far as the method of production is concerned there is little to distinguish Teco from industrially produced artwares. Yet, due to the uniformly high quality of their design, Teco pieces do not have a mass-produced character. Whether created by Gates, by the company's designers, or by Chicago architects, Teco designs are always well thought out and very much the product of an individual sensibility. This is, perhaps, the most important contribution of the Teco studio.

Much of the aesthetic character of the ceramic medium is dictated by its technical character. To understand the aesthetics of clay it is useful to know the basics of the technology.

TECO CLAY BODIES

Found nearly everywhere on earth, clays are compounds composed of two or more elements, chiefly silica and alumina. Other ingredients — such as sodium, calcium, and iron — are present in smaller, but sometimes significant, amounts as well. These elements are bonded together very tightly to create clay molecules which in turn come together to create clay particles. Although these particles are so tiny that they are invisible to the naked eye they are very important, for clays derive their unusual physical characteristics from the unusual shape of their particles, sheet-like crystals called "platelets."

To be workable clays must be mixed with water in such a way that each platelet is surrounded by a film of water; when this happens the platelets slide along each other's surfaces. This characteristic gives clays their "plasticity" so that they can be stretched, rolled, joined, and paddled.

When clay dries, the water-filled spaces between the platelets dry and shrink and the clay becomes impacted and hard. When the clay is fired it shrinks again, becoming more highly impacted, rock hard, and permanent.

Clay, as dug out of the ground or gathered by the bank of a stream, requires additions of other clays and nonclay minerals to make a useful working material. This kind of working material is called a "clay body" and it can be designed to have such specific traits as good color, durability, or suitability for hand-forming, wheel-throwing, or slip-casting.

The Teco bodies were formulated for low-fire work; they are a very light yellow in color and their texture is somewhat crude, marked by the presence of fairly large particles in the mix. They are fairly absorbent and have excellent strength and durability; while they are not as tough as a dense and hard stoneware or porcelain, they are less brittle. Since Teco clay bodies are not dense and glassy they do not warp in the fire, so that there is less cracking and shrinking than with such high-fire bodies as porcelains. As a result the Teco designers were free to employ forms that would not have been possible for those working with dense, warp-prone, high-fire bodies. For example, there is a noteworthy piece in which a complex pattern of openwork forms, thin and leaf-like, was draped over the body of the pot and was joined to the form only at its base and lip (fig. 82). Forms of this type cannot be used with dense, mature clay bodies as they would crack and warp in the fire.

TECO GLAZES

Glazes are glass-like coatings applied to clay. They are used because they form surfaces that are exceptionally durable and enhance the appearance of the piece. They greatly extend the reach of the medium in terms of color and texture.

Glazes have a lot in common with glass; they have similar ingredients and often a similar appearance as well. Glass, however, is amorphous and non-crystalline, whereas most glazes have a pronounced crystalline structure. It is this structure that gives glazes the rich surface and visual texture we value so highly.

Glazes are characterized according to their melting character, transparency or opacity, visual texture, durability, stability, and pattern of glaze flow. Fashions in glaze types periodically sweep over the ceramics world, temporarily eclipsing all others. Currently low-fire, brightly colored, highly painted glazes are most popular; at the turn of the century the most popular were "dead matte" glazes, which were generally applied in thick, opaque layers.

Most glazes are made from a group of ingredients, with each ingredient contributing one or more elements to the recipe. Ceramists use complex multi-ingredient glaze recipes because such glazes often yield rich and visually complex surfaces. Many potters spend years looking for that special combination of ingredients that will produce a glaze with a unique character and impact. The Teco glaze is just such a special recipe.

If we know the chemical make-up of a glaze we can learn a great deal about its physical and visual characteristics. Analysis of a glaze from the past (such as the Teco glaze) can also give us clues as to the level of its formulator's skill and intentions.

Silica is the basic ingredient of all glazes; however, glazes made solely from silica would melt only at temperatures so high as to be impractical. Therefore glazes must contain melting materials that cause the glaze to melt at more attainable temperatures. These materials are called melters or fluxes. Finally, glazes also contain alumina, a material that encourages high viscosity (stiffness) during the firing; otherwise the glaze will run off vertical surfaces (like the walls of a pot) and on to the kiln shelf.

A significant determinant of the character of a glaze is the ratio of silica, alumina, and flux. It is this relationship (along with an appropriate choice of glaze melter) that dictates the opacity or transparency, the texture, stability, and durability of a glaze.

For example, a satin matte, highly figured, strongly flowing glaze is probably low in silica and alumina and high in melter; a stiff nonflowing matte glaze with little visual texture is most likely low in silica and melter and high in alumina.

The glaze melters are minerals added to a clay or glaze to encourage fusing. They also help determine the character of the fired glaze, influencing such aspects of glaze character as opacity and transparency, glaze color, and visual texture.

Glazes with a significant lead content will encourage warm orange and red colors when iron is present, and warm greens with copper and rich royal blues where cobalt is present. Boron and sodium glazes, on the other hand, will encourage muddy iron colors, cool greens with copper and cool blues with cobalt. A rich, deep, waxy transparent or velvety dead matte glaze usually indicates the presence of lead, whereas a shiny, highly reflective and brilliant surface suggests the presence of sodium and boron.

From their names it is usually impossible to tell what each compound contributes to the glaze, so that glaze formulae tend to look like haphazard collections of materials with odd names listed in no particular order. Furthermore, most compounds used in glazes contain a number of different elements, which makes things all the more confusing.

An analysis of the Teco glaze formula reads as follows:

silica (SiO_2) . 42.3
alumina (Al_2O_3) . 11.8
potash (K_2O) . 07.0
lead (PbO) . 16.3
tin oxide (SnO_2) . 12.1
zinc oxide (ZnO) . 05.4
iron oxide (Fe_2O_3) 00.5
copper oxide (CuO) 04.4

This analysis of the Teco glaze was derived from a spectroscopic examination of a Teco shard performed by Peter Bush on March 24, 1988, at the Scanning Electron Microscope Laboratory of the State University of New York at Buffalo. The accuracy of this analysis is somewhat flawed, as this type of analyzing instrument is limited in its sensitivity to sodium, which is too light a metal to be measured easily.

In this formula silica is low, which suggests a fairly soft glaze liable to crazing. Alumina is normal; it encourages nonflowing glazes and hardens the glaze, partially compensating for the low silica. Potash is ample for a glaze of this sort

and contributes durability, strong saturated color, and satin surfaces. It is likely that sodium may be present in the formula in modest amounts; if it contained large amounts of sodium it would probably be more highly melted than it is. Tin is surprisingly high in this formula, and that is the key to this glaze's unusual character. Tin produces very rich surfaces, but because it is expensive it is rarely used in amounts above 2 or 3 percent. The high percentage of tin used here is responsible for the soft, smooth, satin glaze surface and strong saturated color. Due to the formation of tin crystals the glaze is strongly marked with a finely grained visual texture. The zinc content is also significant, reinforcing the action of the tin, encouraging the formation of crystals, and contributing durability and a slightly muted and metallic color response.

The Teco glaze is high in lead (16 percent). Lead has acquired a bad reputation and indeed can be a very dangerous material when used in glazes applied to food containers (it is particularly dangerous when the glaze contains copper, as is the case with Teco). It is also a very useful material — especially in the low fire — because it is a powerful melter and encourages very stable melts and smooth surfaces. Other strong melters tend to encourage unpredictable and unstable melts. Finally, lead encourages very beautiful surfaces that feel good to the touch and are rich in color.

At first glance the Teco glaze looks very similar to the "dead matte" glazes popularized by the Grueby Pottery at the turn of the century, but there are differences which suggest that the two are quite different in composition. The Grueby glazes derive their matte surface not from tin but from a different material, perhaps zinc. Compared to the "dead matte" glazes of such firms as Grueby and Hampshire, the Teco glaze was applied in a thinner coat, is somewhat shinier, and has a more silvery tone.

The nature of the materials and the rigors of the fire render all glazes subject to numerous problems. These include crazing (in which the glaze shrinks more than the clay body), crawling (in which the glaze peels away from the body during firing), shivering (in which the body shrinks more than the glaze and flakes off), and pinholing (in which pinhole-sized breaks mark the surface of the glaze).

The Teco glaze is usually marked by many very tiny, almost imperceptible pinholes, the occasional large, easily visible pinhole, and by a pattern of crazing that may have become quite pronounced over the years. Both the pinholing and, more especially, the crazing are due to the low silica content of this glaze. Since the Teco glaze was applied to a comparatively soft and open clay body its fairly hard and brittle surface is prone to chipping.

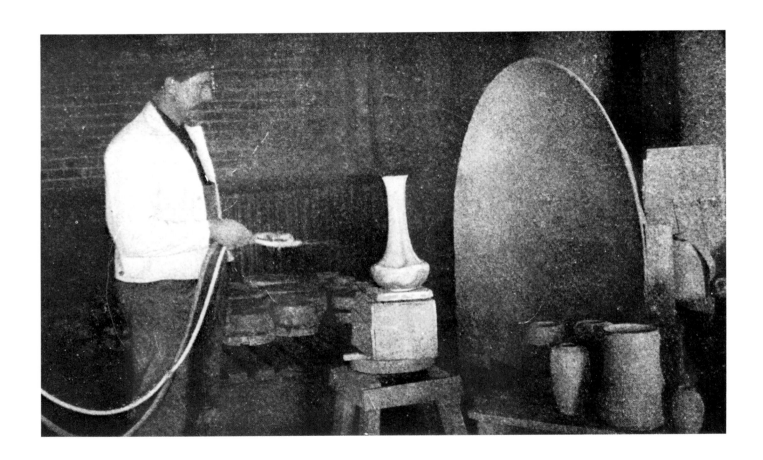

Fig. 78. A Teco vase is sprayed with glaze. The large parabolic shield behind the piece collects any overspray. It seems to be a simple collector with no fan to evacuate dust. The sprayer is fed by two hoses, one feeding glaze and the other air.

APPLICATION OF TECO GLAZES

Glazes are applied in a number of ways: pieces can be dipped into the glaze; sluiced with glaze; painted with a brush or a sponge; or sprayed. Most glazes are difficult to apply with a brush because when they are fired a very fussy pattern of brush marks is revealed. Because of this, glaze-application methods like dipping or spraying, which leave no such marks, are the most common. Sprayed glazes look different from others because their surface is very uniform and unmarked by overlaps, drips, or splashes.

Publicity photographs of the glazing process prove that the Teco glazes were applied with a sprayer. The uniform character of the glaze application reinforces this conclusion.

The Teco glaze surface has a number of identifying features, including a color shift from green to black, a pattern of small pinholes, and a crystalline pattern. The color shift that often marks the Teco glaze is called "gunmetal," and is the result of an excess of copper colorant which floats to the surface of the glaze during the firing, creating a layer of black copper crystals. It is especially noticeable where the glaze is thickly applied — for example, at the lip or shoulder of the piece. The Teco glaze's crystalline marking and pinhole pattern are generalized over the glaze surface and are most easily seen when the piece is moved under a bright light. The pinhole pattern is a result of glaze activity during the firing and the crystal markings (an alternating pattern of shiny and matte particles) are crystals of tin. Other green matte glazes from this era do not exhibit this group of attributes.

THE TECO GLAZE UNDER
LOW MAGNIFICATION

A 30-power hand-held magnifying viewer can be used as an aid in the examination of the Teco glaze. Under this magnification the pinholes are revealed to be tiny craters with sharp edges, betraying their origin in the bubbling and boiling of the glaze surface during the firing. The alternating pattern of shiny and matte patches is now revealed under magnification as coming from an overall pattern of tightly packed crystals. This pattern tends to be most obvious where the glaze has flowed thickly. It is this pattern of light and dark that richly marks the surface of the Teco glaze and differentiates it from other green matte glazes.

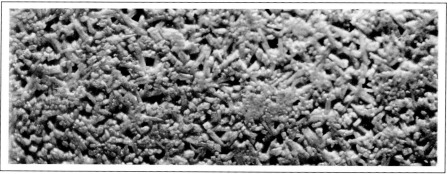

fig. 79. At 20 magnifications the Teco Green glaze is seen to be crystalline. The crystals are oblong and tend to cluster in rosettes. The pores at the interstices of the crystals create an irregular surface which appears matte to the naked eye. In some examples, apparently because of firing variations, the crystals share the surface with amorphous areas pitted with tiny holes — in these cases, the glaze still appears matte, but lacks the lustrous quality of glazes in which the crystals blanket the surface.

Before the Teco low-fire green glaze was developed, Gates experimented with other glazes and firing temperatures. These experimental pieces were fired in high-temperature kilns and made with porcelainous clay bodies. Some especially interesting examples of this early work were finished with a shiny glaze marked by an overall pattern of small gold flecks. This kind of glaze is known as a "Tiger Eye." Its unusual pattern is derived from the presence of small crystals of titanium floating in the matrix of a transparent glaze. These glazes have to be very low in alumina (otherwise the crystals cannot form) and tend to be highly flowing. These are very difficult to control in the fire, which, we can assume, is the reason that they were not made on a commercial basis at Teco.

FORMING TECO SHAPES

The three main forming methods employed by ceramists are hand-forming (slab-building, coiling), throwing on the potter's wheel, and molding (press-molding and slip-casting). Each of these methods leaves a strong mark on the character of the piece. Slab-built work tends to be angular with dramatic joins. Coil-built pieces, by contrast, tend to have few sharp edges. Thrown pieces are usually symmetric and flowing and generally show the mark of the potter's fingers. Mold-formed work tends to be very smooth with controlled, unbroken surfaces: the edges of the form are generally beveled for easy release from the mold.

The choice of forming method is based on tradition and needs. The Teco potters needed to produce a great many pieces in a fairly economical manner. Generally both slab- and coil-built methods are too slow for production pieces. This leaves throwing and mold work. Since Gates and his employees had a great deal of experience with the mold process (used by the firm for the production of its architectural tile) it is not surprising that this was the process chosen to produce Teco pottery. This skill and experience in the mass production of tile on a large scale gave the Teco Potteries an advantage.

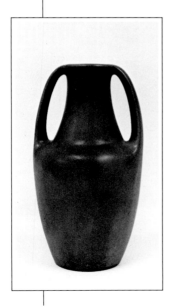 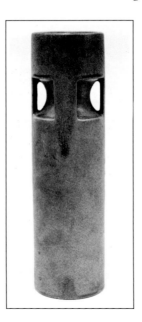

Fig. 80. Vases no. 283 (left) and no. 375 (right) were cast in simple two-piece molds. The seams run along the central part of the handles and along a raised seam in the middle of the pot. This raised seam makes it a very simple matter to clean and finish the form. *Collection: Chicago Historical Society (283); John L. Husmann, McHenry, IL (375).*

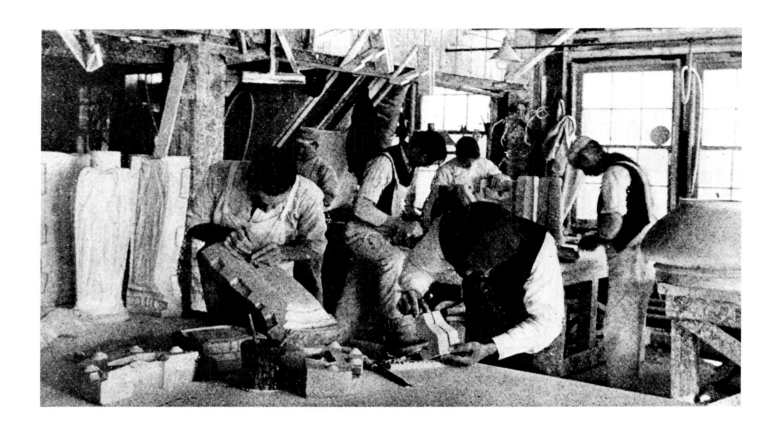

Fig. 81. This photograph reveals a great deal about the way in which Teco pottery was made. The molds are all two-piece rather than complex-compound molds. With good design it is possible to make very complex pieces using two-piece molds: this seems to have been the standard procedure at the Gates Potteries.

Through photographic evidence we know that throwing was employed at the Gates Potteries. But since most Teco ware was not made by this method, we can surmise that throwing was used only to create experimental designs and to form the master models for many of the Teco forms.

In the mold-forming process a clay reproduction is made of the mold. Because clay has no form of its own it can be made to take the form of the mold quite easily.

Pressed molding is the simplest mold-forming process. The ceramist forces moist clay over or into a mold. As the clay dries it releases from the mold. At this point it can be taken from the mold, cleaned, and finished. It is very easy to join separate pressed molded segments together to form a single complex piece and it is common practice to make pieces in this way.

The principle underlying the cast-forming process is quite simple: plaster of Paris will absorb the moisture in the clay slurry or slip (a wet, soupy mixture of clay and water) and dry it, thus creating a form which is, in effect, a replication in clay of the inside of the mold. It is this clay replication that becomes the mold-formed piece. In the creation of a slip-cast piece the slurry adheres to the mold wall, which absorbs some of its water. The slurry in the middle of the mold cavity, however, remains wet. In this way a wall of clay is built up on the inside of the mold. When this wall is of sufficient thickness, the still-wet slurry is poured out or withdrawn. The clay wall clinging to the inside of the mold is allowed to firm and is then taken from the mold, ready to be finished, dried, and fired.

Mold-forming techniques allow for the ready creation of complex form and decoration not available in other ceramic techniques. In some ways the results are closer to printmaking than to ceramics. Economic questions often play a big part in ceramics, and this is especially true of slip-cast processes. Cast pieces can have very complex forms: if made by hand they would have to be sold for very high prices, but since the slip-cast process allows for the easy duplication of complex forms they can be made very economically. We see this a great deal in American art pottery, and especially in Teco ware; the complex sculptural or architectural forms employed in many of the firm's finest designs could never have been used if the ware had not been mold-formed.

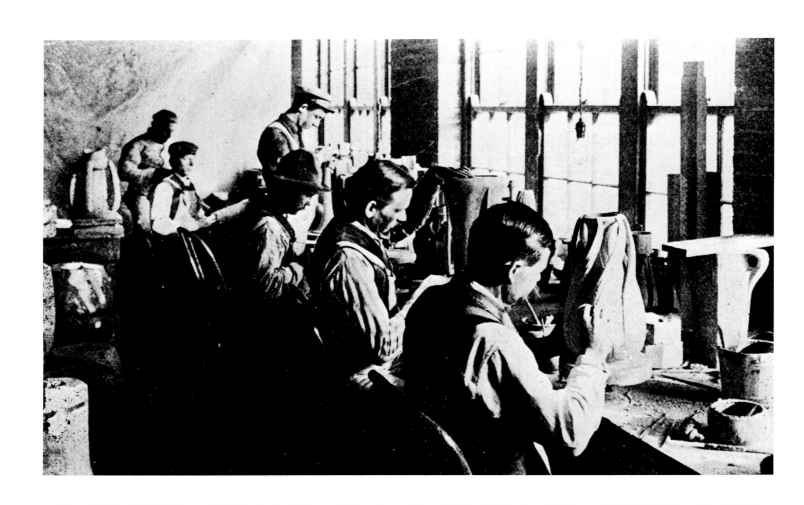

Fig. 82. After being withdrawn from the mold, pieces were taken to the finishing room shown in this photograph. It was here that smaller pieces were luted, that is, joined to the larger forms, and seams left from the mold-forming process were smoothed. This technique would not work in a mature, high-fire body, which shrinks a great deal; it does work in a low-fire body which is not as dense and does not shrink as much. Workmen in the foreground are finishing vases no. 192 (see colorplate 17) and no. 416 (center).

FIRING TECO WARE

Ceramic ware must be subjected to the action of the fire to become hard and permanent. But firing has a strong impact on the aesthetic character of the piece as well. The choices that the ceramist makes in firing method, firing temperature, and type of kiln have a big impact on the look of the piece.

The temperatures at which ceramic ware is fired range from a low of about 1700 degrees Fahrenheit (still quite hot by any except ceramists' standards) to a high of about 2500 degrees. Every part of the range has its champions and its advantages and disadvantages.

The low fire tends to offer the most flexibility in terms of color range, form, and image creation. It can produce extremely seductive surfaces and rich varied colors. For this reason, low-fire glazes were very popular at the turn of the century. The absence of mold marks on Teco pottery is due not merely to skillful cleaning, but to the fact that the body is not fired to maturity, a necessary characteristic of low-fire bodies. While low-fire clay bodies cannot be as dense and hard as those of the high fire, they can be reasonably durable.

The problems of low-fire clay bodies and glazes were very familiar to the ceramists at American Terra Cotta & Ceramic Company, since their architectural work (in which they had a great deal of experience) was low fire. In the low fire, glazes could have a high lead content (lead burns out at high temperatures); such glazes tend to be very stable, consistent, and reliable. It also allowed some freedom in terms of form; complex forms which would be in grave danger of warping and cracking in the high fire can be fired fairly easily in the low fire.

A kiln is a structure designed to contain ceramic ware and heat. Such a structure must be made from a refractory substance, that is, a substance that resists the action of the heat, contains it, and supports the ware. Kilns are usually made from ceramic materials because these are among the few materials that can contain the high temperatures needed to fire clay. It takes clay to fire clay.

Kilns are categorized by fuel type and structure. Originally kilns were fired with simple, readily available fuels, generally wood. By the turn of the century most kilns were fired with coal, oil, or kerosene. The structure of early kilns tended to be fairly simple, comprising a fire box opening onto a firing chamber with an outlet for spent gases at the top. The flame is directed from the bottom of the kiln

Fig. 83. In the double-walled muffle kilns, each wall
was separated by thick pylons. The fire box was in the
lower part of the kiln and the flames passed between
the inner and outer walls. This allowed the firing
chamber to be heated while the work remained free of
fire markings. This was especially important when fir-
ing lead glazes which could bubble and boil upon
exposure to direct flame.

to the top and is drawn up through the ware on the way. Kilns of this sort are called updraft kilns. There is another, more complex design for fuel-burning kilns called a downdraft kiln. In downdraft kilns the flame takes a more circuitous path: it is directed first upward and then redirected downward through the ware and into a vent located under the ware; from there it is vented to a chimney at the rear of the kiln.

Updraft kilns are simple to design and construct and are well suited to the low fire. Downdraft kilns are much more complex but can attain high fire temperatures.

At the turn of the century all kilns were fuel-burning (electric kilns did not become common until the 1930s). Many ceramists fired in muffle kilns, a specialized variation of the updraft kiln. This type of kiln is double-walled and the flame is channeled through the space between the two walls. It is very natural for the flame in a fuel-burning kiln to play over the ware so that sections of many of the pieces fired in the kiln will be touched by the fire. This procedure, called "flashing," strongly affects glaze surfaces, visual textures, and colors. Certain kinds of glazes, especially lead glazes, bubble when exposed to the direct flame; the muffle kiln was designed to avoid this.

Glazes and clay bodies react very strongly to the amount of oxygen in the firing chamber: their melt, color, and visual textures are affected. If, during the firing, the atmosphere inside the kiln becomes depleted in oxygen, the process is called "reduction" firing. In this process the clay body and glaze color are darkened and marked by irregularly spaced dark spots. However, the ceramist can ensure that an adequate amount of oxygen is allowed to enter the kiln, producing what are called "oxidation" firings. The ceramist must decide whether to use an oxidation or reduction firing atmosphere. The choice is partly dictated by the glaze types used and partly by the desired effects. Neither oxidation nor reduction is superior; both are tools to be used by the ceramist when appropriate. When a glaze contains lead, however, reduction firing is not appropriate because lead boils and blisters in this firing atmosphere. Therefore lead-glazed Teco pottery was fired in a muffle kiln, a type of kiln specifically designed to avoid reduction.

Technical evidence points to the conclusion that Teco ware was fired along with the terra cotta ashlars (tile blocks) produced by the parent company, the American Terra Cotta & Ceramic Company. If this is indeed the case, then we can have a pretty good idea of how these pieces were fired, for the firing of architectural tiles is well documented. Such firings lasted for about a week, starting with a preheat of a day, a slow buildup of heat for a few days, and then the final ascent to the desired temperature, which took several days. Once the firing was over, the cooling process would also be quite slow, taking about a week. The soft matte surface so characteristic of Teco is derived, in part, from this slow firing and cooling.

TECHNICAL ANALYSIS

To analyze the Teco clay body and glaze, it was necessary to obtain a fragment of Teco pottery. This fragment was then broken into smaller pieces for use in the clay body and glaze analysis procedures. For the clay body absorption test it was first necessary to prepare the shard: it was fired to 1000 degrees Fahrenheit to drive off any moisture accrued over the years and then weighed. Its weight was 57.1 grams. The fragment was then placed in a container of water for twenty-four hours: at the end of this period its weight was 63.3 grams. This works out to a figure of 10 percent absorption.

In a test of the glaze, another fragment was fired to cone 08 to 07 (1751 to 1803 degrees Fahrenheit). Before firing the glaze was a "dead matte"; after this firing it had become quite frosty and shiny. This strong melting was surprising, for it suggested that the Teco glazes were fired at a very low temperature. But other evidence pointed to a much higher firing. For example, though the glaze had changed a great deal, the clay body remained unchanged. If the piece had been fired at a very low temperature the body as well as the glaze would have been modified.

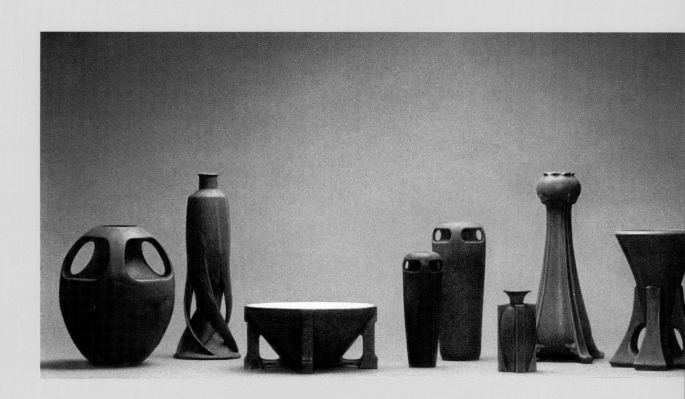

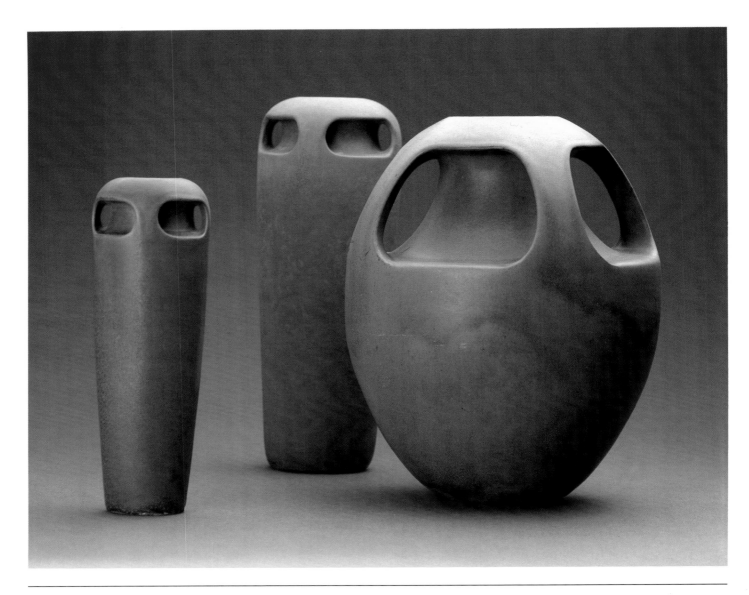

Colorplate 1.
Fritz Albert removed oblongs from the solid bodies of vases no.
117, center, no. 118, left, and no. 119, right, to create dramatic voids
without interrupting the sleek flow of their bodies. h: 10¾″;
h: 13″; h: 13″
Collection: Joel Silver; Stephen Gray; Chicago Historical Society

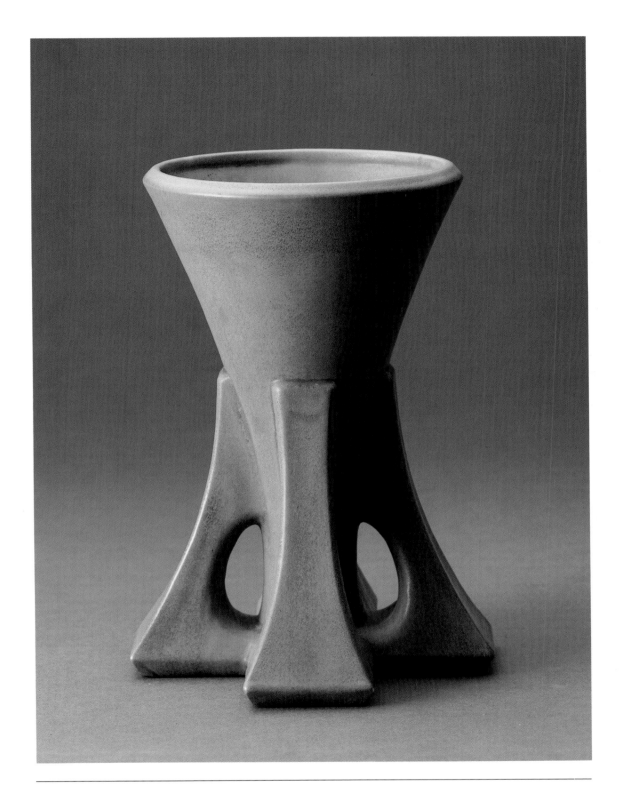

Colorplate 2.
Buttresses support the funnel-shaped neck of vase no. 377, designed
by William D. Gates. h: 13″
Collection: Joel Silver

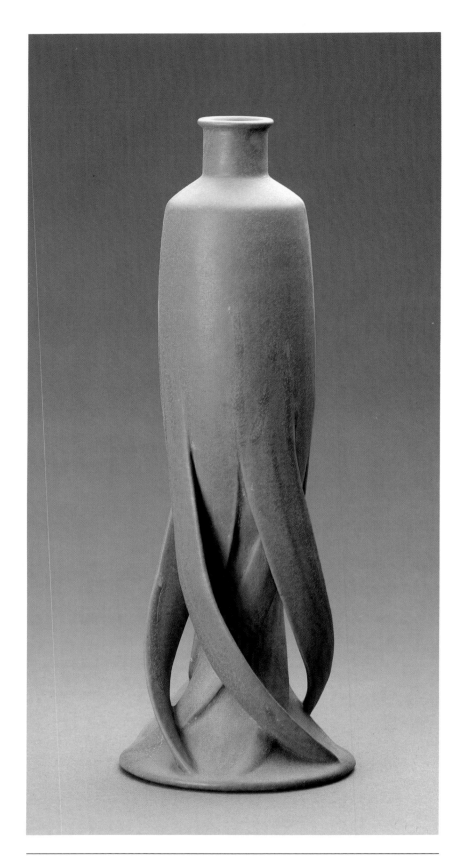

Colorplate 3.
The simple neck and body dissolve into a swirl of leaves at the
base of vase no. 310, designed by Fritz Albert. h: 18½"
Private Collection

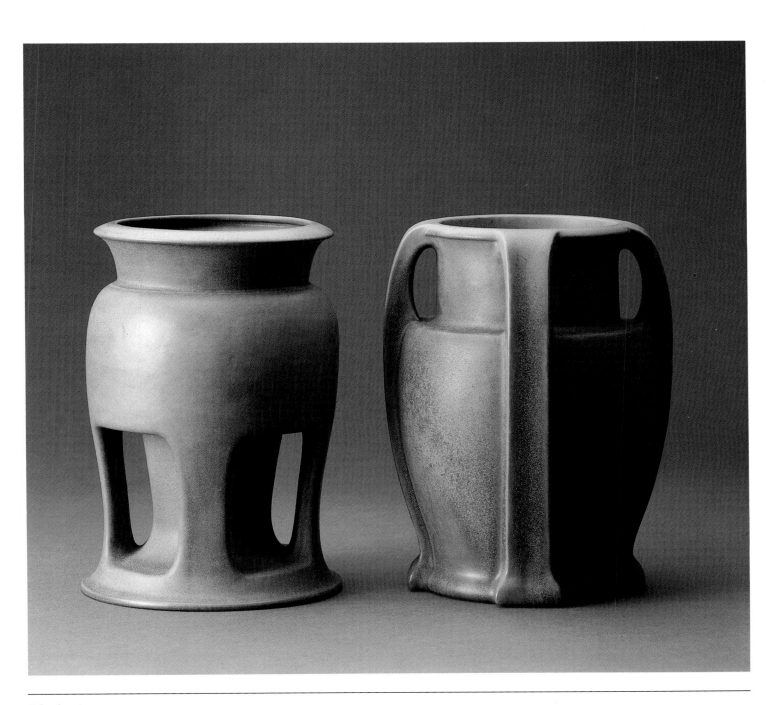

Colorplate 4.
Sections carved out of the bodies give the illusion of revealing
a central core on vases no. 171, left, and no. A418, right, both
designed by Chicago architect Jeremiah K. Cady. h: 13″
Collection: Linda Balahoutis and Jerry Bruckheimer;
Patsy and Steven Tisch

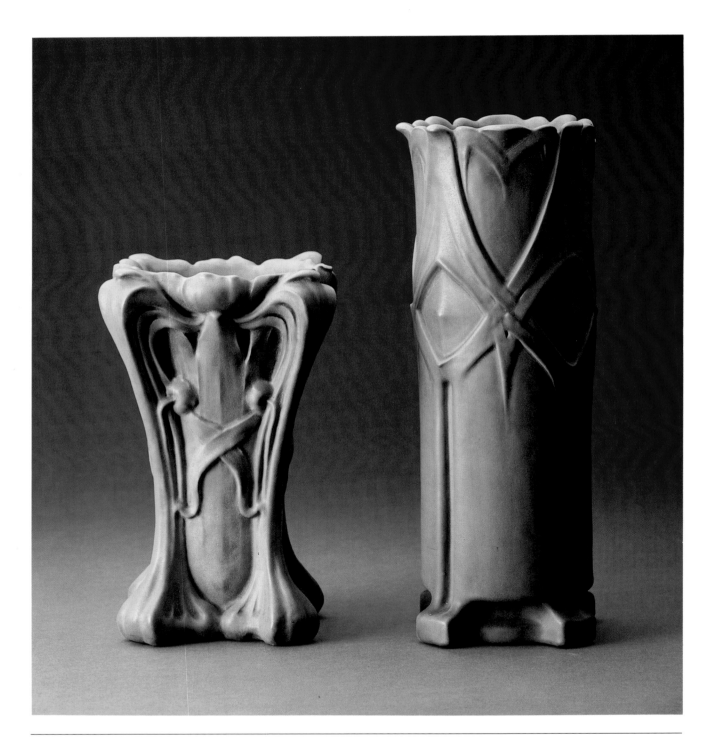

Colorplate 5.
A large bud emerges from a tight cluster of leaves and tendrils to
form vase no. 409, left, designed by Fernand Moreau. Vase no. 408,
also by Moreau, is ornamented with a crisscross pattern of reeds.
These vases may have been special orders, since other shapes
with the same numbers were sold commercially. h: 12½"; h: 17¼"
Collection: William and Mary Hersh

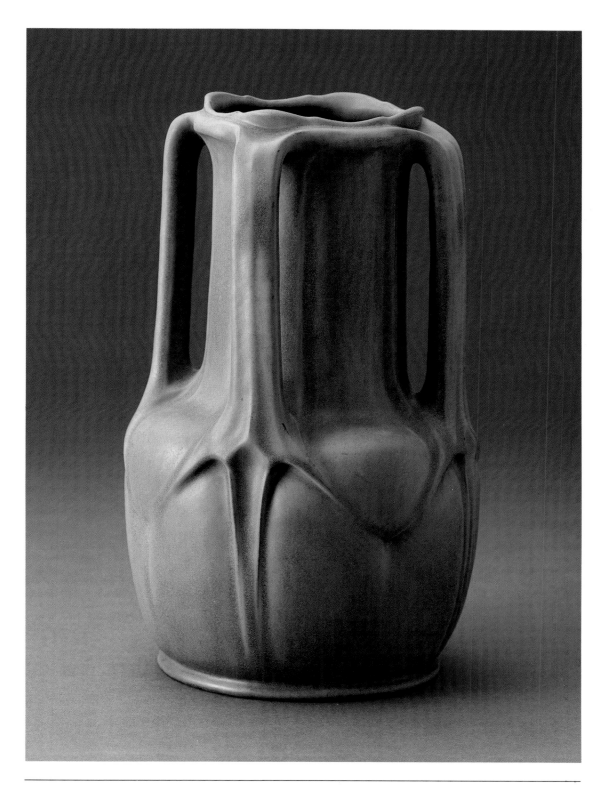

Colorplate 6.
The vegetal form of no. 223, by an unidentified designer, is suitable
for use as a vase or lamp base. h: 14″
Collection: Linda Balahoutis and Jerry Bruckheimer

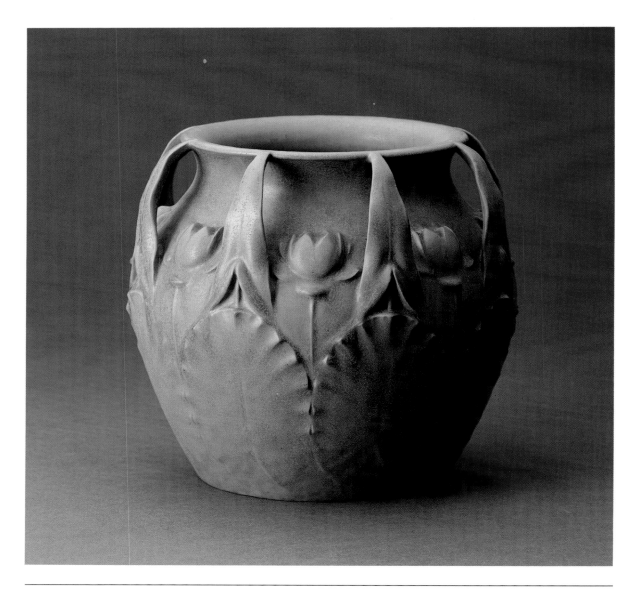

Colorplate 7.
William J. Dodd combined the broad leaves of pond lilies with
pointed leaf tips to create jardiniere no. 86, which has been found
in bright yellow as well as green. h: 9⁹⁄₁₆"
Collection: Patsy and Steven Tisch

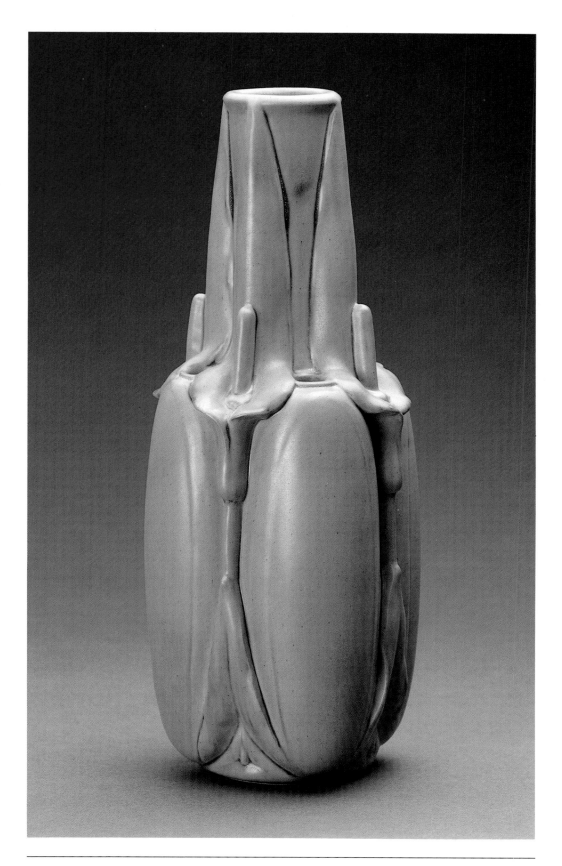

Colorplate 8.
Lilies merge with arrowroot to form organic vase no. 141, designed
by Fritz Albert. h: 17″
Collection: Stephen Gray

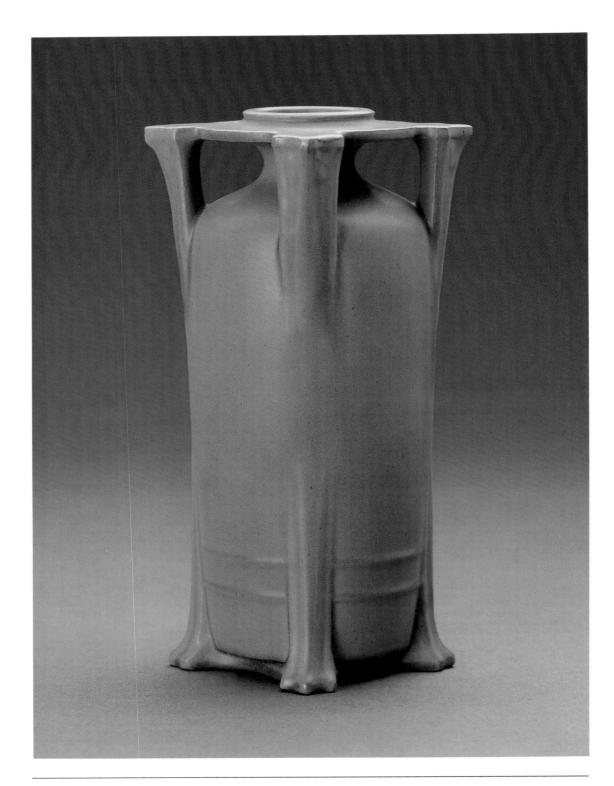

Colorplate 9.
Max Dunning's design, vase no. 265, was suggested as an
accessory for libraries, dens, and other rooms with Mission
furnishings. h: 12″
The Dillenberg-Espinar Collection

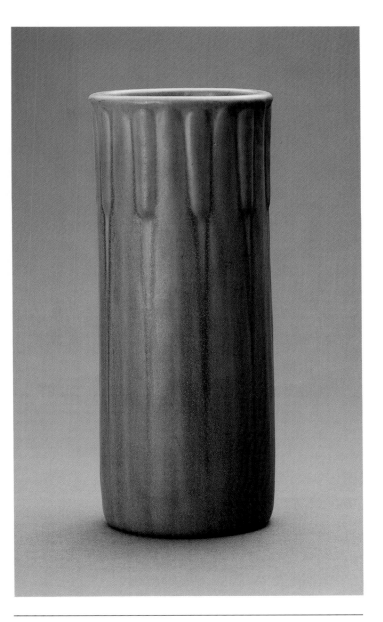

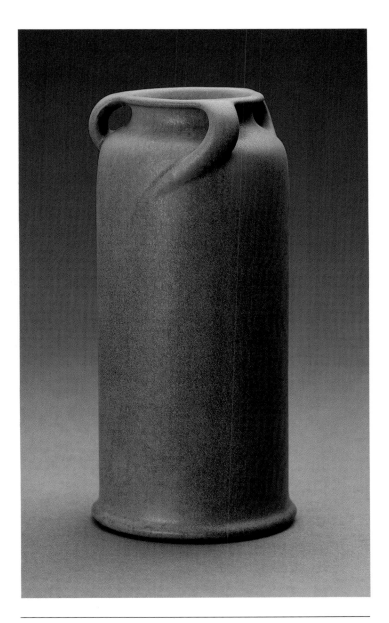

Colorplate 10.
Vase no. 293, ornamented with cattails and rushes,
was designed by R. A. Hirschfeld. h: 12″
Collection: Stephen Gray

Colorplate 11.
Tendrils emerge to form three handles at the mouth
of vase no. 284, a design by William B. Mundie. h: 11″
Collection: Stephen Gray

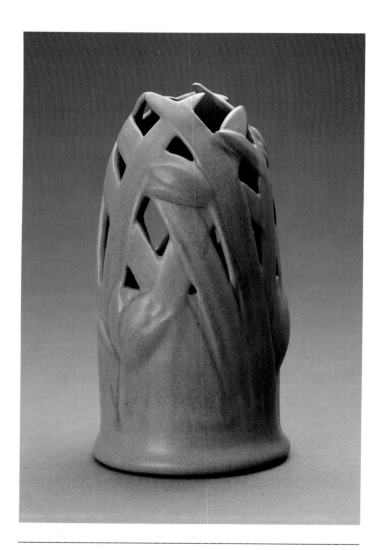

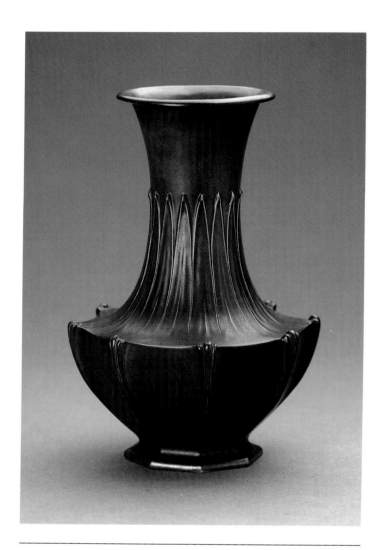

Colorplate 12.
William J. Dodd designed vase no. 151 expressly for cut flowers. Stems casually arranged in the openings between the overlapped leaves would produce "an exceptionally pleasing and artistic effect." h: 11"
The Dillenberg-Espinar Collection

Colorplate 13.
Slender reeds placed side by side encircle vase no. 87. One of a series of vases inspired by the abundant plant life in the factory pond, it was designed by William J. Dodd before 1902. h: 12"
Collection: Barbara and Jack Hartog

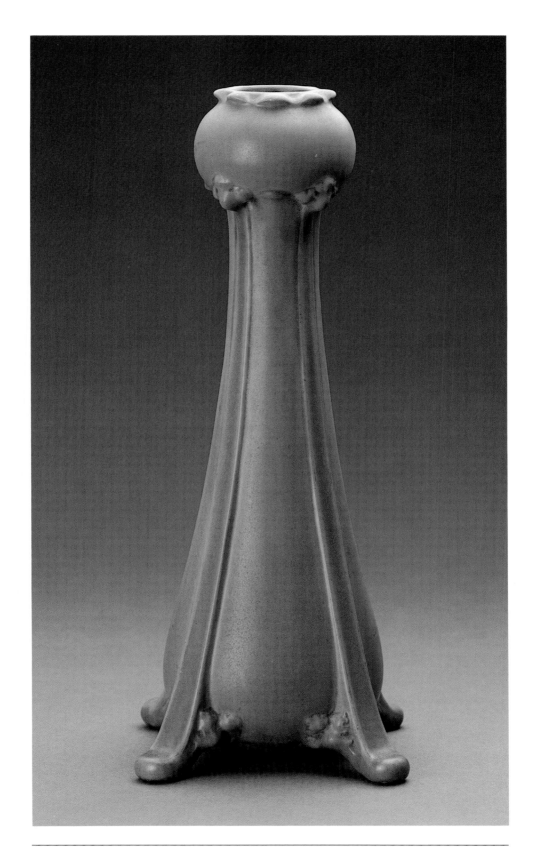

Colorplate 14.
Vase no. 262, designed by architect Melville P. White, was recom-
mended for chrysanthemums. Topped by a yellow glass globe,
it was sold as lamp no. 18. h: 18½″
Collection: Chicago Historical Society

Colorplate 15.
The white lining of Roman Salad Bowl no. 400, designed by
architect Holmes Smith, contrasts crisply with its Teco green
exterior. h: 5⅞″
Collection: Tod M. Volpe

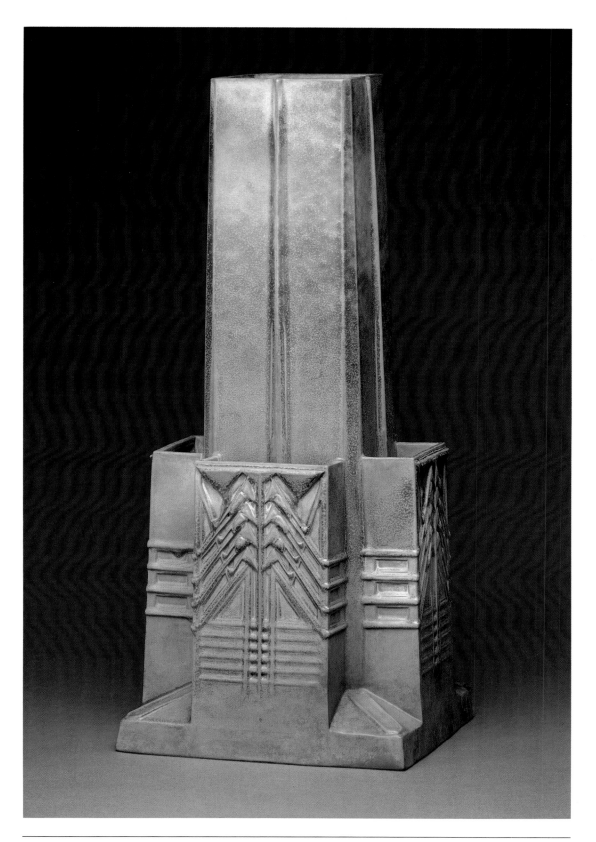

Colorplate 16.
Vase no. 331 was designed by architect Frank Lloyd Wright for
Unity Temple, Oak Park, Illinois. h: 29½"
*Collection: Unity Temple: The Unitarian Universalist Church
in Oak Park*

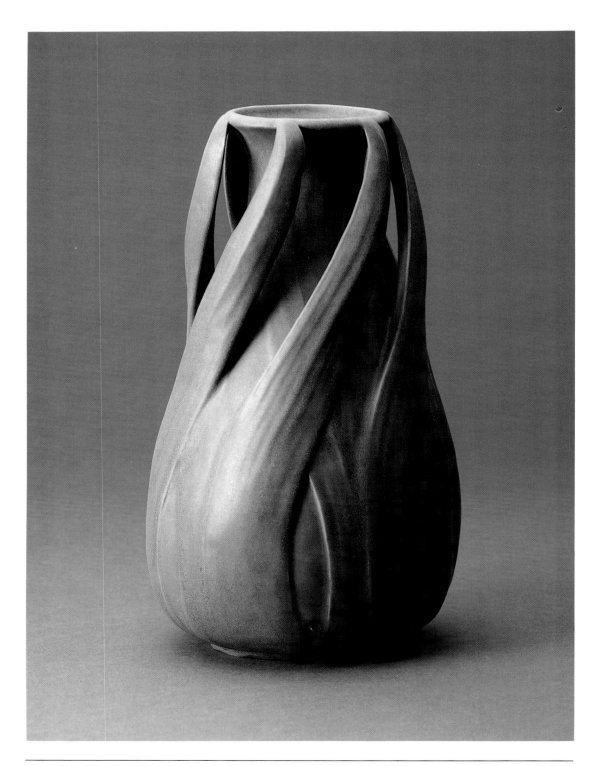

Colorplate 17.
Twisted iris leaves swirl upward from the body to touch their tips
to the lip of vase no. 192. It was designed by Fritz Albert to hold
large flowers or clusters of foliage. h: 14¾"
Collection: Chicago Historical Society

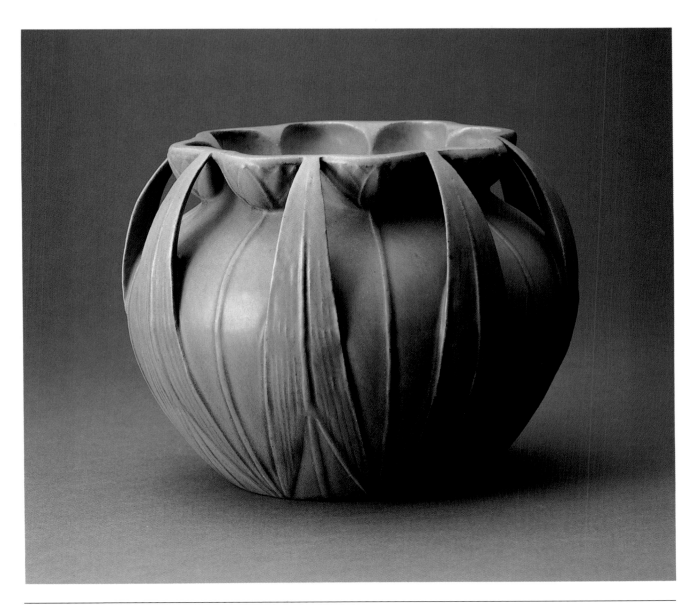

Colorplate 18.
Chicago architect Hugh M. G. Garden gracefully touched the tips
of reeds to a scalloped top to create jardiniere no. 106. h: 9″
Collection: Linda Balahoutis and Jerry Bruckheimer

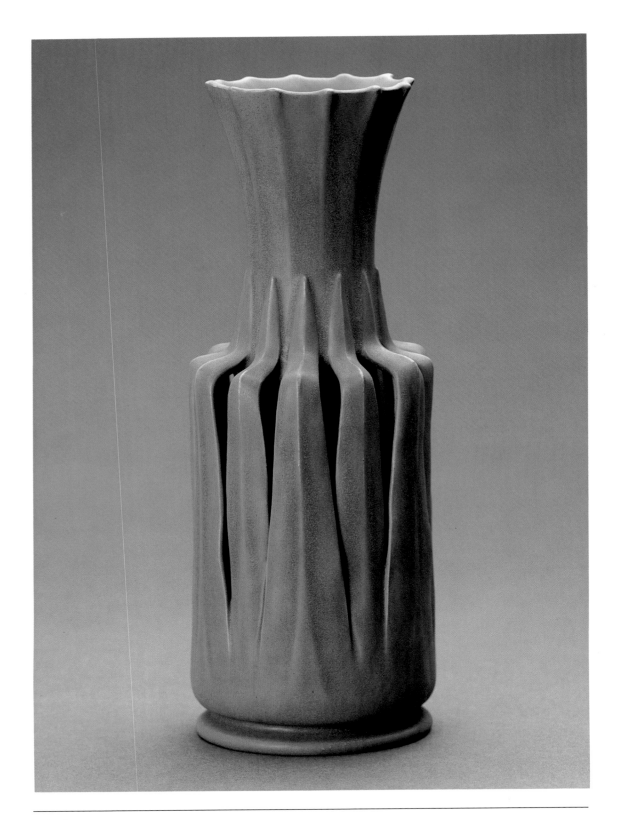

Colorplate 19.
In vase no. 85 by William J. Dodd, the leaf imagery was molded
separately and added to the body of the piece after the clay was
partially hardened. The leaves are attached only at their base and
at the lip, leaving the body of the leaf to stand free of the pot for
much of its length. h: 13″
Collection: Barbara and Jack Hartog

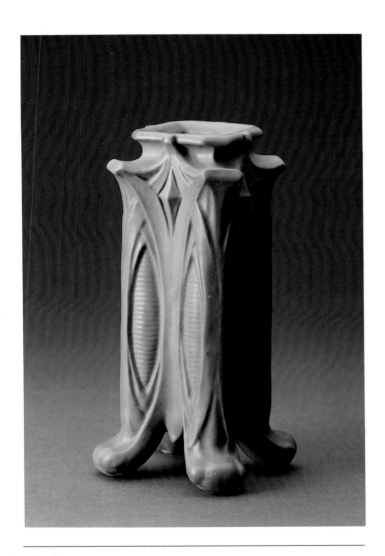

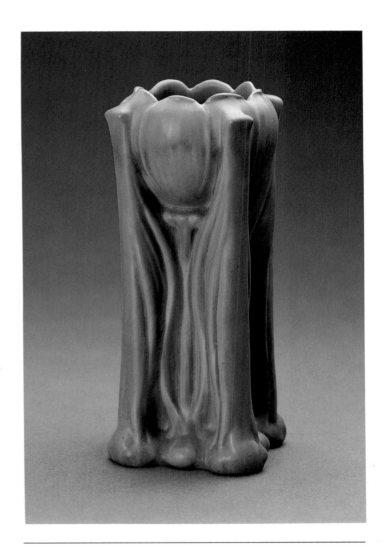

Colorplate 20.
Geometric figures intertwine with tiny seed pods on vase no. 434, reminiscent of the work of architects of the Prairie School. The piece was modeled by Fernand Moreau. h: 11½"
Collection: Joel Silver

Colorplate 21.
Lotus blooming in the factory pond was captured by Fernand Moreau in vase no. 423. h: 11½"
Collection: Barbara and Jack Hartog

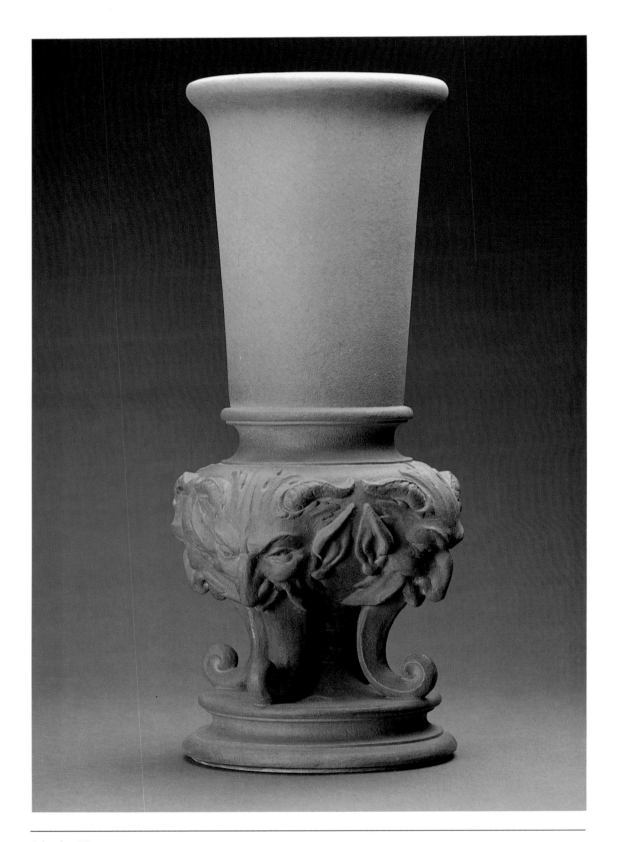

Colorplate 22.
Three satyrs form the base of this vase designed by Fritz Albert.
It is identical to one shown in Gates's living room at "Trail's End"
(fig. 70). The Teco trademark is stamped in ink, rather than
impressed, on the underside of its base. h: 24″
Collection: Chicago Historical Society

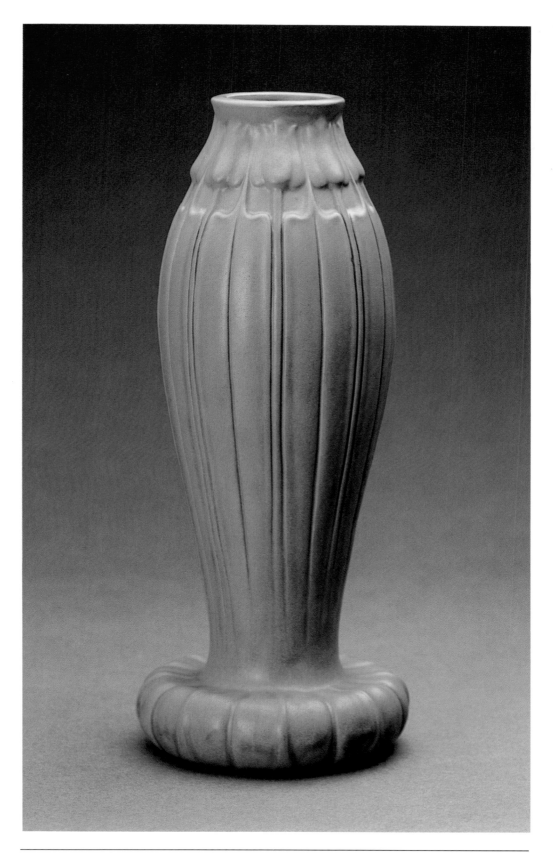

Colorplate 23.
The graceful form of vase no. 397 is a molded bouquet of
miniature tulips. h: 13½″
Collection: Barbara and Jack Hartog

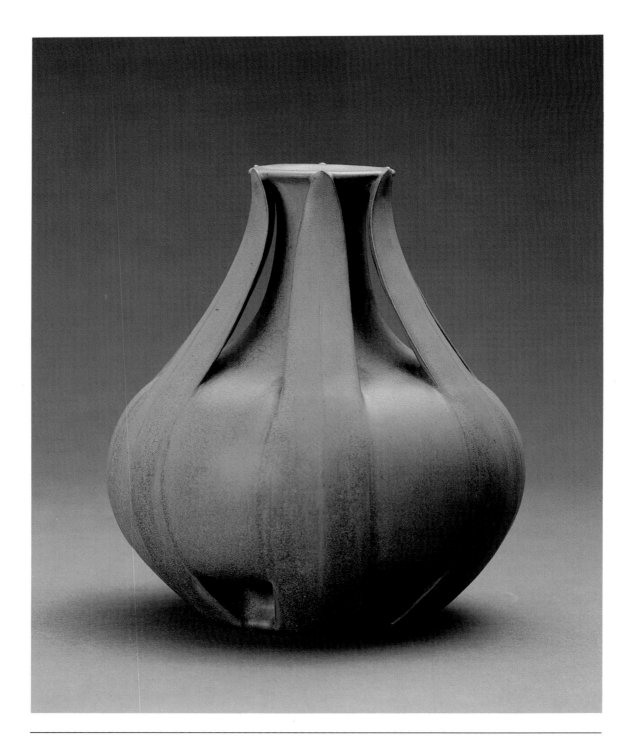

Colorplate 24.
On vase no. 191, attributed to Fritz Albert, leaves are luted
(applied) to the body, which has been cast separately. h: 10¼"
Collection: Jean and Martin Mensch

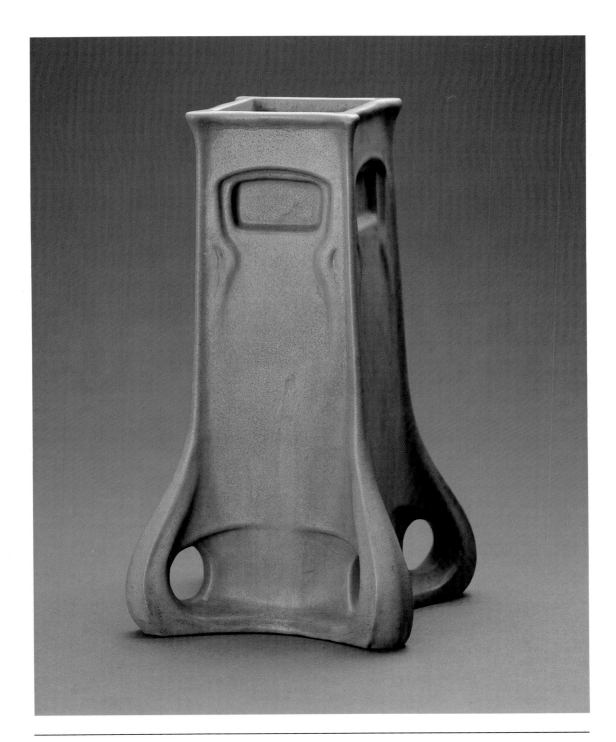

Colorplate 25.
Sculptural vase no. 259, designed by architect Harold Hals, made a
sturdy container for large garden flowers. h: 13″
Collection: Stephen Gray

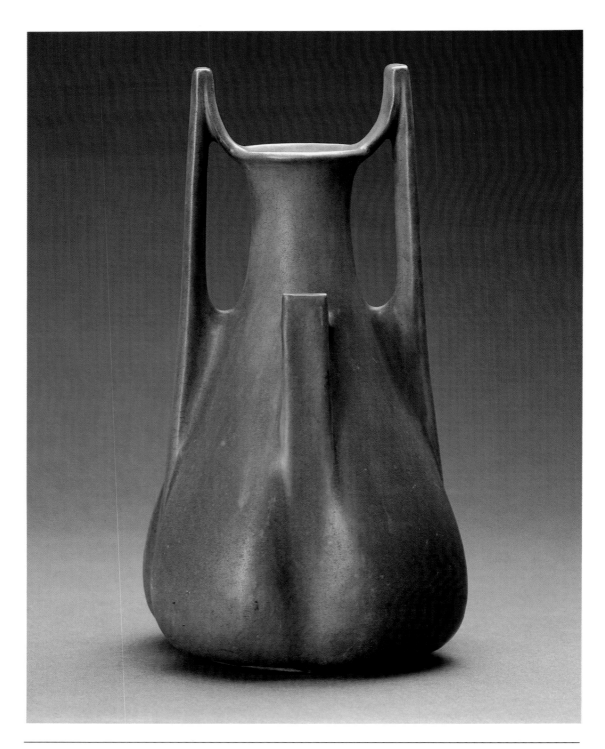

Colorplate 26.
Slender handles soaring from the body of shape no. 181 are held
in check by a body visibly heavier at the base. h: 15″
Collection: Paul R. Ziegler

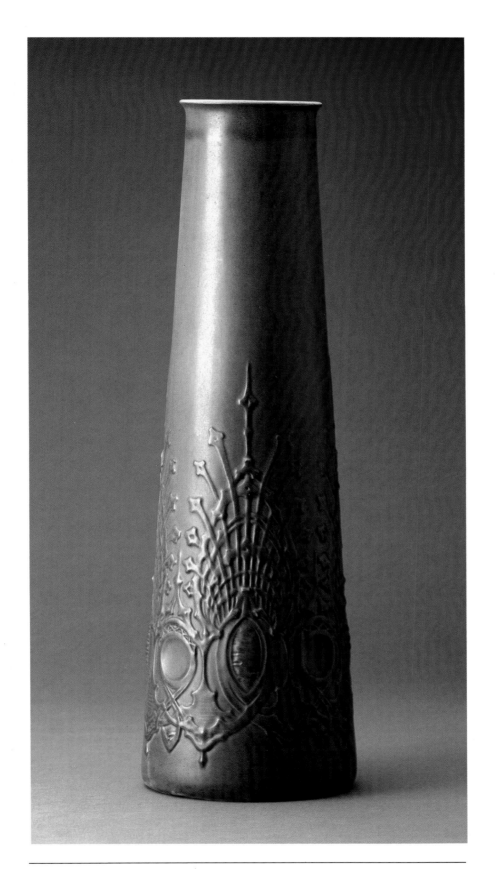

Colorplate 27.
Tall green weed holder no. 74 was shape no. 73 customized by the
application of an intricate pattern of lacy ovals and oblongs. h: 25⅛″
Collection: Chicago Historical Society

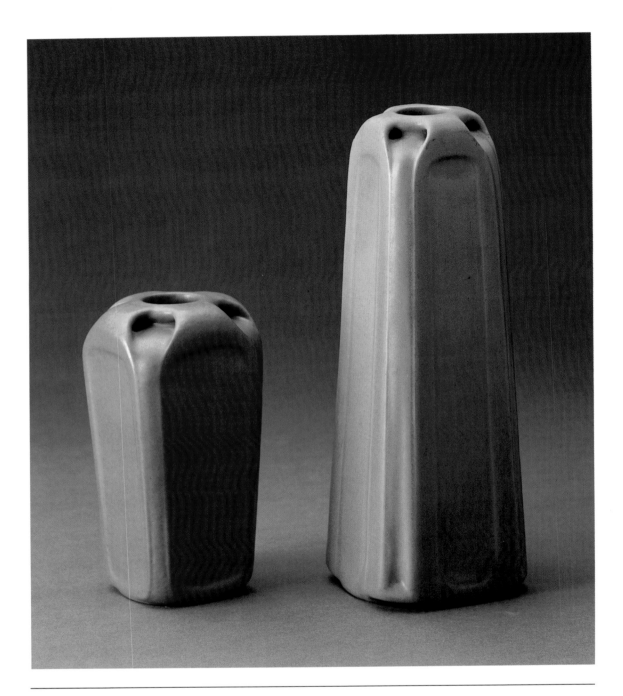

Colorplate 28.
Vase no. 184, left, was described as "plain in treatment but very restful and pleasing to the eye." Shape A184, right, an elongated version of vase no. 184, was distinguished by tendrils emerging at the mouth. Both were designed by Fritz Albert. h: 8⅞" (184); h: 14⁷⁄₁₆" (A184)
Collection: Joel Silver

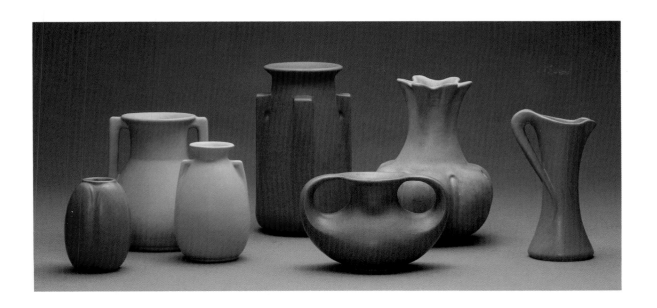

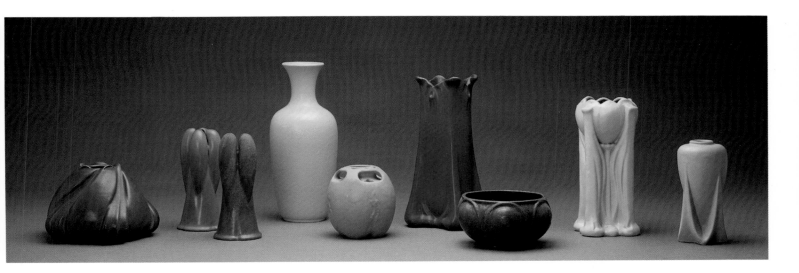

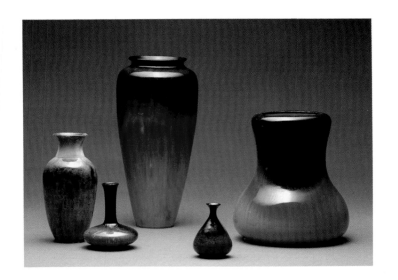

Colorplate 29 (top).
Selections of Teco pottery with colored glazes.
Collection: (left to right) Bruce Baker (114), Chicago Historical Society (403, A402, 444), TC Industries, Inc., Crystal Lake, IL (297, 197), Chicago Historical Society (294).

Colorplate 30 (center).
Collection: Jairus B. Barnes (319), Andrew Lopez (186), Jairus B. Barnes (186), The Beck Family (D64), Gary Struncius (113, Chicago Historical Society (420), John and Nancy Glick (253), Andrew Lopez (423), Toomey-Treadway Collection (127)

Colorplate 31 (left)
The glossy metallic glazes on these Teco vases, probably all designed by William D. Gates, were applied to porcelain bodies.
Collection: James and Mary McWilliams, James and Mary McWilliams, Ilene C. Edison, James and Mary McWilliams, Jerome and Patricia Shaw

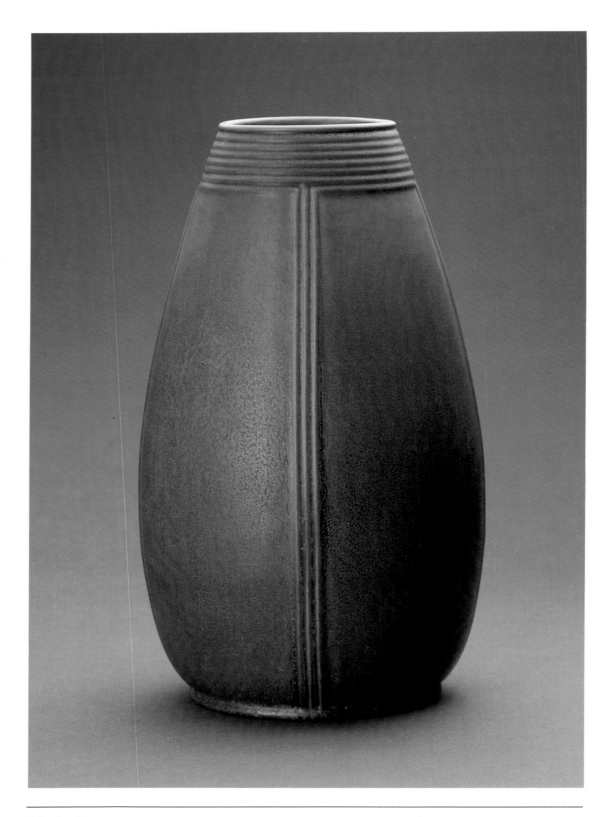

Colorplate 32.
Hugh M. G. Garden's chaste design no. 252 made it suitable for
use as a lamp or a vase. It was available in two sizes. h: 17½″
Collection: Stephen Gray

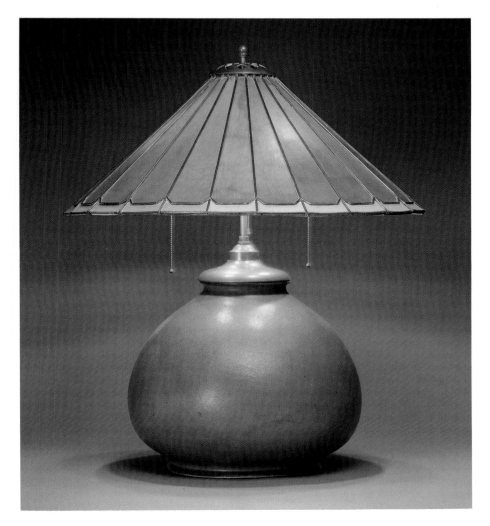

Colorplate 33.
This large lamp may have been intended for a lodge or club house. The art glass shade was created by Orlando Giannini; the base, no. 79, was designed by William D. Gates. h: 33″
Collection: Mr. and Mrs. Timothy Samuelson

Colorplate 34. (bottom left)
Tiles of green and gold glass, leaded to form a domed shade, harmonize with the green of lamp base no. 271, designed by architect William B. Mundie. h: 21¼″
Collection: James and Mary McWilliams

Colorplate 35. (bottom right)
Intersecting planes of art glass form the shade of Prairie style lamp no. 2. The base was designed by architect William B. Mundie; the shade was made by Orlando Giannini. Kerosene lamps like this one were popular in 1904, when electricity was still a luxury. h: 23″
Collection: Chicago Historical Society

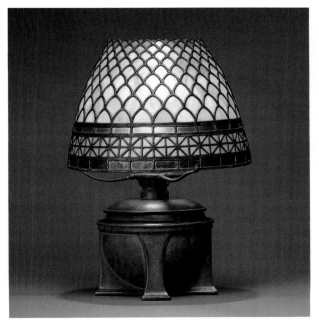

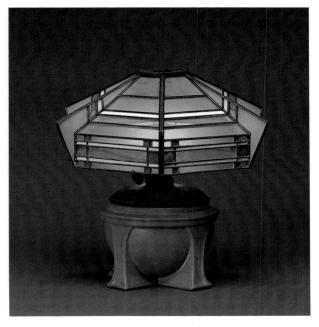

Colorplate 36.
Watercolor rendering of a fireplace faced with Teco tiles in shades
of brown and green around 1910. It may have been painted by
William D. Gates, whose hobbies included sketching and
watercolor painting.
Collection: TC Industries, Inc., Crystal Lake, IL

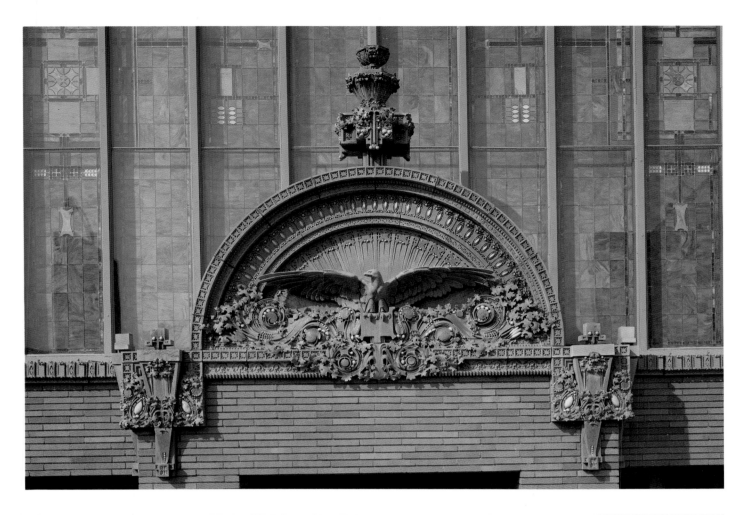

Colorplate 37.
Terra cotta ornament on the exterior of the Merchants Bank of Winona, Minnesota, designed by Purcell, Feick & Elmslie in 1911-12 and executed by the American Terra Cotta & Ceramic Company.

Colorplate 38.
Exterior of the National Farmers Bank of Owatonna, Minnesota, designed by Louis H. Sullivan. Gates's factory produced the terra cotta ornament for this façade.

Colorplate 39, 40.
The *Teco* catalogue issued by the Gates Potteries
around 1910 illustrated shapes in colors other
than the familiar Teco green.
Collection: Chicago Historical Society

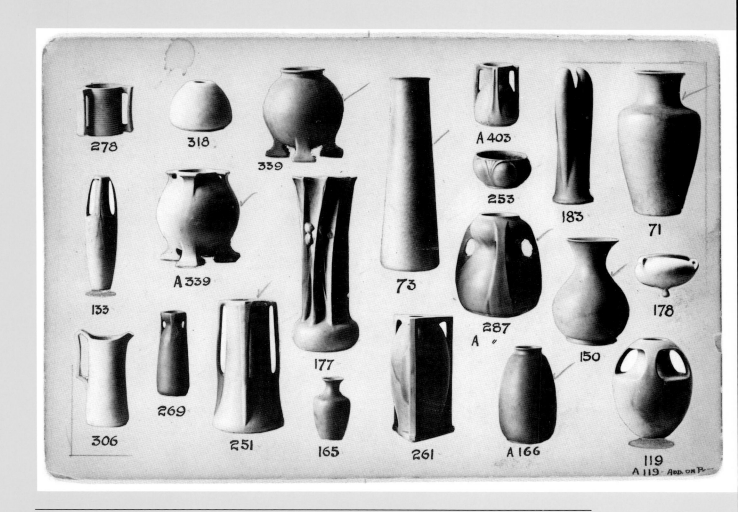

Cardboard cards identifying the Teco shapes by number guided workers in filling orders at the pottery.

This inventory of Teco forms is derived from a variety of publications issued by the Gates Potteries, later known as Teco Potteries, supplemented by information from advertisements, period articles, and paper labels on Teco Ware in various collections. As the information did not always appear in the same format or degree of detail, there are numerous gaps. We hope that readers will be able to supply missing information from objects and documents in their collections and will share it with the Erie Art Museum in order to develop a fully annotated version.

In the listing of dimensions h = height, w = width, d = depth, diam = diameter, and b = base.

Note: Occasionally the pottery assigned the same number to more than one shape. Forms for which no number has been ascertained appear at the end of the list. Unless otherwise indicated, items designated by alphabetical variations of the same number have the same shape.

Entries prefaced by "G" indicate Teco Potteries; all others refer to the Gates Potteries.

KEY TO ABBREVIATIONS:

TAP	*Teco Art Pottery,* 1904
Hints	*Hints for Gifts and Home Decoration,* 1905
Suggestions	*Suggestions for Gifts,* c. 1905
TPA	*Teco Pottery/America,* 1906
GP	*Garden Pottery,* c. 1906
TECO	*Teco,* c. 1910
ITC	*Indianapolis Terra Cotta Co.,* c. 1937
TP	*Teco Potteries,* c. 1937

Shape: 1
Type: Lamp
Designer: Mundie, W. B.
Dimensions: h 27"
Price: $45
Comments: Base no. 287;
TAP, p. 2

Shape: 4
Type: Lamp
Designer: Mundie, W. B.
Dimensions: h 20"
Price: $30
Comments: "Lamp with
Teco base...and leaded glass
shade, in soft green and
blue tones." Suggestions,
p. 15. Base no. 270

Shape: 7
Type: Lamp
Designer: Gates, W. D.
Dimensions: h 19"
Price: $25
Comments: "Lamp with
Teco base and leaded glass
shade, in soft tones of green
and blue." Suggestions, p.14.
Base no. 147

Shape: 10
Type: Lamp
Designer: Mundie, W. B.
Dimensions: h 16"
Price: $30
Comments: Lamp with
Teco base and soft green
leaded glass shade.
Suggestions, p.12.
Base no. 288

Shape: 14
Type:
Designer:
Dimensions:
Price:
Comments:

Shape: 2
Type: Lamp
Designer: Mundie, W. B.
Dimensions: h 23"
Price: $40
Comments: Base no. 271;
TAP, p. 2

Shape: 5
Type:
Designer:
Dimensions:
Price:
Comments:

Shape: 8
Type: Lamp
Designer: Jenney, W. L. B.
Dimensions: (base) h 22"
Price: $35; $43.50
(complete)
Comments: "Lamp with
Teco base and leaded glass
shade, in soft green and
pearl tones." Suggestions,
p. 14. Base no. 154. TPA

Shape: 11
Type:
Designer:
Dimensions:
Price:
Comments:

Shape: 15
Type: Lamp
Designer: Mundie, W. B.
Dimensions: h 18"
Price: $20
Comments: "Lamp with
Teco base...and Japanese
grass cloth shade, in green,
black and gold, with black
bamboo frame." Suggestions,
p. 14. Base no. 272

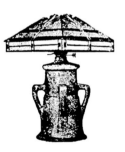

Shape: 3
Type: Lamp
Designer:
Dimensions: h 26"
Price: $50
Comments: Base no. 173;
TAP, p. 2

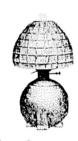

Shape: 6
Type: Lamp
Designer: Gates, W. D.
Dimensions: h 18"
Price: $15
Comments: "Lamp with
Teco base and Japanese
grass cloth shade in green,
gold and black, with black
bamboo frame." Suggestions,
p.15. Base no. 147

Shape: 12
Type:
Designer:
Dimensions:
Price:
Comments:

Shape: 9
Type:
Designer:
Dimensions:
Price:
Comments:

Shape: 16
Type: Lamp
Designer: Hals, H. (base)
Giannini, O. (shade)
Dimensions: h 26"
Price: $35; $46.50
(complete)
Comments: "Lamp with
Teco base and leaded glass
shade in soft green and
blue tones." Suggestions.
Base no. 259. "Leaded
shade by O. Giannini, green
tones, blue relief," TPA

Shape: 13
Type:
Designer:
Dimensions:
Price:
Comments:

Shape: 17
Type: Lamp
Designer: Giannini, O.
Dimensions: h 28″
Price: $55; $65.50 (complete)
Comments: "Lamp with Teco base and leaded glass shade, grape leaf design, in subdued shades of green and yellow." Suggestions, p. 13. "One of the many handsome lamp designs made with Teco pottery. . . an especially attractive lamp with leaded glass shade, grape leaf design in subdued tones of green and yellow, harmonizing with the Teco base." Hints, p. 17

Shape: 18
Type: Lamp
Designer: White, M. P.
Dimensions: h 24″
Price: $20
Comments: "Lamp with Teco base, and soft yellow globe." Suggestions, p. 13. Base no. 262. TPA

Shape: 19
Type:
Designer:
Dimensions:
Price:
Comments:

Shape: 20
Type: Lamp
Designer: Mundie, W. B.
Dimensions: h 18″
Price: $25
Comments: "Lamp with Teco base and cathedral glass shade, in dark green tones, inlaid in copper." Suggestions, p. 15. Base no. 270. TPA

Shape: 21
Type: Lamp
Designer: Cady, J. K.
Dimensions: h 28″
Price: $35 (complete)
Comments: "Lamp with Teco base and Japanese grass cloth shade, in red, green and black, with black bamboo shade." Suggestions, p. 12. Base no. 172. TPA

Shape: 22
Type:
Designer:
Dimensions:
Price:
Comments:

Shape: 23
Type:
Designer:
Dimensions:
Price:
Comments:

Shape: 24
Type:
Designer:
Dimensions:
Price:
Comments:

Shape: 25
Type: Lamp
Designer: Mundie, W. B. (base); Giannini, O. (shade)
Dimensions: h 20″
Price: $30
Comments: "Lamp with Teco base, designed by W. B. Mundie, and dark green cathedral glass shade inlaid with copper, designed by O. Giannini." Suggestions, p. 12. Base no. 271

Shape: 26
Type:
Designer:
Dimensions:
Price:
Comments:

Shape: 27
Type:
Designer:
Dimensions:
Price:
Comments:

Shape: 28
Type:
Designer:
Dimensions:
Price:
Comments:

Shape: 29
Type:
Designer:
Dimensions:
Price:
Comments:

Shape: 30
Type:
Designer:
Dimensions:
Price:
Comments:

Shape: 31
Type:
Designer:
Dimensions:
Price:
Comments:

Shape: 32
Type: Lamp
Designer: Gates, W. D.
Dimensions: (base) h 19″
Price: $20
Comments: "Mosaic shade; bulb and wiring." TPA

Shape: 33
Type:
Designer:
Dimensions:
Price:
Comments:

Shape: 34
Type:
Designer
Dimensions:
Price:
Comments:

Shape: 35 Type: Designer: Dimensions: Price: Comments:	Shape: 39 Type: Designer: Dimensions: Price: Comments:	Shape: 43 Type: Designer: Dimensions: Price: Comments:	Shape: 47 Type: Designer: Dimensions: Price: Comments:	Shape: 51 Type: Flower Vase Designer: Gates, W. D. Dimensions: h 4″ w ″4″ Price: $1 Comments: "Beautiful and useful flower vase. Shows the undying beauty of the old Roman shapes." Hints, p. 18
Shape: 36 Type: Designer: Dimensions: Price: Comments:	Shape: 40 Type: Designer: Dimensions: Price: Comments:	Shape: 44 Type: Designer: Dimensions: Price: Comments:	Shape: 48 Type: Designer: Dimensions: Price: Comments:	 Shape: 52 Type: Vase Designer: Gates, W. D. Dimensions: h 4″ w 4″ Price: $1 Comments: "This decorative and useful vase is another example of the unending variety of shapes." Hints, p.3; TAP, p. 14
Shape: 37 Type: Designer: Dimensions: Price: Comments:	Shape: 41 Type: Designer: Dimensions: Price: Comments:	Shape: 45 Type: Designer: Dimensions: Price: Comments:	 Shape: 49 Type: Vase Designer: Price: Comments: factory photo	 Shape: 53 Type: Vase Designer: Gates, W. D. (attr) Dimensions: Price: $2 Comments: factory photo
Shape: 38 Type: Designer: Dimensions: Price: Comments:	Shape: 42 Type: Designer: Dimensions: Price: Comments:	 Shape: 46 Type: Vase Designer: Gates, W. D. Dimensions: h 17″ Price: Comments: private collection	 Shape: 50 Type: Classical Greek Vase Designer: Gates, W. D. Dimensions: h 5″ w 4″ Price: $2 Comments: "A classical Greek vase, very popular with lovers of classical art. Sweet peas, nasturtiums, bridal wreath, poppies and similar cut flowers arrange beautifully in this charming vase. It lends itself to decorative purposes, and brightens any home." Hints, p. 14; Suggestions, p.7; TAP, p. 14	 Shape: 54 Type: Vase Designer: Gates, W. D. (attr) Dimensions: h 4″ w 5″ Price: $1 Comments: TAP, p. 14

Shape: 55
Type:
Designer:
Dimensions:
Price:
Comments:

Shape: 59
Type:
Designer:
Dimensions:
Price:
Comments:

Shape: 60 B Orn.
Type: Vase
Designer: Gates, W. D. and Albert, F.
Dimensions: h 8″ w 4″
Price: $4
Comments: "A very practical vase, as it can be used for so many purposes. Modelled design of daffodil blossoms and leaves. This is one of the most popular Teco vases and will give constant pleasure." Hints, p. 8; Suggestions, p. 6. "Daffodils in low relief," TPA (lists both as designers)

Shape: 60 E
Type: Garden Vase
Designer: Gates, W. D.
Dimensions: h 26″ w 12″ b 9″
Price: $10
Comments: GP

Shape: 64 A
Type:
Designer:
Dimensions:
Price:
Comments:

Shape: 56
Type: Pitcher
Designer: Gates, W. D.
Dimensions: h 4″ w 4″
Price: $2.50
Comments: "A pitcher which is very artistic and original." Hints, p.12; Suggestions, p. 8. TAP, p. 14; TPA

Shape: 60 A
Type: Classical Greek Vase
Designer: Gates, W. D.
Dimensions: 6″ x 3″
Price: $1.50
Comments: "A classsical Greek vase which fits anywhere and is charming for arranging poppies, lilies of the valley and other cut flowers. It is made in four different sizes. Be sure and give the letter as well as the number, for the letter indicates size." Hints, p. 25; Suggestions, p. 8; TECO

Shape: 61
Type: Vase
Designer:
Dimensions:
Price:
Comments: factory photo

Shape: 64 B
Type: Vase
Designer: Gates, W. D.
Dimensions: h 11″ w 4″
Price: $3
Comments: TAP, p. 10

Shape: 57
Type:
Designer:
Dimensions:
Price:
Comments:

Shape: 60 C
Type: Classical Greek Vase
Designer: Gates, W. D.
Dimensions: h 13″ w 5″
Price: $5
Comments:

Shape: 62
Type:
Designer:
Dimensions:
Price:
Comments:

Shape: 64 C
Type: Vase
Designer: Gates, W. D.
Dimensions: h 14½″ w 5½″
Price:
Comments:

Shape: 58
Type: Pitcher
Designer: Gates, W. D.
Dimensions: h 3″
Price: $1.50
Comments: TECO

Shape: 60 B
Type: Classical Greek Vase
Designer: Gates, W. D.
Dimensions: h 8″ x 4″
Price: $3
Comments:

Shape: 60 D
Type: Classical Greek Vase
Designer: Gates, W. D.
Dimensions: h 16″ w 8″
Price: $12
Comments:

Shape: 63
Type:
Designer:
Dimensions:
Price:
Comments:

Shape: 64 D
Type: Vase
Designer: Gates, W. D.
Dimensions: h 17″ w 7″
Price: $10
Comments: TAP, p. 8; "For tall roses," TPA

Shape: 65
Type:
Designer:
Dimensions:
Price:
Comments:

Shape: 66
Type:
Designer:
Dimensions:
Price:
Comments:

Shape: 67
Type:
Designer:
Dimensions:
Price:
Comments:

Shape: 68
Type:
Designer:
Dimensions:
Price:
Comments:

Shape: 69
Type:
Designer:
Dimensions:
Price:
Comments:

Shape: 70
Type:
Designer:
Dimensions:
Price:
Comments:

Shape: 71
Type: Garden Vase
Designer: Gates, W. D.
Dimensions: h 20″ w 11″
b 7″
Price: $8
Comments: GP; illustrated
Brush and Pencil, Feb. 1902,
p. 294

Shape: 72
Type: Vase
Designer: Gates, W. D.
Dimensions: h 18″ w 6″
Price: $7
Comments: "This hand-
some vase. . . is one of the
handsomest decorative
pieces ever modeled. The
severe simplicity of its lines
will commend it to all art
lovers." Hints, p.4; "Super-
classical vase," TPA

Shape: 73
Type: Vase
Designer: Gates, W. D.
Dimensions: h 25″
Price:
Comments: handle added
to create Chicago Architec-
tural Sketch Club stein

Shape: 74
Type: Vase
Designer:
Dimensions: h 25″ w 7½″
Price:
Comments: intertwined
lacy pattern of ovals and
oblongs in relief on lower
half of shape no. 73

Shape: 75
Type: Jardiniere
Designer: Dodd, W. J. (attr)
Dimensions: h 9 ⅜″ w 8″
Price:
Comments: factory photo

Shape: 76
Type: Vase
Designer: Gates, W. D. or
Dodd, W. J. (attributed to
both)
Dimensions: h 5″
Price: $3
Comments: attributed to
Dodd in *Brush and Pencil*,
(Feb. 1902), p. 296; attrib-
uted to Gates in TECO

Shape: 77
Type: Vase
Designer:
Dimensions: h 4½″ w 3″
Price:
Comments: factory photo

Shape: 78
Type: Vase
Designer: Gates, W. D.
Dimensions: h 3″ x w 4″
Price: $3
Comments: "A novel Teco
design. For purely
decorative purposes this
design is rarely excelled.
Good flower vase also."
Hints, p.12; TPA; shown in
color in TECO

Shape: 79
Type: Vase or Lamp Base
Designer: Gates, W. D.
(attr)
Dimensions: h 15″ w 18″
Price:
Comments: See
colorplate 33

Shape: 80
Type: Flower Bowl
Designer: Gates, W. D.
Dimensions: h 2″ w 6″
Price: $2
Comments: "A severely
simple flower bowl. All
designs of this artist are
recognized for their classic
beauty and grace of form."
Hints, p.14; "A fern bowl,"
TPA; TECO

Shape: 81
Type:
Designer:
Dimensions:
Price:
Comments:

Shape: 82
Type: Wall Pocket
Designer: Fuller, Mrs. F. R.
Dimensions: w 10″
Price: $7
Comments: exhibited
Chicago Architectural Club,
1908; TECO

Shape: 83
Type:
Designer:
Dimensions:
Price:
Comments:

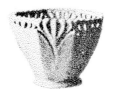

Shape: 84
Type: Jardiniere
Designer: Dodd, W. J.
Dimensions:
Price:
Comments: *Brush and Pencil* (Feb. 1902), p. 290

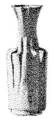

Shape: 85
Type: Vase
Designer: Dodd, W. J.
Dimensions: h 11½″ w 4″
Price: $7
Comments: "A charming piece of Teco. Decorated with modelled leaves, arranged around the vase, but attached to it at the top and bottom only, the form of the vase showing through the leaves." Hints, p. 21; Suggestions, p. 5; TAP, p. 10; TPA

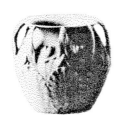

Shape: 86
Type: Jardiniere
Designer: Dodd, W. J.
Dimensions: h 10″ w 11″
Comments: *Brush and Pencil* (Feb. 1902), p. 290

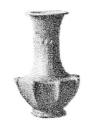

Shape: 87
Type: Vase
Designer: Dodd, W. J.
Dimensions: h 12″ w 8″
Price:
Comments: *Brush and Pencil* (Feb. 1902), p. 292

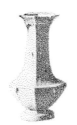

Shape: 88
Type: Vase
Designer: Dodd, W. J.
Dimensions: h 13½″ w 6⅜″
Price:
Comments: *Brush and Pencil* (Feb. 1902), p. 292

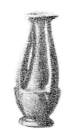

Shape: 89
Type: Vase
Designer: Dodd, W. J.
Dimensions: h 11″ w 5″
Price: $8
Comments: "A modelled vase with four arms attached at top and bottom, giving a very graceful effect which is very pleasing. Charming for ferns or foliage." Hints, p. 16; Suggestions, p. 5; TAP; "4-arm fern vase," TPA

Shape: 90
Type: Jardiniere
Designer: Dodd, W. J. (attr)
Dimensions:
Price:
Comments: factory photo

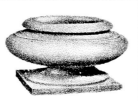

Shape: 91
Type: Jardiniere
Designer: Gates, Ellis D.
Dimensions: h 13″ w 24″ b 18″
Price: $15
Comments: GP

Shape: 92
Type: Garden Vase
Designer: Gates, W. D.
Dimensions: h 30″ w 15″ b 12″
Price: $18
Comments: GP

Shape: 93
Type:
Designer:
Dimensions:
Price:
Comments:

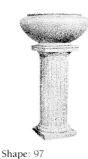

Shape: 94
Type: Garden Urn
Designer: Gates, W. D.
Dimensions: h 4′10″ w 3′4″ b 1′11″
Price: $250
Comments: GP

Shape: 95
Type: Garden Vase
Designer: Gates, W. D.
Dimensions: h 7 feet
Price: $1400 (Teco); $1200 (delft blue, heavily glazed)
Comments: TPA

Shape: 96
Type:
Designer:
Dimensions:
Price:
Comments:

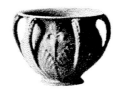

Shape: 97
Type: Garden Vase
Designer: Garden, Hugh M. G.
Dimensions: h 13″ w 26″ b 12″
Price: $15
Comments: "With the pedestal shown (no. 222) . . . this makes one of the handsomest of lawn decorations. This vase is suitable for either ferns or any of the hardy flower plants." Hints, p. 2; GP; "red terra cotta;" TECO

Shape: 97 A
Type: Garden Vase
Designer: Garden,
Hugh M. G.
Dimensions: h 9″ w 20″
b 8″
Price: $12
Comments:

Shape: 98
Type:
Designer:
Dimensions:
Price:
Comments:

Shape: 99
Type: Pitcher
Designer:
Dimensions: h 7″
Price:
Comments: flowing handle
connects scalloped opening
to base

Shape: 100
Type: Garden Vase
Designer: Gates, W. D.
Dimensions: h 20″ w 12″
Price: $7.50
Comments: GP

Shape: 100 A
Type: Stand
Designer: Gates, W. D.
Dimensions: h 21½″
Price: $25
Comments: "For umbrellas
and sticks," TPA

Shape: 101
Type: Punch Bowl
Designer:
Dimensions:
Price:
Comments: exhibited
Chicago Architectural Club,
1908

Shape: 102
Type:
Designer:
Dimensions:
Price:
Comments:

Shape: 103
Type:
Designer:
Dimensions:
Price:
Comments:

Shape: 104
Type:
Designer:
Dimensions:
Price:
Comments:

Shape: 105
Type: Urn
Designer: Gates, W. D.
Dimensions: h 21″ w 15″
b 14″
Price: $15
Comments: GP

Shape: 105 A
Type: Urn
Designer: Gates, W. D.
Dimensions: h 23″ w 22″
b 22″
Price: $30
Comments:

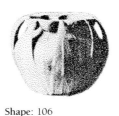

Shape: 106
Type: Jardiniere
Designer: Garden,
Hugh M. G.
Dimensions: h 9″ w 12″
Price: $15
Comments: "Combines
graceful contours with an
openwork design that is
exceedingly pleasing."
Hints, p. 5; TAP, p. 12;
"Demi-conventional
jardiniere," TPA; TECO

Shape: 107
Type: Vase
Designer: Ostertag, Blanche
Dimensions: h 12″ w 5″
Price: $6
Comments: TAP, p. 4; "A
motif in rushes," TPA

Shape: 108
Type:
Designer:
Dimensions:
Price:
Comments:

Shape: 109
Type:
Designer:
Dimensions:
Price:
Comments:

Shape: 110
Type: Garden Urn
Designer: Clark, N. L.
Dimensions: h 33″ w 30″
b 24″
Price: $35
Comments: GP

Shape: 111
Type: Lobby or Garden Vase
Designer: Dean, Geo. R.
Dimensions: h 30″ w 17″
b 8″
Price: $25
Comments: GP; TPA

Shape: 112
Type: Vase
Designer: Albert, F.
Dimensions: h 10 3/8″
Price:
Comments: *Brush and
Pencil* (Feb. 1902), p. 294

Shape: 113
Type: Vase
Designer: Albert, F.
Dimensions: h 6″ w 5½″
Price:
Comments: *Brush and Pencil* (Feb. 1902), p. 290

Shape: 114
Type: Vase
Designer: Albert, F.
Dimensions: h 5″ w 3½″
Price:
Comments: *Brush and Pencil* (Feb. 1902), p. 290

Shape: 115
Type: Vase
Designer: Albert, F.
Dimensions: h 8½″ w 6½″
Price:
Comments: *Brush and Pencil* (Feb. 1902), p. 290

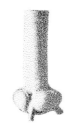

Shape: 116
Type: Vase
Designer: Albert, F.
Dimensions: h 15″ w 6″
Price: $8
Comments: TAP, p. 6

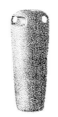

Shape: 117
Type: Vase
Designer: Albert, F.
Dimensions: h 13″ w 5″
Price: $8
Comments: "A vase of striking originality. . .one of the finest examples of Teco art. For decorative purposes or flower arrangement it is distinctly noticeable and attracts favorable comment." Hints, p. 16; Suggestions, p. 10; TAP, p. 4; "Example of purity," TPA

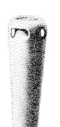

Shape: 118
Type: Vase
Designer: Albert, F. (attr.)
Dimensions: h 10¾″
Price:
Comments: factory photo

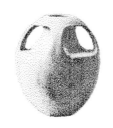

Shape: 119
Type: Lamp or Vase
Designer: Albert, F.
Dimensions: h 13″ w 10″
Price: $15
Comments: TAP, p.14; TPA

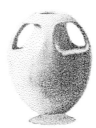

Shape: 119 A
Type: Lamp or Vase
Designer:
Dimensions:
Price:
Comments: no. 119 on round footed base

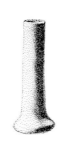

Shape: 120
Type: Vase
Designer: Albert, F.
Dimensions: h 13″
Price: $6
Comments: TECO

Shape: 121
Type:
Designer:
Dimensions:
Price:
Comments:

Shape: 122
Type:
Designer:
Dimensions:
Price:
Comments:

Shape: 123
Type: Classic Greek Vase
Designer: Albert, F.
Dimensions: h 13″ w 4″
Price: $4
Comments: "Classic Greek vase. . .commended on account of the wide base which prevents any possibility of tipping over when filled with heavy, long stemmed flowers." Hints, p. 6

Shape: 124
Type:
Designer:
Dimensions:
Price:
Comments:

Shape: 125
Type:
Designer:
Dimensions:
Price:
Comments:

Shape: 126
Type:
Designer:
Dimensions:
Price:
Comments:

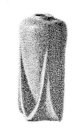

Shape: 127
Type: Vase
Designer: Moreau, F.
Dimensions: h 7″
Price: $4
Comments: TECO

Shape: 128
Type: Inkstand
Designer:
Dimensions: h 2″ w 3″
Price: $1
Comments: TAP, p. 14

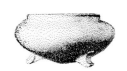

Shape: 129
Type: Bowl
Designer: Albert, F.
Dimensions: diam 13″
Price: $12
Comments: TECO

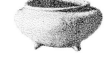

Shape: 130
Type: Bowl
Designer: Albert, F.
Dimensions: h 4″ w 6″
Price: $4
Comments: smaller version of no. 129; TAP, p. 14

Shape: 131
Type:
Designer:
Dimensions:
Price:
Comments:

Shape: 132
Type:
Designer:
Dimensions:
Price:
Comments:

Shape: 133
Type: Vase
Designer: Albert, F.
Dimensions: h 16″
Price: $12
Comments: "A study in flags," TPA

Shape: 134
Type: Vase
Designer: Albert, F.
Dimensions: h 13″ w 5″
Price: $8
Comments: "A modelled vase with lily decoration in relief. This Teco vase is welcomed by lovers of art and flowers, as it lends itself to the artistic arrangement of nearly all kinds of flowers, foliage, ferns, etc. In the dining room, parlor, hall, library, den or bedroom, it is always graceful, beautiful and effective." Hints, p. 21; Suggestions, p. 9; TAP, p. 4; TPA

Shape: 135
Type:
Designer:
Dimensions:
Price:
Comments:

Shape: 136
Type: Cut Flower Vase
Designer: Albert, F.
Dimensions: h 2″ w 8″
Price: $4
Comments: "A cut flower vase...especially intended for the arrangement of short stemmed flowers, such as pansies, pond lilies, nasturtiums, etc. Fitted with a metal flower holder, daffodils, Chinese lilies, tulips, etc., are very effective. This vase is very popular as an ornament for table, shelf, cabinet, etc. as well as being charming when used with the flowers indicated above." Hints, p. 4; Suggestions, p. 7

Shape: 136 A
Type: Flower Bowl
Designer: Albert, F.
Dimensions: h 2″ w 8″
Price:
Comments: outer rim of no. 136

Shape: 137
Type:
Designer:
Dimensions:
Price:
Comments:

Shape: 138
Type:
Designer:
Dimensions:
Price:
Comments:

Shape: 139
Type:
Designer:
Dimensions:
Price:
Comments:

Shape: 140
Type: Garden Urn
Type: Albert, F.
Dimensions: h 30″ w 18″ b 14″
Price: $25
Comments: GP

Shape: 141
Type: Vase
Designer: Albert, F.
Dimensions: h 17″ w 7″
Price:
Comments: *Brush and Pencil* (Feb. 1902), p. 293

Shape: 142
Type:
Designer:
Dimensions:
Price:
Comments:

Shape: 143
Type:
Designer:
Dimensions:
Price:
Comments:

Shape: 144
Type: Jardiniere
Designer: Albert, F.
Dimensions: h 10″ w 15″
Price: $15
Comments: TAP, p. 8; TECO

Shape: 145
Type: Vase
Designer:
Dimensions:
Price:
Comments: factory photo

Shape: 146
Type:
Designer:
Dimensions:
Price:
Comments:

Shape: 147
Type: Vase or Lamp Base
Designer: Gates, W. D.
Dimensions: h 7″ w 7″
Price: $4
Comments: "A vase which also makes a very chaste and beautiful lamp base." Hints, p. 17; TAP, p. 6

Shape: 148
Type:
Designer:
Dimensions:
Price:
Comments:

Shape: 151
Type: Cut Flower Vase
Designer: Dodd, W. J.
Dimensions: h 11″ w 4″
Price: $10
Comments: "This beautiful vase is unique in its conception and was designed . . . expressly for cut flowers. The lower part of the vase holds the water while flowers are carelessly arranged in different openings, producing an exceptionally pleasing and artistic effect." Hints, p. 8; TAP, p.12; TPA

Shape: 153 A
Type: Vase
Designer:
Dimensions: h 12″ w 5″
Price: $8
Comments: TAP, p. 4

Shape: 156 A
Type: Wall Pocket
Designer: Albert, F.
Dimensions: h 16″ w 6½″
Price: $6
Comments: "Wall pocket . . . for cut flowers, vines, ferns, etc." Hints, p. 13; Suggestions, p. 11; TECO

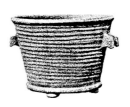

Shape: 158 A
Type: Jardiniere
Designer: Shaw, Howard V. D.
Dimensions: 12″ x 15″
Price: $10
Comments: GP

Shape: 149
Type: Vase
Designer:
Dimensions:
Price:
Comments: factory photo

Shape: 154
Type: Vase or Lamp Base
Designer: Jenney, W. L. B.
Dimensions: h 10″ w 7″
Price: $12
Comments: "Vase with conventional flower design in raised lines. Also suitable for lamp base." Hints, p. 9

Shape: 156 B
Type: Wall Pocket
Designer: Albert, F.
Dimensions: h 14″ w 7″
Price: $5
Comments: Hints, p. 13; Suggestions, p. 11

Shape: 158 B
Type: Jardiniere
Designer: Shaw, Howard V.D.
Dimensions: h 18″ w 23″
Price: $28
Comments:

Shape: 150
Type: Vase
Designer:
Dimensions: h 5½″ w 4″
Price:
Comments: factory photo

Shape: 152
Type: Garden Vase
Designer: Gates, W. D.
Dimensions: h 36″ w 13″ b 12″
Price: $20
Comments: GP

Shape: 155
Type: Vase
Designer: Gates, W. D.
Dimensions: h 8″
Price: $6
Comments: TECO

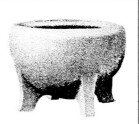

Shape: 157
Type: Jardiniere
Designer: Gates, W. D.
Dimensions: h 14″ w 21″; h 16″ w 30″
Price: $15; $30
Comments: "For ornamental trees." GP; TECO

Shape: 158 C
Type: Jardiniere
Designer: Shaw, Howard V.D.
Dimensions: h 22″ w 28″
Price: $35
Comments:

Shape: 153
Type:
Designer:
Dimensions:
Price:
Comments:

Shape: 155 A
Type: Vase
Designer:
Dimensions:
Price:
Comments: factory photo

Shape: 159
Type:
Designer:
Dimensions:
Price:
Comments:

Shape: 160
Type:
Designer:
Dimensions:
Price:
Comments:

Shape: 161
Type: Vase
Designer:
Dimensions:
Price:
Comments: factory photo

Shape: 162
Type: Vase
Designer: Gates, W. D.
Dimensions: h 13″ w 4″
Price: $6
Comments: "The lines are graceful, and the shapes and sizes make these designs very desirable for stem flowers." Hints, p. 5; TAP, p. 8; TECO

Shape: 162 A
Type: Vase
Designer: Gates, W. D.
Dimensions: h 14″ w 5″
Price: $7
Comments: One of "three beautiful vases in exceptionally pleasing design." Hints, p. 5; TAP, p. 8; "Grecian trend," TPA

Shape: 163
Type:
Designer:
Dimensions:
Price:
Comments:

Shape: 164
Type: Vase
Designer: Gates, W. D.
Dimensions: h 10″ w 5″
Price: $6
Comments: Pictured with A162 and 162. "The lines are graceful and the shapes and sizes make these designs very desirable for stem flowers." Hints, p. 5; TAP, p. 8

Shape: 165
Type: Pompeian Vase
Designer: Gates, W. D.
Dimensions: h 8″ w 4″
Price: $4
Comments: "This Pompeian vase. . .designed in lines of graceful beauty, makes a very acceptable gift, for it can be used in an endless variety of ways." Hints, p.26; TPA; TECO

Shape: 166 A
Type: Vase
Designer:
Dimensions: h 13″ w 7″
Price: $7
Comments: "This graceful piece is made in two sizes: the larger. . .gives a most pleasing effect when used as a lamp base; the smaller size. . .makes a very pretty flower holder." Hints, p. 9; TAP, p. 14

Shape: 166 B
Type:
Designer:
Dimensions:
Price:
Comments:

Shape: 166 C
Type: Vase
Designer:
Dimensions: h 6″ w 3″
Price: $1.50
Comments: ". . .makes a very pretty flower holder"; two sizes. Hints, p. 9

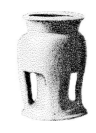

Shape: 167
Type: Lamp Base
Designer: Giannini, O.
Dimensions: h 16″ w 9″
Price: $25
Comments: no shade pictured, TAP, p. 4; "Effective lamp base," TPA

Shape: 168
Type: Mug
Designer: Gates, W. D.
Dimensions: h 3″
Price: $1.50
Comments: handle added to no. 305; TECO

Shape: 169
Type:
Designer:
Dimensions:
Price:
Comments:

Shape: 170
Type:
Designer:
Dimensions:
Price:
Comments:

Shape: 171
Type: Vase
Designer: Cady, J. K.
Dimensions: h 13″ w 8″
Price: $20
Comments: TECO

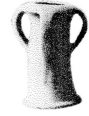

Shape: 172
Type: Vase
Designer:
Dimensions:
Price:
Comments: factory photo

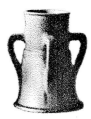

Shape: 173
Type: Vase
Designer:
Dimensions: h 13½″ w 9½″
Price:
Comments: factory photo

Shape: 174
Type:
Designer:
Dimensions:
Price:
Comments:

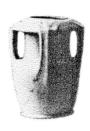

Shape: 175
Type: Vase
Designer:
Dimensions:
Price:
Comments: factory photo

Shape: 176
Type: Vase
Designer:
Dimensions:
Price:
Comments: factory photo

Shape: 177
Type: Vase
Designer: Albert, F.
Dimensions: h 22″ w 8″
Price: $25
Comments: "Decorated in relief with iris blossoms and leaves. This vase is especially suitable for long American beauty roses, chrysanthemums and other long stemmed flowers, and makes an exquisite centerpiece for dinners, receptions, etc." Hints, p. 21; Suggestions, p. 4; TAP, p. 4; "Daring in theme; banquet centerpiece," TPA; TECO

Shape: 178
Type: Hanging Vase
Designer: Clark, N. L.
Dimensions: h 5″ w 8″
Price: $8
Comments: "An entirely new departure in pottery that is as beautiful in its effect as it is useful and ornamental." Hints, p. 9

Shape: 179
Type:
Designer:
Dimensions:
Price:
Comments:

Shape: 180
Type: Jardiniere
Designer: Clark, N. L.
Dimensions: h 13″ w 17″ b 10″
Price: $8
Comments: GP

Shape: 180 A
Type: Jardiniere
Designer: Clark, N. L.
Dimensions: h 4″ w 5″
Price: $2
Comments: factory photo

Shape: 180 B
Type:
Designer:
Dimensions:
Price:
Comments:

Shape: 180 C
Type: Jardiniere
Designer: Clark, N.L.
Dimensions:
Price:
Comments:

Shape: 181
Type: Vase
Designer:
Dimensions:
Price:
Comments: factory photo

Shape: 182
Type: Vase
Designer: Albert, F. and Gates, W. D.
Dimensions: h 16″ w 8″
Price: $7
Comments: "Another of the Teco vases suitable for holding long stemmed flowers and is one of the most popular vases made. It lends itself to the effective display of flowers and foliage and adds much to their beauty." Hints, p. 22; Suggestions, p. 4; TAP, p. 6; "For American beauties," (Gates), TPA

Shape: 183
Type: Vase
Designer: Albert, F. (attr)
Dimensions:
Price:
Comments: factory photo

Shape: 184
Type: Vase
Designer: Albert, F.
Dimensions: h 9″ w 4″; h 11″ w 5″
Price: $5; $7
Comments: "Original and ornamental vase . . . plain in treatment but very restful and pleasing to the eye." Hints, p. 14

Shape: 184 A
Type: Vase
Designer: Albert, F.
Dimensions: h 14″ w 5″
Price: $7
Comments: TAP, p.4

Shape: 185
Type: Vase
Designer:
Dimensions:
Price:
Comments: factory photo

Shape: 186
Type: Vase
Designer:
Dimensions: h 9″ w 4″
Price:
Comments: factory photo

Shape: 187
Type:
Designer:
Dimensions:
Price:
Comments:

Shape: 188
Type: Vase
Designer:
Dimensions: h 16″ w 7″
Price: $10
Comments: TAP, p. 14

Shape: 189
Type:
Designer:
Dimensions:
Price:
Comments:

Shape: 190
Type:
Designer:
Dimensions:
Price:
Comments:

Shape: 191
Type: Vase
Designer: Albert, F. (attr)
Dimensions: h 10¼″ w 9″
Price:
Comments: see colorplate 24

Shape: 192
Type: Vase
Designer: Albert, F.
Dimensions: h 14″ w 7″
Price: $12
Comments: "Modelled vase with twisted iris leaves, attached at top and side. . . . Beautiful for displaying large flowers or clusters of foliage," TAP, p. 10; "Inter-woven rushes, " TPA; TECO

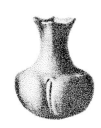

Shape: 193
Type: Vase
Designer:
Dimensions: h 14″ w 6½″
Price:
Comments: factory photo

Shape: 194
Type: Vase
Designer:
Dimensions:
Price:
Comments: factory photo

Shape: 195
Type: Vase
Designer:
Dimensions:
Price:
Comments: factory photo

Shape: 196
Type:
Designer:
Dimensions:
Price:
Comments:

Shape: 197
Type: Vase
Designer:
Dimensions: h 10½″
Price:
Comments: factory photo

Shape: 198
Type: Vase
Designer:
Dimensions: h 7″
Price: $3
Comments:

Shape: 198 A
Type: Vase
Designer:
Dimensions:
Price:
Comments: factory photo

Shape: 199
Type: Vase
Designer:
Dimensions:
Price:
Comments: factory photo

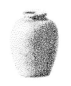

Shape: 200
Type: Vase
Designer: Gates, W. D.
Dimensions: h 4″ w 3″
Price: $1
Comments: "This dainty little vase. . .will be an acceptable gift in any home, and is especially pleasing in a boudoir, as it will harmon-ize with the most dainty furnishings." Hints, p. 23

Shape: 201
Type: Vase
Designer: Gates, W. D. (attr)
Dimensions: h 2¾″ w 2¾″
Price:
Comments: factory photo

Shape: 201 A
Type: Vase
Designer: Gates, W. D. (attr)
Dimensions:
Price:
Comments: factory photo

Shape: 202
Type: Vase
Designer: Gates, W. D.
Dimensions: h 4″ w 3″
Price:
Comments: factory photo

Shape: 203
Type:
Designer:
Dimensions:
Price:
Comments:

Shape: 207
Type:
Designer:
Dimensions:
Price:
Comments:

Shape: 211
Type: Vase
Designer: Gates, W. D.
(attr)
Dimensions:
Price:
Comments: factory photo

Shape: 215
Type:
Designer:
Dimensions:
Price:
Comments:

Shape: 219
Type:
Designer:
Dimensions:
Price:
Comments:

Shape: 204
Type:
Designer:
Dimensions:
Price:
Comments:

Shape: 208
Type: Vase
Designer: Gates, W. D.
(attr)
Dimensions: h 4″ w 4″
Price:
Comments: factory photo

Shape: 212
Type:
Designer:
Dimensions:
Price:
Comments:

Shape: 216
Type: Vase
Designer: Gates, W. D.
(attr)
Dimensions: h 3½″ w 4″
Price:
Comments: factory photo

Shape: 220
Type:
Designer:
Dimensions:
Price:
Comments:

Shape: 205
Type:
Designer:
Dimensions:
Price:
Comments:

Shape: 209
Type:
Designer:
Dimensions:
Price:
Comments:

Shape: 213
Type:
Designer:
Dimensions:
Price:
Comments:

Shape: 217
Type: Vase or Lamp Base
Designer:
Dimensions: h 16″ w 11″
Price:
Comments: Chicago
Historical Society
Collection

Shape:221
Type:
Designer:
Dimensions:
Price:
Comments:

Shape: 206
Type:
Designer:
Dimensions:
Price:
Comments:

Shape: 210
Type:
Designer:
Dimensions:
Price:
Comments:

Shape: 214
Type:
Designer:
Dimensions:
Price:
Comments:

Shape: 218
Type:
Designer:
Dimensions:
Price:
Comments:

Shape: 222
Type: Pedestal
Designer: Smith, H.
Dimensions: h 36″ w 14″
Price: $30
Comments: Shown with
vase no. 97, GP; Hints, p. 2

Shape: 222 A
Type: Pedestal
Designer: Smith, H.
Dimensions: h 26″ w 10″
Price: $20
Comments:

Shape: 226
Type: Vase
Designer: Gates, W. D.
(attr)
Dimensions: h 4″ w 4¼″
Price:
Comments: factory photo

Shape: 230
Type:
Designer:
Dimensions:
Price:
Comments:

Shape: 234
Type:
Designer:
Dimensions:
Price:
Comments:

Shape: 238
Type:
Designer:
Dimensions:
Price:
Comments:

Shape: 223
Type: Vase or Lamp Base
Designer:
Dimensions: h 14″ w 8″
Price: $12
Comments: TAP, p. 8

Shape: 227
Type:
Designer:
Dimensions:
Price:
Comments:

Shape: 231
Type:
Designer:
Dimensions:
Price:
Comments:

Shape: 235
Type:
Designer:
Dimensions:
Price:
Comments:

Shape: 239
Type:
Designer:
Dimensions:
Price:
Comments:

Shape: 224
Type:
Designer:
Dimensions:
Price:
Comments:

Shape: 228
Type:
Designer:
Dimensions:
Price:
Comments:

Shape: 232
Type:
Designer:
Dimensions:
Price:
Comments:

Shape: 236
Type:
Designer:
Dimensions:
Price:
Comments:

Shape: 240
Type:
Designer:
Dimensions:
Price:
Comments:

Shape: 225
Type:
Designer:
Dimensions:
Price:
Comments:

Shape: 229
Type:
Designer:
Dimensions:
Price:
Comments:

Shape: 233
Type: Vase
Designer: Albert, F.
Dimensions: h 5″ w 4½″
Price: $1.50
Comments: "A delightful
little vase. . .which is useful
as well as very beautiful."
Hints, p. 26; Suggestions,
p. 8; TPA; TECO

Shape: 237
Type:
Designer:
Dimensions:
Price:
Comments:

Shape: 241
Type:
Designer:
Dimensions:
Price:
Comments:

Shape: 242
Type:
Designer:
Dimensions:
Price:
Comments:

Shape: 246
Type:
Designer:
Dimensions:
Price:
Comments:

Shape: 250
Type: Vase or Lamp Base
Designer: Gates, W. D.
Dimensions: h 9″ w 10″
Price: $5
Comments: "This classic vase . . . makes a pleasing and appropriate gift because of its combined beauty and usefulness as lamp base." Hints, p. 25; TAP, p. 8; TPA

Shape: 252 A
Type: Vase or Lamp Base
Designer: Garden, Hugh M. G.
Dimensions: h 17½″
Price:
Comments:

Shape: 255 A
Type: Planter
Designer: Gates, W. D.
Dimensions: h 13″ w 20″
Price: $15
Comments: "For potted trees, ferns, etc," GP; TECO

Shape: 243
Type: Jardiniere
Designer: Gates, W. D.
Dimensions: h 13″ w 15″
Price: $5
Comments: GP

Shape: 247
Type:
Designer:
Dimensions:
Price:
Comments:

Shape: 253
Type: Jardiniere
Designer: Garden, Hugh M. G.
Dimensions: h 4″ w 8″
Price: $5; porous pot to fit, $1.
Comments: "Jardiniere . . . with design modelled in relief. A charming piece for ferns or potted plants." Hints, p. 16. Suggestions, p. 7; TAP, p.12

Shape: 255 B
Type: Planter
Designer: Gates, W. D.
Dimensions: h 14″ w 22″
Price: $20/22
Comments:

Shape: 248
Type: Vase
Designer: Gates, W. D.
Dimensions: h 6″
Price: $2
Comments: TECO

Shape: 251
Type: Vase or Lamp Base
Designer: Gates, W. D. (attr)
Dimensions: h 17″ w 10″
Price: $15
Comments: TAP, p. 8

Shape: 244
Type:
Designer:
Dimensions:
Price:
Comments:

Shape: 252
Type: Vase or Lamp Base
Designer: Garden, Hugh M. G.
Dimensions: h 12″
Price: $8
Comments: "Very chaste in design. A great favorite." Hints, p. 25; Suggestions, p. 9; TPA; TECO. Made in two sizes

Shape: 254
Type: Vase
Designer:
Dimensions:
Price:
Comments: factory photo

Shape: 255 C
Type: Planter
Designer: Gates, W. D.
Dimensions: h 16″ w 25″
Price: $30
Comments:

Shape: 245
Type:
Designer:
Dimensions:
Price:
Comments:

Shape: 249
Type:
Designer:
Dimensions:
Price:
Comments:

Shape: 255 D
Type: Planter
Designer: Gates, W. D.
Dimensions: h 18″ w 28″
Price: $38
Comments:

Shape: 256
Type:
Designer:
Dimensions:
Price:
Comments:

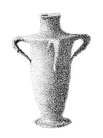

Shape: 260
Type: Vase
Designer:
Dimensions: h 13″ w 3″
Price: $12
Comments: TAP, p. 4

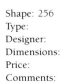

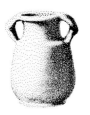

Shape: 257
Type: Vase or Lamp Base
Designer:
Dimensions: h 9″ w 9″
Price: $12
Comments: TAP, p. 6

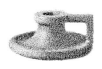

Shape: 258
Type: Candlestick
Designer: Gates, W. D.
Dimensions: h 2″
Price: $2
Comments: TECO

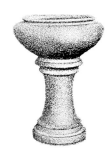

Shape: 261
Type: Vase
Designer:
Dimensions: h 16″
Price:
Comments: factory photo

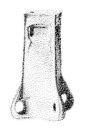

Shape: 259
Type: Vase
Designer: Hals, H.
Dimensions: h 13″ w 4″
Price: $15
Comments: TAP, p. 6;
TECO

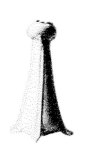

Shape: 262
Type: Vase
Designer: White, M. P.
Dimensions: h 19″ w 3″
Price: $15
Comments: "Combines the useful with the decorative in a high degree. This piece is particularly recommended for chrysanthemums. Also makes a beautiful electrolier." Hints, p. 10; TAP, p. 10; TPA; TECO

Shape: 262 A
Type: Vase
Designer: White, M. P.
Dimensions:
Price:
Comments:

Shape: 263
Type: Garden Pedestal
Designer: Gates, W. D.
Dimensions: h 24″ w 14″ b 16″
Price: $20
Comments: GP

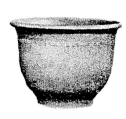

Shape: 264
Type: Jardiniere
Designer: Gates, W. D.
Dimensions: h 15″ w 19″ b 10″
Price: $10
Comments: GP

Shape: 265
Type: Vase
Designer: Dunning, Max
Dimensions: h 12″ w 5″
Price: $12
Comments: "On account of its shape and the character of its design it is especially adapted for rooms with Mission furnishings, such as library, den or office." Hints, p. 22; TAP, p. 6; TPA

Shape: 268
Type: Vase
Designer: Mundie, W. B. (attr)
Dimensions: h 11″ w 12″
Price: $12
Comments: TAP, p. 8

Shape: 266
Type: Vase
Designer: Mundie, W. B.
Dimensions: h 11″ w 5″
Price: $6
Comments: "Very original and effective for decorative purposes and arranging flowers." Hints, p.22; Suggestions, p. 7; TAP, p. 6; "Modified classical," TPA; TECO

Shape: 269
Type: Vase
Designer: Mundie, W. B.
Dimensions: h 11″ w 4″
Price: $8
Comments: ". . .noticeable for its originality." Hints, p. 22; Suggestions, p. 6; TAP, p. 10; "Full of creative feeling," TPA

Shape: 270
Type: Vase or Lamp
Designer: Mundie, W. B.
Dimensions: h 8″ w 9″
Price: $8
Comments: TAP, p. 6

Shape: 267
Type: Vase
Designer: Mundie, W. B.
Dimensions: h 9″ w 7″
Price: $10
Comments: TAP, p.10; TPA

Shape: 270 A
Type: Cigar Holder with Cover
Designer: Mundie, W. B.
Dimensions: h 7″ w 7″
Price: $10
Comments: "A useful and appropriate gift for the man who smokes." Hints, p. 4; TAP, p. 10; TPA; see fig. 70

Shape: 271
Type: Jardiniere or Lamp Base
Designer: Mundie, W. B.
Dimensions: h 7″ w 10″
Price: $10
Comments: "The classic beauty of this jardiniere... is its own commendation. The many uses to which it can be put are readily apparent." Hints, p. 12; TAP, p. 10; TPA

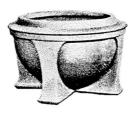

Shape: 271 A
Type: Jardiniere
Designer: Mundie, W. B.
Dimensions: h 19″ w 28″ b 26″
Price: $30
Comments: GP

Shape: 272
Type: Vase
Designer: Mundie, W. B. (after design by)
Dimensions: h 6″ w 10″
Price: $8
Comments: "This charming vase...will be found very useful for short stemmed flowers, such as violets, lily of the valley, etc. and the wide base and narrow top will allow of a very graceful display of such flowers." Hints, p. 21; TAP, p. 12

Shape: 273
Type: Vase
Designer: Mundie, W. B.
Dimensions: h 14″ w 8″
Price: $15
Comments: "This graceful vase with its heavy base and long stem makes a most artistic decorative piece...can always be used appropriately for long stemmed flowers." Hints, p. 16; TAP, p. 6

Shape: 274
Type: Vase
Designer:
Dimensions:
Price:
Comments: factory photo

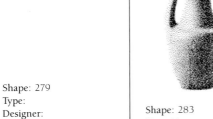

Shape: 275
Type: Vase
Designer: Gates, W. D.
Dimensions: w 3″
Price: 50 cents
Comments: TECO

Shape: 276
Type:
Designer:
Dimensions:
Price:
Comments:

Shape: 277
Type:
Designer:
Dimensions:
Price:
Comments:

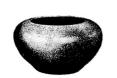

Shape: 278
Type: Vase or Lamp Base
Designer: Gates, W. D.
Dimensions: h 6″
Price: $6
Comments: TECO

Shape: 279
Type:
Designer:
Dimensions:
Price:
Comments:

Shape: 280
Type:
Designer:
Dimensions:
Price:
Comments:

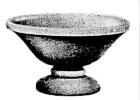

Shape: 281
Type: Jardiniere
Designer: Gates, W. D.
Dimensions: h 16″ w 24″ b 13″
Price: $15
Comments: GP

Shape: 282
Type: Jardiniere
Designer: Gates, W. D.
Dimensions: h 14″ w 24″ b 12″
Price: $14.50
Comments: GP

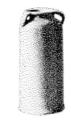

Shape: 283
Type: Vase
Designer: Albert, F.
Dimensions: h 9″
Price: $5
Comments: "Classical Pompeian in style and particularly effective for mantel, den or book shelf." Hints, p. 8; Suggestions, p. 6; TPA

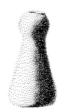

Shape: 284
Type: Vase
Designer: Mundie, W. B.
Dimensions: h 11″ w 5″
Price: $7
Comments: "Beautiful three handled vase... suitable for its plain decorative effect or for long stemmed flowers." Hints, p. 14; TPA

Shape: 285
Type: Egyptian Vase
Designer: Mundie, W. B.
Dimensions: h 9″ w 4″
Price: $3
Comments: "One of the chief beauties of Teco Pottery is the charm given to the most severe patterns by the soft green color of the Teco finish." Hints, p. 26; TAP, p. 12

Shape: 286
Type: Vase
Designer: Mundie, W. B. (attr)
Dimensions: h 13″ w 6½″
Price:
Comments: factory photo; illustrated *World's Work* (Aug. 1904), p. 5217

Shape: 288
Type: Vase or Lamp Base
Designer: Mundie, W. B.
Dimensions: h 8″ w 8″
Price: $10
Comments: "A vase. . .which illustrates the versatility of this well-known artist. Also suitable for lamp base." Hints, p. 22; TAP, p. 12

Shape: 291 B
Type: Low Bowl or Planter
Designer:
Dimensions:
Price:
Comments: factory photo; size variation of 291 A

Shape: 294
Type: Pitcher
Designer: Gates, W. D.
Dimensions: h 9″ w 4″
Price: $6
Comments: "A pitcher which has attracted wide attention. A pleasing piece for the dining room, plate rack or shelf." Hints, p. 26; Suggestions, p. 6; TAP, p. 10; TPA; TECO

Shape: 297
Type: Vase
Designer: Forester, N.
Dimensions: h 5″ w 8″
Price: $6
Comments: "A Grecian shape and a great favorite." Hints, p. 24; Suggestions, p. 10; TAP, p. 12; "Hellenic vase," TPA; TECO

Shape: 287
Type: Vase or Lamp Base
Designer: Mundie, W. B.
Dimensions: h 7″ w 5″
Price: $5
Comments: "It is one of the most artistic effects in Teco pottery, and especially suitable for decorative purposes. Made in two sizes." Hints, p. 16; Suggestions, p. 10; TAP, p. 12; TPA

Shape: 289
Type: Candlestick
Designer: Gates, W. D.
Dimensions: h 7″ w 6″
Price: $4
Comments: Suggestions, p. 10; TAP, p. 14; TPA; TECO

Shape: 292
Type:
Designer:
Dimensions:
Price:
Comments:

Shape: 295
Type: Garden Urn
Designer: Clark, N. L.
Dimensions: h 24″ w 20″ b 11″
Price: $20
Comments: GP

Shape: 297 A
Type: Vase
Designer: Forester, N.
Dimensions: h 5″ w 8″
Price:
Comments: factory photo; No. 297 with four handles

Shape: 293
Type: Vase
Designer: Hirschfeld, R. A.
Dimensions: h 12″ w 5″
Price: $12
Comments: Cattail flag design. The decorative treatment of the piece is in itself restful to the eye, and its many practical uses make it a most desirable selection." Hints, p. 8; TAP, p. 10; "Cattails and rushes," TPA

Shape: 290
Type:
Designer:
Dimensions:
Price:
Comments:

Shape: 287 A
Type: Vase or Lamp Base
Designer: Mundie, W. B.
Dimensions: h 13″ w 11″
Price: $20
Comments:

Shape: 296
Type: Jardiniere
Designer: Clark, N. L.
Dimensions: h 28″ w 30″ b 20″
Price: $35
Comments: GP

Shape: 298
Type: Mug
Designer:
Dimensions: h 6″ w 5″
Price:
Comments: factory photo

Shape: 291 A
Type: Low Bowl or Planter
Designer:
Dimensions: h 1½″ w 7″
Price:
Comments: factory photo

Shape: 299
Type:
Designer:
Dimensions:
Price:
Comments:

Shape: 300
Type: Bird Bath
Designer: Gates, W. D.
Dimensions: h 39″ w 29″
b 26″
Price: $40
Comments: buff terra cotta.
GP; TECO

Shape: 304
Type: Jardiniere
Designer: Dorr, J. I.
Dimensions: h 17″ w 24″
b 20″
Price: $22.50
Comments: GP; initials
misprinted in catalogue as
"A. L."

Shape: 308
Type:
Designer:
Dimensions:
Price:
Comments:

Shape: 311
Type:
Designer:
Dimensions:
Price:
Comments:

Shape: 314
Type: Greek Pitcher
Designer: Albert, F.
Dimensions: h 12″ w 3″
Price: $8
Comments: "This stately
Greek pitcher. . . has a
charming distinctiveness of
pattern that cannot fail to
please. The chaste beauty of
its lines commend it for
decorative purposes as well
as for its usefulness." Hints,
p. 6

Shape: 301
Type:
Designer:
Dimensions:
Price:
Comments:

Shape: 305
Type: Vase
Designer: Gates, W. D.
Dimensions: h 4½″ w 2½″
Price:
Comments: factory photo;
see No. OSM

Shape: 309
Type: Flower Bowl
Designer: Albert, F. (attr)
Dimensions: h 2″ w 9″
Price: $6
Comments: "An orna-
mental decorative piece
. . .that is a favorite
wherever it is shown.
Suitable for centerpieces or
for acqueous plants and
bulbs." Hints, p. 10; TPA;
exhibited Chicago Architec-
tural Club, 1908; TECO

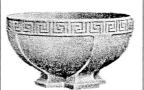

Shape: 312
Type: Garden Urn
Designer: Gates, W. D.
Dimensions: h 13″ w 20″
b 11″
Price: $15
Comments: GP

Shape: 302
Type:
Designer:
Dimensions:
Price:
Comments:

Shape: 303
Type: Jardiniere
Designer: Gates, W. D.
Dimensions: h 7″ w 16″
b 7″
Price: $5.50
Comments: GP

Shape: 306
Type: Pitcher
Designer: Gates, W. D.
(attr)
Dimensions:
Price:
Comments: factory photo

Shape: 307
Type: Tray
Designer: Gates, W. D.
(attr)
Dimensions:
Price:
Comments: factory photo

Shape: 310
Type: Vase
Designer: Albert, F.
Dimensions: h 18″ w 6″
Price: $15
Comments: "This piece
can be used for decorative
purposes either with or
without flowers." Hints,
p. 4; TPA

Shape: 313
Type: Vase
Designer: Albert, F.
Dimensions: h 16″
Price: $15
Comments: "A represen-
tation of an ear of corn . . .
a very effective piece for
decorative purposes. This is
one of the newer pieces of
Teco which has received
the highest praise of
pottery connoisseurs, and
is very popular."
Suggestions, p. 5

Shape: 315
Type: Flower Bowl
Designer: Albert, F.
Dimensions:
Price: $4
Comments:

Shape: 316
Type:
Designer:
Dimensions:
Price:
Comments:

Shape: 317
Type: Flower Bowl
Designer: Albert, F.
Dimensions: h 2″ w 8″
Price:
Comments: A very pretty flower bowl . . . an exceedingly effective piece for such flower as sweet peas, pansies, etc." Hints, p. 25

Shape: 321
Type:
Designer:
Dimensions:
Price:
Comments:

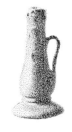

Shape: 325
Type: Candlestick
Designer: Albert, F. (attr)
Dimensions:
Price:
Comments: factory photo

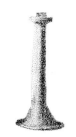

Shape: 327
Type: Candlestick
Designer: Gates, W. D.
Dimensions: h 16″ b 6″
Price: $7
Comments: "This graceful candlestick . . . can be fitted with electric globe and shade if desired." Hints, p. 18; TPA. Also found with silver overlay and applied frog crawling up stem

Shape: 329
Type: Vase
Designer: Wright, F. L.
Dimensions: h 23⅜″ w 11⅛″
Price:
Comments: designed for Susan Lawrence Dana residence, Springfield, Illinois

Shape: 318
Type: Vase
Designer: Albert, F. (attr)
Dimensions:
Price:
Comments: factory photo

Shape: 322
Type:
Designer:
Dimensions:
Price:
Comments:

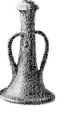

Shape: 326
Type: Candlestick
Designer: Albert, F.
Dimensions: h 9″ x b 5″
Price: $8
Comments: "The two handles contribute largely to the effectiveness of this piece for decorative uses." Hints, p. 6; TPA

Shape: 327 A
Type: Candlestick
Designer: Gates, W. D.
Dimensions:
Price:
Comments:

Shape: 330
Type: Triplicate Vase
Designer: Wright, F. L.
Dimensions: h 32″
Price: $30
Comments: TPA; exhibited at The Art Institute of Chicago in 1907

Shape: 319
Type: Vase
Designer: Albert, F.
Dimensions: h 6½″ w 9″
Price:
Comments: original paper label; leaves applied to no. 318

Shape: 323
Type: Vase
Designer:
Dimensions: h 8½″ w 7½″
Price:
Comments: private collection

Shape: 326 A
Type: Candlestick
Designer: Albert, F.
Dimensions: h 16″ b 6″
Price:
Comments: no. 326 with modified top

Shape: 328
Type:
Designer:
Dimensions:
Price:
Comments:

Shape: 331
Type: Vase
Designer: Wright, F. L.
Dimensions: h 26″ w 14″
Price:
Comments: designed for Unity Temple, Oak Park, Illinois

Shape: 320
Type:
Designer:
Dimensions:
Price:
Comments:

Shape: 324
Type:
Designer:
Dimensions:
Price:
Comments:

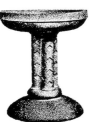

Shape: 332
Type: Bird Bath
Designer: Gates, W. D.
Dimensions: h 35″ w 29″
b 26″
Price: $35
Comments: GP

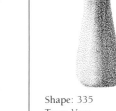

Shape: 335
Type: Vase
Designer: Albert, F.
Dimensions: h 12″ w 5″
Price: $6
Comments: "A decorative
and useful vase, following a
unique design." Hints,
p. 20; "For Mission
interior," TPA

Shape: 338
Type: Planter
Designer: Gates, W. D.
Dimensions: h 21″ w 20″
Price: $25
Comments: red terra cotta;
GP; TECO

Shape: 339 A
Type: Vase
Designer: Mundie, W. B.
Dimensions:
Price:
Comments: factory photo

Shape: 343
Type:
Designer:
Dimensions:
Price:
Comments:

Shape: 333
Type: Jardiniere
Designer: Gates, W. D.
Dimensions: h 13″ w 12″
Price: $8
Comments: GP

Shape: 336
Type: Vase
Designer: Albert, F.
Dimensions: h 8″ w 4″
Price: $4
Comments: "Especially
intended for daisies,
goldenrod, asters, etc., the
variegated colors of the
flowers contrasting
pleasingly with the
beautiful Teco green." Hints,
p. 20; TPA; shown in color,
TECO

Shape: 339
Type: Garden Urn
Designer: Schneider, K.
Dimensions: h 25″ w 37″
b 14″
Price: $50
Comments: GP

Shape: 340
Type: Bowl
Designer: Mundie, W. B.
Dimensions: h 2″ w 10″
Price: $6
Comments: "Artistic bowl
with unique base. May be
used for holding fruit, such
as apples, pears, etc." Hints,
p. 20; TPA; TECO

Shape: 344
Type:
Designer:
Dimensions:
Price:
Comments:

Shape: 334
Type: Flower Bowl
Designer: Albert, F.
Dimensions: h 3″ w 8″
Price: $4
Comments: "Flower bowl
with slight suggestion of
ornamentation. The many
charming ways in which
bowls of this description
can be used in the home
make this piece very
popular." Hints, p. 21

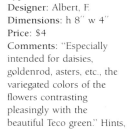

Shape: 337
Type: Jardiniere
Designer: Gates, W. D.
Dimensions: h 16″ w 16″
Price: $12
Comments: GP

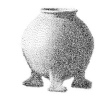

Shape: 339
Type: Vase or Lamp Base
Designer: Mundie, W. B.
Dimensions: h 10″ w 12″
Price: $15
Comments: "The strength
and treatment of this
beautiful piece of Teco
pottery illustrates the
beauty of form that is so
pronounced in the designs
by W. D.(sic) Mundie. It
also makes a very pretty
lamp base." Hints, p. 20;
"Very striking as lamp
base," TPA

Shape: 341
Type: Flower Bowl
Designer:
Dimensions:
Price:
Comments: factory photo

Shape: 342
Type:
Designer:
Dimensions:
Price:
Comments:

Shape: 345
Type:
Designer:
Dimensions:
Price:
Comments:

Shape: 346
Type: Conception of Pan
Designer: Albert, F.
Dimensions: h 77″
Price: $450
Comments: "Bust and
pedestal in one piece," TPA

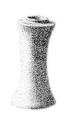

Shape: 347
Type: Vase
Designer: Gates, W. D.
Dimensions: h 7″ w 3″
Price: $3
Comments: "Another severely plain vase: very graceful in contour." Hints, p. 26; "Beauty in severity," TPA

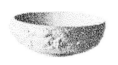

Shape: 348
Type: Punch Bowl
Designer: Albert, F.
Dimensions: h 5″ w 14″
Price: $20
Comments: "One of the most ornate pieces yet produced in Teco Pottery." Hints, p. 28; TPA

Shape: 349
Type: Flower Bowl (with clay liner)
Dimensions: h 3″ w 11″ d 11″
Price:
Comments: factory photo

Shape: 350
Type: Flower Bowl
Designer: Gates, W. D.
Dimensions: h 1″ diam 4″
Price: 50 cents
Comments: "Little flower bowl." Hints, p. 7; see OSM; TECO

Shape: 351
Type: Pansy Bowl or Saucer
Designer: Gates, W. D.
Dimensions: h 1″ w 5″
Price: 75 cents
Comments: Hints, p. 18; TPA

Shape: 352
Type: Tray
Designer: Gates, W. D.
Dimensions: w 9″
Price:
Comments: factory photo; see OSM

Shape: 353
Type:
Designer:
Dimensions:
Price:
Comments:

Shape: 354
Type: Jar
Designer: Gates, W. D.
Dimensions: h 3½″ diam 3″
Price: $1
Comments: "The severe plainness of this jar makes it very effective for decorative purposes. The plain surface of the piece brings out the rich Teco green most pleasingly." Hints, p. 24

Shape: 355
Type: Cigar Holder with Cover
Designer: Gates, W. D.
Dimensions: h 4″ diam 4″
Price: $4
Comments: "Teco Pottery makes an ideal receptacle for cigars for it keeps them cool and fresh. This particular design will be the most effective decoration for either the den or office." Hints, p. 18; "For the master's cigars," TPA

Shape: 356
Type: Vase
Designer: Gates, W. D.
Dimensions: h 3″ w 3″
Price: $1
Comments: "A pretty and useful flower vase of odd design. This piece shows the beauty of the classic lines and deep moss green color of the Teco pottery most pleasingly. It has a charm distinctly its own." Hints, p.11; TPA

Shape: 357
Type: Vase
Designer: Gates, W. D.
Dimensions: h 4″
Price: $1
Comments: shown in color, TECO

Shape: 358
Type: Vase
Designer: Gates, W. D.
Dimensions: h 4″ w 3″
Price: $1
Comments: "The vase can be used in a variety of ways and is a pleasing decoration of itself." Hints, p. 15

Shape: 359
Type: Vase
Designer: Gates, W. D.
Dimensions: h 4″ w 3″
Price: $1
Comments: "One of the chief beauties of Teco Pottery is the many variations in shapes. This vase. . .shows the classical Greek treatment. Its simple beauty will commend it." Hints, p. 22; TPA

Shape: 360
Type: Vase
Designer: Gates, W. D. (attr)
Dimensions: h 4½″ w 4″
Price:
Comments: factory photo

Shape: 360 A
Type: Vase
Designer: Gates, W. D. (attr)
Dimensions: h 4½″ w 4″
Price:
Comments: factory photo; no. 360 with thumbprints

Shape: 361
Type: Vase
Designer: Gates, W. D.
Dimensions: h 4″
Price: $1
Comments: TECO

Shape: 362
Type: Vase
Designer: Gates, W. D.
Dimensions: h 4″ w 3″
Price: $1
Comments: "Among the many pleasing Teco shapes this design. . .possesses distinct advantages both for decorative purposes and for its usefulness. It will display a small bouquet of flowers very pleasingly as the oval shape of the flowers will conform in outline to the oval of the base." Hints, p. 27

Shape: 363
Type: Vase
Designer: Gates, W. D. (attr)
Dimensions: h 5″ w 4″
Price:
Comments: factory photo

Shape: 364
Type: Vase
Designer: Gates, W. D.
Dimensions: h 5″ w 4″
Price: $1.50
Comments: "The ribbed effect in this design . . . makes pleasing variation from the perfectly plain pattern. This vase on account of its perfectly straight sides will lend itself to almost endless uses, and will therefore make a very acceptable gift." Hints, p. 17; TPA

Shape: 365
Type: Vase
Designer: Gates, W. D.
Dimensions: h 4″
Price: $1
Comments: TECO

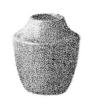

Shape: 366
Type: Vase
Designer: Gates, W. D. (after design by)
Dimensions: h 4″ w 4″
Price: $1
Comments: "Its shape is distinctly different from the usual pottery effects." Hints, p. 18

Shape: 367
Type: Pompeian Flower Vase
Designer: Gates, W. D.
Dimensions: h 5″ w 5″
Price: $3
Comments: "This vase is very effective for lilies of the valley, nasturtiums, etc. and when filled with them will give a very dainty effect to the breakfast table." Hints, p. 24

Shape: 368
Type: Vase
Designer: Gates, W. D.
Dimensions: h 2″ w 2″
Price: 50 cents
Comments: "This little gem . . . makes a unique and useful gift at a modest cost." Hints, p. 19

Shape: 369 A
Type: Bowl
Designer: Gates, W. D.
Dimensions: h 2″ w 3″
Price: $1
Comments: "This beautiful bowl is made in three sizes. The surface has a corrugated effect that is decidedly artistic. The many uses of this bowl will readily suggest themselves." Hints, p. 24; TECO

Shape: 369 B
Type: Bowl
Designer: Gates, W. D.
Dimensions: h 3″ w 4½″
Price: $2
Comments:

Shape: 369 C
Type: Bowl
Designer: Gates, W. D.
Dimensions: h 4″ w 7″
Price: $4
Comments:

Shape: 370
Type: Vase
Designer: Gates, W. D. (after design by)
Dimensions: h 4″ w 4″
Price: $2
Comments: "Commended for its simplicity. It makes a very handsome decoration when filled with short stemmed flowers." Hints, p. 12; TPA

Shape: 371
Type: Centerpiece
Designer: Gates, W. D.
Dimensions: h 1½″ w 7″
Price: $2
Comments: "Severely plain centerpiece." Hints, p. 17

Shape: 372
Type: Centerpiece
Designer: Gates, W. D.
Dimensions: h 2″ w 10″
Price: $4
Comments: Hints, p. 17

Shape: 373
Type:
Designer:
Dimensions:
Price:
Comments:

Shape: 374
Type: Vase
Designer: Gates, W. D.
Dimensions: h 7″
Price: $3.50
Comments: TECO

Shape: 375
Type: Vase
Designer: Gates, W. D.
Dimensions: h 10″
Price: $4
Comments: TECO

Shape: 376
Type: Ornamental Flower Tub
Designer: Fellows, W. K.
Dimensions: h 4″ w 7″
Price: $7; clay liner $1 extra
Comments: "Can be had with or without porous clay lining." Hints, p. 9; TECO

Shape: 377
Type: Vase
Designer: Gates, W. D.
Dimensions: h 13″
Price: $10
Comments: TECO

Shape: 378
Type: Safety Match Holder
Designer: Fellows, W. K.
Dimensions: h 4″ w 5″
Price: $3
Comments: "One of the rare things in Teco pottery." Hints, p. 25; TPA

Shape: 379
Type: Vase
Designer:
Dimensions:
Price:
Comments: private collection

Shape: 380
Type:
Designer:
Dimensions:
Price:
Comments:

Shape: 381
Type:
Designer:
Dimensions:
Price:
Comments:

Shape: 382
Type:
Designer:
Dimensions:
Price:
Comments:

Shape: 383
Type: Flower Bowl
Designer:
Dimensions:
Price:
Comments: factory photo

Shape: 384
Type: Match Box
Designer: Clark, N. L.
Dimensions: h 2″ w 4″ l 3″
Price: $3
Comments: "The graceful lines of this box make it a pleasing decoration for almost any room, and its usefulness is apparent." Hints, p. 18

Shape: 385
Type: Match Box
Designer: Clark, N. L. (attr)
Dimensions: h 2″ w 3″ l 3½″
Price:
Comments: factory photo

Shape: 386
Type: Ring Holder
Designer: Gates, W. D. (attr)
Dimensions: h 3″ w 3¾″
Price:
Comments: factory photo; see EXY

Shape: 387
Type: Covered Round Box
Designer: Gates, W. D.
Dimensions: h 2″ w 4″
Price:
Comments: factory photo; see EXY

Shape: 388
Type: Wall Pocket (Basket)
Designer: Clark, N. L.
Dimensions: h 8″ w 5″
Price: $3
Comments: "This basket can be fastened to the wall with a screw or nail and will hold any creeping vines or running flowers that grow in water. It makes a very pretty decorative effect for interiors, conservatories and porches." Hints, p. 13

Shape: 389
Type: Oval Dish
Designer: Gates, W. D.
Dimensions: h 5″ w 2″
Price:
Comments: factory photo; see EXY

Shape: 390
Type: Oblong Tray
Designer: Gates, W. D.
Dimensions: w 10″ l 15″
Price:
Comments: factory photo; see EXY

Shape: 391
Type:
Designer:
Dimensions:
Price:
Comments:

Shape: 392
Type: Vase
Designer: Gates, W. D.
Dimensions: h 7″
Price: $2
Comments: TECO

Shape: 393
Type: Oblong Tray
Designer: Gates, W. D.
Dimensions: w 3″ l 10″
Price:
Comments: factory photo; see EXY

Shape: 394
Type:
Designer:
Dimensions:
Price:
Comments:

Shape: 395
Type:
Designer:
Dimensions:
Price:
Comments:

Shape: 396
Type:
Designer:
Dimensions:
Price:
Comments:

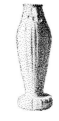

Shape: 397
Type: Vase
Designer:
Dimensions: h 13½″ w 5″
Price:
Comments: factory photo

Shape: 398
Type:
Designer:
Dimensions:
Price:
Comments:

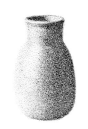

Shape: 399
Type: Vase
Designer: Gates, W. D. (attr)
Dimensions: h 7″ w 4″
Price:
Comments: factory photo

Shape: 399 A
Type: Vase
Designer: Gates, W. D.
Dimensions: h 7″ w 4″
Price:
Comments: paper label lists designer

Shape: 400
Type: Roman Salad Bowl
Designer: Smith, Holmes
Dimensions: h 5″ w 11″
Price: $10
Comments: "The classic severity of the design is relieved by the pleasing tone of the Teco green." Hints, p. 28; TPA

Shape: 401
Type:
Designer:
Dimensions:
Price:
Comments:

Shape: 402
Type: Vase
Designer: Gates, W. D. (attr)
Dimensions: h 7″
Price:
Comments: factory photo

Shape: 402 A
Type: Vase
Designer: Gates, W. D. (attr)
Dimensions: h 7″
Price:
Comments: no. 402 with two handles

Shape: 403
Type: Vase
Designer: Gates, W. D.
Dimensions: h 8″ w 6″
Price:
Comments: factory photo

Shape: 403 A
Type: Vase
Designer: Gates, W. D.
Dimensions: h 8″
Price: $6
Comments: no. 403 with four handles instead of two; shown in color, TECO

Shape: 404
Type: Vase
Designer: Gates, W. D. (attr)
Dimensions: h 7½″
Price:
Comments: factory photo

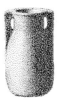

Shape: 405
Type: Vase
Designer: Gates, W. D.
Dimensions: h 7″
Price: $2.50
Comments: TECO

Shape: 406
Type: Jardiniere
Designer: Gates, W. D.
Dimensions: h 15″ w 22″ b 11″
Price: $10
Comments: GP

Shape: 407
Type: Vase
Designer: Gates, W. D. (attr)
Dimensions: h 9″ w 4″
Price:
Comments: factory photo; see no. 429

Shape: 408
Type: Vase
Designer:
Dimensions: h 10″ w 5″
Price:
Comments: factory photo

Shape: 408
Type: Vase
Designer: Moreau, F.
Dimensions: h 17¼″ w 6¾″
Price:
Comments: see colorplate 5

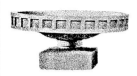

Shape: 409
Type: Garden Urn
Designer: Dorr, J. I.
Dimensions: h 13″ w 27″
b 12″
Price: $16
Comments: GP

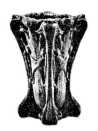

Shape: 409
Type: Vase
Designer: Moreau, F.
Dimensions: h 12½″ w 7½″
Price:
Comments: private
collection

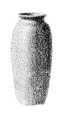

Shape: 410
Type: Vase
Designer:
Dimensions:
Price:
Comments: factory photo

Shape: 411
Type: Vase
Designer: Gates, W. D.
(attr)
Dimensions:
Price:
Comments: factory photo

Shape: 411 A
Type: Vase
Designer: Gates, W. D.
(attr)
Price:
Comments: factory photo;
handles added top of
no. 411

Shape: 412
Type: Vase
Designer: Gates, W. D.
(attr)
Dimensions: h 6½″
Price:
Comments: factory photo

Shape: 412 A
Type: Vase
Designer: Gates, W. D.
(attr)
Dimensions: h 6½″
Price:
Comments: factory photo;
no. 412 with four handles

Shape: 413
Type: Planter
Designer: Nimmons, Geo. C.
Dimensions: h 7″ w 9″
l 36″
Price: $25
Comments: GP

Shape: 414
Type:
Designer:
Dimensions:
Price:
Comments:

Shape: 415
Type:
Designer:
Dimensions:
Price:
Comments:

Shape: 416
Type: Vase
Designer: Gates, W. D.
(attr)
Dimensions:
Price:
Comments: factory photo

Shape: 417
Type: Vase
Designer: Gates, W. D.
(attr)
Dimensions:
Price:
Comments: factory photo

Shape: 418
Type: Vase
Designer: Cady, J. K.
Dimensions: h 11″
Price: $20
Comments: "Graceful
virility," TPA; TECO

Shape: 418 A
Type: Vase
Designer: Cady, J. K.
Dimensions:
Price:
Comments:

Shape: 419
Type:
Designer:
Dimensions:
Price:
Comments:

Shape: 420
Type: Vase
Designer: Moreau, F.
Dimensions: h 14″
Price: $10
Comments: TECO

Shape: 421
Type:
Designer:
Dimensions:
Price:
Comments:

Shape: 422
Type: Vase
Designer:
Dimensions: h 6″ w 2½″
Price:
Comments: factory photo

Shape: 423
Type: Vase
Designer: Moreau, F.
Dimensions: h 12″
Price: $10
Comments: TECO

Shape: 427
Type: Vase
Designer: Gates, W. D.
(attr)
Dimensions: h 5″ w 3″
Price:
Comments: factory photo

Shape: 429
Type: Vase
Designer: Gates, W. D.
Dimensions: h 8″
Price: $3
Comments: TECO

Shape: 432
Type: Vase
Designer: Gates, W. D.
Dimensions: h 12″
Price: $5
Comments: TECO

Shape: 435
Type: Vase
Designer: Gates, W. D.
Dimensions: h 7″
Price: $3
Comments: TECO

Shape: 424
Type:
Designer:
Dimensions:
Price:
Comments:

Shape: 428
Type: Vase
Designer: Gates, W. D.
(attr)
Dimensions: h 5″ w 3″
Price:
Comments: factory photo

Shape: 430
Type:
Designer:
Dimensions:
Price:
Comments:

Shape: 433
Type: Vase
Designer: Gates, W. D.
(attr)
Dimensions: h 7″ w 4½″
Price:
Comments: factory photo

Shape: 435 A
Type: Vase
Designer: Gates, W. D.
Dimensions: h 7″
Price:
Comments: factory photo;
no. 435 with four handles

Shape: 425
Type: Vase
Designer: Gates, W. D.
Dimensions: h 4″
Price: $1
Comments: factory photo
has nos. 425 and 440;
TECO

Shape: 428 A
Type: Vase
Designer: Gates, W. D.
Dimensions: h 6″
Price: $1.75
Comments: no. 428 with
four handles instead of two;
TECO

Shape: 431
Type: Vase
Designer: Gates, W. D.
Dimensions: h 10″ w 4″
Price: $5
Comments: TECO

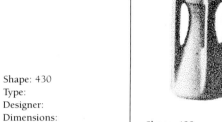

Shape: 434
Type: Vase
Designer: Moreau, F. (attr)
Dimensions: h 11½″ w 6½″
Price:
Comments: private
collection

Shape: 436
Type: Vase
Designer: Gates, W. D.
(attr)
Dimensions: h 7½″
Price:
Comments: factory photo

Shape: 426
Type: Vase
Designer: Gates, W. D.
Dimensions: h 4″
Price: $1.50
Comments: shown in
color, TECO

Shape: 437
Type: Vase
Designer: Gates, W. D.
Dimensions: h 5″
Price: $1.50
Comments: shown in
color, TECO

Shape: 439 A
Type: Wall Pocket
Designer: Gates, W. D.
Dimensions: w 5″
Price:
Comments: factory photo

Shape: 442
Type: Vase
Designer: Gates, W. D.
(attr)
Dimensions:
Price:
Comments: factory photo

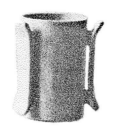

Shape: 445
Type: Loving Cup
Designer: Gates, W. D.
(attr)
Dimensions:
Price:
Comments: factory photo;
exhibited Chicago
Architectural Club, 1908

Shape: 447 A
Type: Vase
Designer: Gates, W. D.
Dimensions: h 6″
Price: $1.50
Comments: TECO

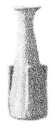

Shape: 438
Type: Vase
Designer: Gates, W. D.
(attr)
Dimensions: h 18″ w 6″
Price:
Comments: factory photo

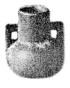

Shape: 440
Type: Vase
Designer: Gates, W. D.
Dimensions: h 6″
Price: $2.50
Comments: same as
no. 425; TECO

Shape: 443
Type: Wall Pocket
Designer: Gates, W. D.
(attr)
Dimensions:
Price:
Comments: factory photo

Shape: 446
Type:
Designer:
Dimensions:
Price:
Comments:

Shape: 448
Type:
Designer:
Dimensions:
Price:
Comments:

Shape: 439
Type: Wall Pocket
Designer: Gates, W. D.
Dimensions: w 5″
Price: $3.50
Comments: TECO

Shape: 441
Type: Vase
Designer: Gates, W. D.
(attr)
Dimensions: h 5″ w 2½″
Price:
Comments: factory photo

Shape: 444
Type: Vase
Designer: Gates, W. D.
(attr)
Dimensions: h 10½″ w 6″
Price:
Comments: factory photo

Shape: 447
Type: Vase
Designer: Gates, W. D.
Dimensions: h 6″
Price:
Comments: factory photo

Shape: 449
Type:
Designer:
Dimensions:
Price:
Comments:

Shape: 450
Type:
Designer:
Dimensions:
Price:
Comments:

Shape: 500 G
Type: Loving Cup or Lamp Base
Designer: Gates, W. D.
Dimensions: h 9″ w 6″
Price: $10
Comments: "Suitable for ornament, flowers or lamp base. A unique piece which is very original and especially good with Mission furniture." Hints, p. 10; Suggestions, p. 9; TAP, p. 12; "Mission loving cup or lampbase," TPA

Shape: 501
Type: Jardiniere
Designer:
Dimensions: h 12″ w 15″ b 9″
Price: $3.50
Comments: four sizes; GP

Shape: 502
Type: Jardiniere
Designer:
Dimensions: h 14″ w 17″ b 11″
Price: $5
Comments: same shape as 501

Shape: 503
Type: Jardiniere
Designer:
Dimensions: h 18″ w 21″ b 14″
Price: $9
Comments: same shape as 501

Shape: 504
Type: Jardiniere
Designer:
Dimensions: h 11″ w 17″ b 9″
Price: $5
Comments: same shape as 501

Shape: 505
Type: Jardiniere
Designer:
Dimensions: h 11″ w 17″ b 9″
Price: $4
Comments: GP

Shape: 506
Type: Jardiniere
Designer:
Dimensions: h 12″ w 21″ b 11″
Price: $5
Comments: same shape as 505

Shape: 507
Type: Jardiniere
Designer:
Dimensions: h 15″ w 24″ b 14″
Price: $12
Comments: same shape as 505

Shape: 508
Type: Jardiniere
Designer:
Dimensions: h 17″ w 27″ b 16″
Price:
Comments: same shape as 505

Shape: 509
Type:
Designer:
Dimensions:
Price:
Comments:

Shape: 510
Type:
Designer:
Dimensions:
Price:
Comments:

Shape: 511
Type: Window Box
Designer: Gates, Neil H.
Dimensions: w 12″ l 5′2″ d 10″
Price: $30
Comments: GP

Shape: 512
Type: Drinking Fountain
Designer: Hamilton, J. L.
Dimensions: h 25″ w 14″ d 12″
Price: $20
Comments: GP

Shape: 513
Type: Jardiniere
Designer:
Dimensions: top: h 12″ w 12″ l 16″; base: w 10″ l 14″
Price: $8.50
Comments: GP

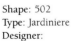

Shape: 514
Type: Urn
Designer: Gates, W. D.
Dimensions: w 27″ h 39″ b 20″
Price: $60
Comments: GP

Shape: EXY
Type: Dresser Set
Designer: Gates, W. D. (attr)
Dimensions:
Price:
Comments: factory photo; oblong tray 303, covered powder box 387, ring holder 386, on tray 390

Shape: OSM
Type: Smoking Set (5 piece)
Designer: Gates, W. D.
Dimensions: cigar holder h 4″, tray w 9″
Price: $10
Comments: "Five piece smoking set for library, den or office. The kind of smoking set that any man will appreciate." Hints, p.10. Consists of nos. 355, 305, 350, 352

Shape: OX0
Type: Vase
Designer: Gates, W. D. (attr.)
Dimensions: h 8″ w 5″
Price: $5
Comments: TAP, p.14

Shape: G1
Type: Garden Vase
Designer:
Dimensions: h 15″ w 19″ b 11½″
Price:
Comments: buff, grey, red; ITC

Shape: G2
Type: Garden Bowl
Designer:
Dimensions: w 15″
Price:
Comments: ITC

Shape: G3
Type: Garden Vase
Designer:
Dimensions: h 16″ w 19″ b 10″
Price:
Comments: ITC

Shape: G4
Type: Garden Vase
Designer:
Dimensions: h 9″ w 16″ b 10″
Price:
Comments: ITC

Shape: G5
Type: Square Base
Designer:
Dimensions: w 16″
Price:
Comments: ITC

Shape: G6
Type: Garden Planter
Designer:
Dimensions: h 12″ w 16″ b 12½″
Price:
Comments: ITC

Shape: G7
Type:
Designer:
Dimensions:
Price:
Comments:

Shape: G8
Type: Garden Urn
Designer:
Dimensions: w 20″ b 12½″ h 24″
Price:
Comments: ITC

Shape: G9
Type:
Designer:
Dimensions:
Price:
Comments:

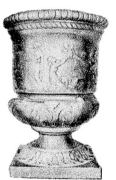

Shape: G10
Type: Garden Urn on Square Base
Designer:
Dimensions: h 30″ w 20″ b 16″
Price:
Comments: ITC

Shape: G11
Type:
Designer:
Dimensions:

Price:
Comments:

Shape: G12
Type:
Designer:
Dimensions:
Price:
Comments:

Shape: G13
Type:
Designer:
Dimensions:
Price:
Comments:

Shape: G14
Type: Garden Vase
Designer:
Dimensions: h 16″ w 15½″
Price:
Comments: ITC

Shape: G15
Type: Garden Urn
Designer:
Dimensions: h 21″ w 20″
Price:
Comments: ITC

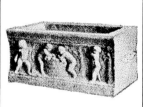

Shape: G16
Type: Garden Planter
Designer:
Dimensions: h 10″ w 10″ l 2½″
Price:
Comments: ITC

Shape: G17
Type: Rectangular Planter
Designer:
Dimensions: h 10″ w 10″
l 21½″
Price:
Comments: ITC

Shape: G18
Type: Bird Bath
Designer:
Dimensions: h 40″ w 30″
b 20″
Price:
Comments: "Tall and graceful this Teco Bird Bath will add charm to your garden. Its smooth, glazed surface is easily cleaned and can be left out all year around. Its height adds dignity to the lines and also protects the birds." TP; ITC

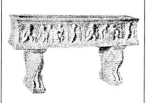

Shape: G19
Type: Stand for Planter
Designer:
Dimensions: h 14½″
Price:
Comments: ITC

Shape: G20
Type: Garden Bench
Designer:
Dimensions: h 17″ w 16″
l 41″
Price:
Comments: "This lovely bench is often needed in a shady nook to make your garden more inviting. Withstanding all weather, it is ever present for resting, and most useful for lunches and teas served out-of-doors." TP; ITC

Shape: G21
Type: Vase
Designer:
Dimensions: h 11½″ w 12″
Price:
Comments: ITC

Shape: G22
Type: Oil Jar
Designer:
Dimensions: h 30″ w 18″
b 11″
Price:
Comments: "The oil jar has been popular for centuries as a decorative pottery vase. This size is most effective in larger surroundings. Its converging ascending lines will add repose and dignity to garden or veranda." TP;ITC

Shape: G23
Type: Garden Vase
Designer:
Dimensions: h 10″ w 10″
Price:
Comments: ITC

Shape: G24
Type: Garden Vase
Designer: h 12″ w 27″
b 16″
Dimensions:
Price:
Comments: ITC

Shape: G25
Type: Garden Vase
Designer:
Dimensions: h 16″ w 19″
b 12″
Price:
Comments: ITC

Shape: G26
Type: Rectangular Planter
Designer:
Dimensions: h 10″ w 11″
l 43″
Price: $7
Comments: ITC

Shape: G27
Type:
Designer:
Dimensions:
Price:
Comments:

Shape: G28
Type:
Designer:
Dimensions:
Price:
Comments:

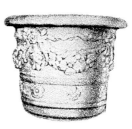

Shape: G29
Type: Bird Bath
Designer:
Dimensions: h 19″ w 29″
b 15″
Price:
Comments: ITC

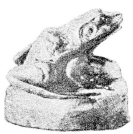

Shape: G30
Type: Fountain Frog
Designer:
Dimensions: h with b 15″
w 15″
Price:
Comments: yellow green. "This amazing life-like frog will give variety to your pool or rock garden. For fountain use there is a hole from the base thru to the mouth for a water connection." TP; ITC

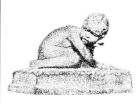

Shape: G31
Type: Boy Fountain
Designer:
Dimensions: h 14″ w 12″
l 18½″
Price:
Comments: ITC

Shape: G32
Type: Sun-dial Pedestal
Designer:
Dimensions: h 37″ b 18″ top 12″
Price:
Comments: ITC

Shape: G33
Type: Small Frog Fountain Ornament
Designer:
Dimensions: h 5″
Price:
Comments: ITC

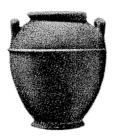

Shape: G34
(A with handles, B without handles)
Type: Corinthian Style Vase
Designer:
Dimensions:
Price:
Comments: "This squatty, bowl shaped vase is very popular in the modern garden settings. It enhances the home where low spots of color are needed. The effect is often more pleasing when the jar is planted. Comes with or without handles." TP

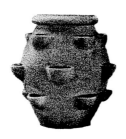

Shape: G35
Type: Small Strawberry Jar
Designer:
Dimensions: h 17″ w 14″ b 7¼″
Price:
Comments: robin's egg blue, light green, cream yellow, white gloss glaze, brickred, buff, mottled green. "Strawberry jars are the garden fashion note of the season. So cheerful are they when colorful plants are poking their heads from the cups and top, that they make a vacant porch or garden corner inviting again." TP

Shape: G36
Type:
Designer:
Dimensions:
Price:
Comments:

Shape: G37
Type: Planting Vase
Designer:
Dimensions: h 9″ w 20″ b 8″
Price:
Comments: dark blue, robin's egg blue, light green, cream yellow, white. "This Teco bowl shape is most attractive when planted and placed on an elevation. In winter it is useful indoors to brighten up the home." TP

Shape: G38
Type:
Designer:
Dimensions:
Price:
Comments:

Shape: G39
Type:
Designer:
Dimensions:
Price:
Comments:

Shape: G40
Type: Flower Vase
Designer:
Dimensions: h 16½″ w 8½″ b 6″
Price:
Comments: "An ideal vase where a smaller accent is needed in the garden or in the house. Also useful for holding tall flowers and branches"; all Teco colors. TP

Shape: G41
Type: Flower Vase
Designer:
Dimensions: h 20″ w 11″ b 7″
Price:
Comments: all Teco colors; TP

Shape: G42
Type: Large Strawberry Jar
Designer:
Dimensions: h 28″ w 20″ b 12″
Price:
Comments: same as G35; TP

Shape: G60
Type: Vase
Designer: Gates, W. D.
Dimensions: h 26″ w 12″ b 9″
Price:
Comments: "California style. The tall modern line of this vase is in keeping with the architecture of today. It will add color to a doorway. Also useful as an umbrella stand in a vestibule. Available in all Teco colors." TP; ITC

Shape:
Type: Vase
Designer: Gates, W. D.
Dimensions:
Price:
Comments: metallic glaze; illustrated in *Brush and Pencil* (Feb. 1902), p. 291, 294

Shape:
Type: Stein
Designer: Gates, W. D.
Dimensions: h 20″
Price:
Comments: presented to Chicago Architectural Sketch Club by William D. Gates; illustrated *Clay-Worker* (Jan. 1902), p. 25; see fig. 14

Shape:
Type: Wall Pocket or Wall Sconce
Designer: Giannini, O.
Dimensions:
Price:
Comments: used as sconces in Gates living room; private collection; see fig. 70

Shape:
Type: Vase
Designer: Albert, F.
Dimensions:
Price:
Comments: illustrated in *Brush and Pencil* (Feb. 1902), p. 295

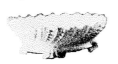

Shape:
Type: Bowl
Designer: Dodd, W. J.
Dimensions:
Price:
Comments: *Brush and Pencil* (Feb. 1902), p. 290

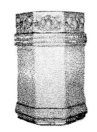

Shape:
Type: Stand
Designer:
Dimensions: h 15″ w 10″
Price:
Comments: private collection

Shape:
Type: Flower Bowl
Designer:
Dimensions: h 2″ w 9″
Price:
Comments:

Shape:
Type: Sundial
Designer:
Dimensions: h 2″ w 10″
Price:
Comments: gray terra cotta

Shape:
Type: Bookends
Designer:
Dimensions: h 6″ w 6″ b 4″
Price:
Comments: woman with jug gazing into pool

Shape:
Type: Bookends
Designer:
Dimensions: h 5″ w 6″ b 4″
Price:
Comments: Dutch girl seated reading book, windmill rear

Shape:
Type: Vase
Designer: Gates, W. D.
Dimensions:
Price:
Comments: *Brush and Pencil* (Feb. 1902), p. 294

Shape:
Type: Tea Set or Chocolate Set
Designer: Gates, W. D.
Dimensions: teapot h 5″ w 6½″
Price:
Comments: see fig. 63

Shape:
Type: Wall Pocket
Designer:
Dimensions: h 19″ w 11″
Price:
Comments: variation of nos. 156 A and B

Shape:
Type: Trivet
Designer:
Dimensions: h 1″ diam 6″
Price:
Comments: outer band of leaves and berries; four ball feet

Shape:
Type: Vase
Designer:
Dimensions: h 13″ w 8″
Price:
Comments: gourd-shaped

Shape:
Type: Vase
Designer:
Dimensions: h 8″
Price:
Comments: bottom of 258

Shape:
Type: Vase
Designer:
Dimensions:
Price:
Comments: similar to
no. 188

Shape:
Type: Bowl with Frog
Designer: Gates, W. D.
(attr)
Dimensions: h 2¼″ w 4¼″
Price:
Comments: beige frog on
white bowl

Shape:
Type: Vase
Designer:
Dimensions: h 10½″ w 9″
Price:
Comments: metallic glaze,
inscribed on base "1/3";
see colorplate 31, far right,
private collection

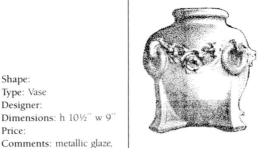

Shape:
Type: Crematory Urn
Designer: Gates, W. D.
Dimensions:
Price:
Comments: *The Clay
Worker*

Shape:
Type: Vase
Designer: Gates, W. D.
Dimensions:
Price:
Comments: *Brush and
Pencil* (Feb. 1902), p. 294

Shape:
Type: Vase
Designer: Gates, W. D.
(attr)
Dimensions: h 9″
Price:
Comments: similar to
nos. 162, 162A, 164

Shape:
Type: Tea Tile
Designer:
Dimensions: h 5¾″ w 5¾″
Price:
Comments: private
collection

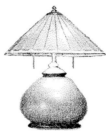

Shape:
Type: Lamp
Designer: Base: Gates, W. D.
(attr). Shade: Giannini, O.
Dimensions:
Price:
Comments: base no. 79

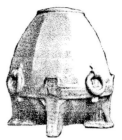
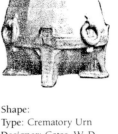

Shape:
Type: Crematory Urn
Designer: Gates, W. D.
Dimensions:
Price:
Comments: *The Clay
Worker*

Shape:
Type: Vase
Designer:
Dimensions: h 14⅞′ w 6¼″
Price:
Comments: metallic glaze;
see colorplate 31, third
from left, private collection

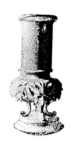

Shape:
Type: Satyr Vase or
Umbrella Stand
Designer: Albert, F. (attr)
Dimensions: h 24″ w 10″
b 9½″
Price:
Comments: shown in
"Trail's End" living room,
1927; see fig. 70

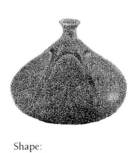

Shape:
Type: Vase
Designer: Gates, W. D.
(attr)
Dimensions: h 4″ w 5″
Price:
Comments: variation of
no. 54

Shape:
Type: Lamp
Designer: Base: Mundie, W. B.
Dimensions:
Price:
Comments:

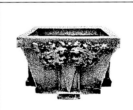

Shape:
Type: Jardiniere
Designer: Sullivan, Louis H.
Dimensions: h 8¼″ w 13½″
d 13½″
Price:
Comments: from the
National Farmers Bank of
Owantonna, Minnesota,
c. 1907

Shape:
Type: Vase
Designer:
Dimensions:
Price:
Comments: appears in period photograph of The Art Institute of Chicago Collection

Shape:
Type: Vase
Designer: Gates, W.D.
Dimensions:
Price:
Comments: illustrated in *Brush and Pencil* (Feb. 1902), p. 291

BIOGRAPHIES OF TECO DESIGNERS

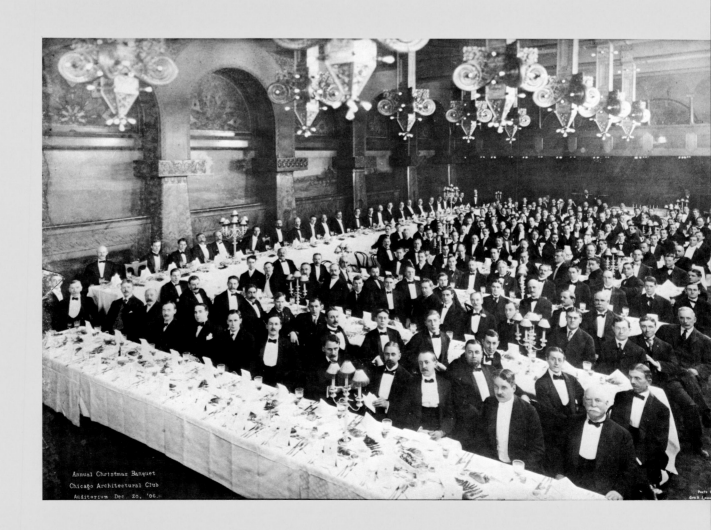

Annual Christmas Banquet
Chicago Architectural Club
Auditorium Dec. 20, '06.

FRITZ WILHELM ALBERT
(1865-1940)

A sculptor, Albert was born with the surname d'Albert in Alsace-Lorraine. He was educated at the Royal Academy of Berlin. In 1893 he came to Chicago to work for the German government at the World's Columbian Exposition. Remaining in Chicago after the Fair, he carved a marble sculpture of a lioness and cubs which he sold to raise funds so that he could travel to Rome to study. After his return to America, William D. Gates hired him as a modeler. Albert sculpted architectural terra cotta ornament as well as Teco pottery and garden ornaments. In 1905 he modeled a bust of Gates that remains in the collection of TC Industries, Inc. The following year, he left to become foreman of the modeling department at the Northwestern Terra Cotta Company. He executed many of that company's most fanciful commissions, including the Egyptian-inspired Reebie Storage Warehouse in Chicago, and numerous movie palaces. His own residence on Sherwood Terrace was renowned for its elegant garden, which was described by Chicago's *Herald-Examiner* as "The Garden of Eden in Chicago."

It is probable that Albert worked as a free-lance sculptor during the late 1920s and 1930s, since he is known to have executed ornament for the Midland Terra Cotta Company as well as for Northwestern during that period. In 1935 he completed terra cotta ornament at Midland for George Grant Elmslie's Thornton Township High School in Calumet City, Illinois, when Kristian Schneider suffered a stroke and was unable to finish the work.

In the mid-1930s, when Chicago's terra cotta companies closed for lack of business, Albert had little work. He died of heart failure on April 17, 1940, the day he was to sign papers foreclosing the mortgage on his beloved home and garden.

The author is grateful to Charles R. Steers for sharing material in an unpublished interview with Esther Sheperd, 1980. See also Susan Stuart Frackelton, "Our American Potteries, Maratta's and Albert's Work at the Gates Potteries," *The Sketch Book* 5 (October 1905), 78.

JEREMIAH KIERSTED CADY
(1855-1924)

An architect, Cady was born in Indianapolis, Indiana, and graduated from Cornell University in 1876. He moved to Chicago in 1883 to enter the employ of the architectural firm of Burnham & Root as a draftsman. Four years later he became a partner in the firm of Handy, Cady & Elzner. He was associated with pioneer Chicago architect Frederick Baumann from 1889 until 1892, when he formed a partnership with Frank W. Handy (Handy & Cady) that lasted through 1909. Later Cady was associated with J. Spencer Crosby (Cady & Crosby). He was the architect of numerous Chicago buildings, including the Teutonic Building (1891), and the State Bank, Madison and Kedzie streets (1920). He also designed the Medical Arts Building, Omaha, Nebraska (1925), bank buildings in LaCrosse, Wisconsin, and Winona, Minnesota, several industrial plants, and many residences in Chicago and elsewhere in the Midwest.

Henry F. and Elsie Rathburn Withey, *Biographical Dictionary of American Architects (Deceased)* (Los Angeles: Hennessey & Ingalls, Inc, 1970), 104; *Book of Chicagoans* (Chicago: A. N. Marquis, 1911), 112.

GEORGE ROBINSON DEAN
(1864-1919)

An architect, Dean was born of American parents in Bombay, India, and brought to the United States as a boy. After graduating from Doane College in Crete, Nebraska, he studied architecture in Paris at the Ecole des Beaux-Arts. Returning to the United States in 1893, Dean first worked as a draftsman in Minneapolis for W. Channing Whitney, and then joined the office of Shepley, Rutan & Coolidge in Boston. The firm sent Dean to supervise several buildings under construction in Chicago and he decided to open his own office in that city. In 1896-97 Dean taught architectural design at the Chicago School of Architecture, replacing William K. Fellows who was studying in Europe. He formed a partnership with his brother Arthur (Dean & Dean) in 1903. Although the firm did several residential and college buildings in the "arts and crafts" idiom, many of its commissions were in the industrial field, including buildings for the Goodman Manufacturing Plant (1903-14), and offices and workers' houses for U.S. Steel plants in Indiana, Pennsylvania, and Minnesota (1903-14).

Henry F. and Elsie Rathburn Withey, *Biographical Dictionary of American Architects (Deceased)* (Los Angeles: Hennessey & Ingalls, Inc., 1970), 167; *Book of Chicagoans* (Chicago: A. N. Marquis, 1917).

WILLIAM J. DODD
(1862-1930)

An architect, Dodd grew up in Chicago, where he served an apprenticeship in architecture in the office of William LeBaron Jenney. He later joined the firm of S. S. Beman, where he worked on plans for the town of Pullman. Around 1884 he moved to

Louisville, Kentucky, where he practiced for more than twenty years in association with various architects, but primarily worked alone. Between 1899 and 1902 he was listed in the Chicago city directories as a salesman with a business address at 216 Monroe Street. It is possible that he worked as a draftsman for the American Terra Cotta & Ceramic Company on a free-lance basis, as several of the early Teco designs published in *Brush & Pencil* in 1902 are attributed to Dodd. That same year he entered a ceramic mosaic mantel facing in the Chicago Architectural Club exhibit, listing his address as 24 Adams St. After 1918 Dodd practiced in Los Angeles, California in partnership with William S. Richards (Dodd & Richards).

Obituary in *The Architect & Engineer* (September 1930); Henry F. and Elsie Rathburn Withey, *Biographical Dictionary of American Architects (Deceased)* (Los Angeles: Hennessey & Ingalls, Inc., 1970), 176-77.

JOHN I. DORR

An architect, Dorr was listed in the Chicago city directories between 1899 and 1901.

NELSON MAX DUNNING
(1873-1945)

An architect, Dunning was born in Kenosha, Wisconsin. He attended the University of Wisconsin before entering the Chicago office of J. C. Llewelyn in 1894. In 1900 he won the first traveling scholarship of the Chicago Architectural Club, allowing him a year of travel and study in England and Central Europe. Returning to Chicago, he operated his own architectural firm until 1933, when he moved to Washington. There he served on various federal commissions, including the Reconstruction Finance Committee. While in Chicago he designed several churches and, in association with Henry Raeder and George Nimmons, the huge American Furniture Mart at 666 N. Lake Shore Drive. Dunning was one of the organizers of the Architectural League of America and served as its first president in 1904. Later he was an active member of the American Institute of Architects. In 1922 Dunning and George Nimmons initiated and raised funds for the American Institute of Architects' book projects, including the underwriting of Louis H. Sullivan's *The Autobiography of an Idea* and his *A System of Architectural Ornament*.

American Art Annual (vol. 21); Henry F. and Elsie Rathburn Withey, *Biographical Dictionary of American Architects (Deceased)* (Los Angeles:

Hennessey & Ingalls, Inc., 1970), 184-85; Illinois Society of Architects, *Bulletin* (June-July 1945); Obituary in the *New York Times* (April 19, 1945); Willard Connely, *Sullivan As He Lived* (New York: Horizon Press, 1960), 215, 282-3, 296, 300-2, 304-7; *Who's Who in Chicago* (Chicago: A. N. Marquis & Company, 1926); *Who's Who in America*, 1940.

GEORGE GRANT ELMSLIE
(1871-1952)

An architect, Elmslie emigrated from Scotland to Chicago with his parents in 1884. In 1887 he was hired as a draftsman by William LeBaron Jenney and later worked in the office of residential architect J. L. Silsbee. Two years later he went to work for Adler & Sullivan and became chief draftsman after the departure of Frank Lloyd Wright in 1893. He remained chief draftsman to Louis H. Sullivan until 1909, when he joined William Gray Purcell and George Feick, Jr., in partnership (Purcell, Feick & Elmslie). Purcell had worked briefly in Sullivan's office under Elmslie in 1903. Purcell and Feick maintained an office in Minneapolis, while Elmslie took charge of work in Chicago. After Feick withdrew in 1913, Purcell and Elmslie worked together until 1920, when failing health led Purcell to retire to Oregon. Purcell & Elmslie were among the most productive of the Prairie School architects, designing residences, banks, factories, schools, and public buildings throughout the Midwest.

George G. Elmslie, "Sullivan Ornamentation," *Journal of the American Institute of Architects* 6 (October 1946), 155-58; David Gebhard, "Louis Sullivan and George Grant Elmslie," *Journal of the Society of Architectural Historians* 19 (1960), 62-68; H. Allen Brooks, *The Prairie School: Frank Lloyd Wright and His Midwest Contemporaries* (New York: W. W. Norton, 1972), and *Prairie School Architecture, Studies from "The Western Architect"* (Toronto: University of Toronto Press, 1975), particularly "The Statics and Dynamics of Architecture" featuring the work of Purcell, Feick & Elmslie originally published in *The Western Architect* 21 (January 1915), 1-8; Gebhard, "Purcell and Elmslie, Architects" and "A Guide to the Architecture of Purcell and Elmslie," *The Prairie School Review* 2 (First Quarter 1965).

WILLIAM KINNE FELLOWS
(1870-1948)

An architect, Fellows was born in Winona, Minnesota, and graduated from the Columbia School of Mines and Architecture in 1894. He served as an instructor at The Art Institute of Chicago from 1894 through 1896, when he was awarded a Columbian scholarship to study architecture at the American Academy in

Rome. Returning to Chicago in 1898, he practiced with George C. Nimmons (Nimmons & Fellows) until 1910. He then worked in partnership with Dwight H. Perkins and John L. Hamilton (Perkins, Fellows & Hamilton). They became known as specialists in school architecture and were chosen to design school buildings throughout the Midwest. After 1925 Fellows practiced alone until his retirement in 1936.

Henry F. and Elsie Rathburn Withey, *Biographical Dictionary of American Architects (Deceased)* (Los Angeles, Hennessey & Ingalls, Inc., 1970), 206; *Who's Who in Chicago* (Chicago: A. N. Marquis & Company, 1911, 1926). Obituary in Illinois Society of Architects *Bulletin* (July 1948) and *The New York Times* (August 11, 1948).

HUGH MACKIE GORDON GARDEN
(1873-1961)

An architect, Garden was born in Toronto, Canada. After moving to Chicago, he worked as a draftsman in several architectural offices. In 1893 he became a free-lance renderer. Two years later he began sharing an office with Richard E. Schmidt, while still carrying on an independent practice. By the end of the century Garden was creating decorative designs for many clients, including Schmidt. In 1906 this relationship was formalized when he became Schmidt's partner, along with structural engineer Edgar Martin (Richard E. Schmidt, Garden & Martin; later Schmidt, Garden & Martin). In 1901 Garden designed the Albert F. Madlener house, Chicago (now headquarters of the Graham Foundation for Advanced Studies in the Fine Arts), and in 1906 the Montgomery Ward warehouse located at 618 W. Chicago Avenue. The firm was especially noted for its hospital designs. Throughout his career Garden was recognized as an extremely talented decorative designer.

Obituary in *Architectural Forum*, 115 (November 1961), 16; Hugh Garden, "The Chicago School," *Prairie School Review* 3 (First Quarter 1966), 19-23; Bernard C. Greengard, "Hugh M. G. Garden," *Prairie School Review* 3 (First Quarter 1966), 5-18; the same edition includes a survey of Garden's work.

WILLIAM DAY GATES
(1852-1935)

Founder of the Gates Potteries, Gates was born in Ashland, Ohio, and brought to Illinois as an infant. He was the son of Simon S. and Sylvia Day Gates, the largest landowners in Nunda Township, McHenry County, Illinois. An 1877 graduate of Wheaton College, he was admitted to the Illinois bar in 1879. He practiced law in Chicago until 1887, when he incorporated the American Terra Cotta & Ceramic Company. A complete listing of the firm's work can be found in Statler Gilfillen, compiler, *The American Terra Cotta Index* (Palos Park, Illinois: The Prairie School Press, 1973).

Gates married Ida Mae Babcock of LaGrange, Illinois, in 1877. They had four sons and two daughters. His sons all studied ceramic engineering at Ohio State University; each began his career in the family firm. William Paul (1879-1920), a ceramic chemist, was instrumental in developing Teco pottery. Ellis Day (1880-1923) worked at the plant until 1908, when he left to become superintendent of the terra cotta department of a company in Seattle; he later joined the New York Architectural Terra Cotta Company. Neil Hurlburt (1884-1971) was secretary-treasurer of the firm for many years. Major Earl (1886-1970) was the inventor of pulsichrome (see page 65) and held several patents. He served as superintendent and later general manager of the plant. Gates's daughter Margaret (1882-1978) married Price Williams of Mobile, Alabama. Sylvia Day (b. 1892) married Robert T. Evans and later Ronald M. Byrnes; she operated the Jokake Inn, an early desert resort in Phoenix, Arizona, for many years. William Gates's marriage to Ida Mae ended in divorce around 1902; he married Katherine Fallon of Chicago in 1909.

For nearly fifty years Gates was an acknowledged leader in the ceramics field. He was a founder of the National Brick Manufacturers Association, the American Ceramic Society, and the National Terra Cotta Society. He served as president of each organization, and was a regular contributor to their publications. In Chicago he was a member of the Chicago Arts and Crafts Society, the Builders Club, the Cliff Dwellers Club, the Chicago Athletic Association, and a patron of the Chicago Architectural Club. An avid traveler, he visited Europe four times and also toured Central America.

The author is grateful to Ora Gates, Major Frederick Gates, Sarah Gates, Mrs. Ronald M. Byrnes, and Jessie Benton Evans Gray for sharing biographical information about the Gates family. See also "W. D. Gates," *American Ceramic Society Journal* 6 (January 1923), 25-26; *The Book of Chicagoans* (Chicago: A. N. Marquis Company, 1905, 1911, 1917); *Who's Who in Chicago* (Chicago: A. N. Marquis, 1931), 355. Obituaries in *American Ceramic Society Bulletin*, 14 (February 1935), 93; *Ceramic Age* (March 1935), 92-93; *Crystal Lake Herald* (January 31, 1935); *The New York Times* (January 30, 1935), 20. See also issues of *Brick, The Clay-Worker*, and *Transactions of the American Ceramic Society* for references to Gates and "Button-Hole Talks" columns.

ORLANDO GIANNINI
(1861-1928)

An artist, Giannini was born in Cincinnati, Ohio, where he was trained as a sculptor. In the early 1880s he worked as manager of the Cincinnati Art Pottery Company before moving to New York in 1885. Relocating in Chicago he worked as a designer for Adams & Westlake, a brass and bronze foundry, between 1894 and 1898. Working as a free-lance designer, he created books and posters for several Chicago firms and periodicals and also painted murals, including two with Indian motifs and one portraying "Arabian Nights" in Frank Lloyd Wright's Oak Park residence.

In July 1898 two of Giannini's renderings for jardinieres were published in *Forms and Fantasies;* their forms resemble some early pieces of Teco pottery and may have served as inspiration for Gates. That year Giannini opened a stained glass studio, Giannini & Hilgart, in partnership with Fritz Hilgart, a German glass stainer. From then until 1909, when Giannini moved to California, the firm executed art glass windows, lighting fixtures, and glass mosaic fireplace facings for numerous Chicago architects, among them Hugh Garden, George Maher, Howard Van Doren Shaw, and Frank Lloyd Wright. Giannini designed most of the leaded art glass shades sold by the Gates Potteries and also designed several Teco shapes, including the spear-shaped wall sconces used in Gates's residence "Trail's End."

Wendy Kaplan, ed., *"The Art That is Life": The Arts and Crafts Movement in America, 1875-1920* (Boston: Museum of Fine Arts, 1987), 387-88; Sharon S. Darling, *Chicago Ceramics & Glass* (Chicago: Chicago Historical Society, 1979), 120 et passim; David A. Hanks, "Giannini & Hilgart," *The Decorative Designs of Frank Lloyd Wright* (New York: E. P. Dutton, 1979), 203-5.

HAROLD HALS

Hals was listed as an architect in the 1902 Chicago city directory and as a draftsman in 1903.

JOHN L. HAMILTON
(1878-1955)

An architect, Hamilton was born in Bloomington, Illinois. A graduate of the Chicago Manual Training School, he fought in the Spanish-American War before returning to Chicago to practice architecture. In 1905 he joined Dwight Perkins and William Fellows to form Perkins, Fellows & Hamilton. Between 1907 and 1911 Hamilton served as staff architect for Chicago's Lincoln Park; in 1912 he received a gold medal from the Illinois Chapter of the American Institute of Architects for his design of the park's lion house. In 1927, the firm became Hamilton, Fellows & Nedved; after 1934 Hamilton practiced alone. In addition to many commercial structures, Hamilton and his partners designed numerous schools and colleges in Illinois, Indiana, and Iowa.

Who's Who in Chicago and Illinois (Chicago: A. N. Marquis Company, 1945); *The Annuary of the American Institute of Architects*, 1926-27 (Washington, D. C.: The Octagon), 1927.

WILLIAM LEBARON JENNEY
(1832-1907)

An architect, Jenney is best known for his Home Insurance Building (1884), which has been called "the true father of the skyscraper," for in it he introduced the nucleus of iron skeleton frame construction for the tall, fireproofed commercial building. Born in Massachusetts, Jenney studied engineering at the Lawrence Scientific School in Cambridge before going to Paris to study architecture at the Ecole des Beaux-Arts. After receiving a diploma in 1856, he remained abroad studying art and architecture until the outbreak of the Civil War. Returning to America, he enlisted in the Union Army and served on the engineering staffs of Generals Sherman and Grant, attaining the rank of major-general. In the late 1860s, Jenney opened an architectural practice in Chicago, and for a period worked in partnership with Sanford E. Loring, one of the founders of the Chicago Terra Cotta Company. After the Great Fire of 1871 Jenney became one of the city's leading architects, active in reconstruction work and in designing new buildings.

In 1891 Jenney elevated designer William B. Mundie, who had joined his staff in 1884, to partnership (Jenney & Mundie). In 1905, not long after Elmer C. Jensen became a partner (Jenney, Mundie & Jensen), Jenney retired and moved to Los Angeles, California, where he died two years later. In his long career Jenney influenced the architecture of Chicago through his buildings and his training of architects. Among those employed by his firm were Mundie, Dodd, Elmslie, and Shaw, as well as such renowned architects as Louis H. Sullivan, William Holabird, Martin Roche, and Daniel H. Burnham.

Henry F. and Elsie Rathburn Withey, *Biographical Dictionary of American Architects (Deceased)* (Los Angeles: Hennessey & Ingalls, Inc., 1970), 324; Adolph K. Placzek, ed. *MacMillan Encyclopedia of Architecture* vol. 2 (New York: The Free Press, 1982), 494-96; Theodore Turak, *William LeBaron Jenney: A Pioneer of Modern Architecture* (Ann Arbor, Michigan: University of Michigan, 1986).

HARDESTY GILLMORE MARATTA
(b. 1864)

A landscape painter and muralist, Maratta was born in Chicago. After studying with Lawrence Earle, then considered the best watercolorist in the city, he attended The School of the Art Institute of Chicago before going abroad to study in European galleries. Following his return, he wandered through the Southwest studying the art of the Zuni and Hopi Indians. By 1895 he was conducting a series of traveling Art Institute classes, staying four weeks in each place. Maratta was intrigued by the work of French Impressionist painter Edouard Manet and published an article on the influence of Manet on American artists, "Impressionism as Interpreted through the Work of Manet," in *Arts for America* (December 1895).

In 1896 when Maratta and F. C. Peyrand, also a Chicago muralist, were commissioned to decorate the Peoria Public Library with fourteen large murals, *Arts for America* called the two "among the best landscape painters and the strongest colorists in the West" (April 1896), 116. Among landscapes exhibited by Maratta in the 1897 Chicago Artists' Exhibition were *A Summer Day*, purchased by the Union League Club, and *The River Road*, purchased by the Englewood Woman's Club. By 1904 Maratta also was working as a "clay painter" at the American Terra Cotta & Ceramic Company, where he created landscapes on the damp surfaces of clay tiles using colored slip.

Susan Stuart Frackelton, "Our American Potteries; Maratta's & Albert's Work at the Gates Potteries," *The Sketch Book* 5 (October 1905), 73-74, 76.

FERNAND CESAR AUGUSTE BERNARD JAMES MOREAU
(1853-1920)

A sculptor, Moreau was trained in his native France. Emigrating to Washington, D. C., in 1880, he operated a studio for two years before moving to New York. Having been drawn to Chicago by work for the 1893 World's Fair, he stayed on, working from a studio on Lill Street and later at 335 Wabash Avenue. By 1902 Moreau was teaching an evening course in Ornamental Modeling at The Art Institute of Chicago in association with Chicago sculptor Lorado Taft. According to the school's catalogue, this was "a special class in plastic decoration, for wood and stone carvers, plaster workers, frame makers, metal chasers, etc."

Moreau joined the American Terra Cotta & Ceramic Company as a modeler in 1904. He modeled architectural ornament and worked in the potteries until World War I, when he devoted his time to war work and aid to France. After the war, Moreau worked for the Northwestern Terra Cotta Company until his death on April 2, 1920.

Biographical information was supplied by Moreau's daughter, the late Valentine Epstein, and his granddaughter, Mary Claire Hersh, during an interview in 1980. Wendy Kaplan, ed., *"The Art That Is Life": The Arts and Crafts Movement in America, 1875-1920* (Boston: Museum of Fine Arts, 1987), 260-61; *Catalogue*, School of The Art Institute of Chicago, 1902-03, 35; Susan Stuart Frackelton, "Our American Potteries; Maratta's and Albert's Work at the Gates Potteries," *The Sketch Book* 5 (October 1905), 78.

WILLIAM BRYCE MUNDIE
(1863-1939)

An architect, Mundie was born in Ontario, Canada, and educated at Hamilton Collegiate Institute. Moving to Chicago in 1884, he became a draftsman in the office of William LeBaron Jenney. Seven years later he became Jenney's partner (Jenney & Mundie). In 1905, joined by Elmer C. Jensen, the firm became Jenney, Mundie & Jensen and later Mundie & Jensen. The firm was responsible for many commercial structures in Chicago and Illinois. Between 1898 and 1905 Mundie served as architect for the Chicago Board of Education.

Henry F. and Elsie Rathburn Withey, Biographical Dictionary of American Architects (Deceased) (Los Angeles: Hennessey & Ingalls, Inc., 1970), 434; Obituary in Illinois Society of Architects *Bulletin* (November 11, 1939); *Who's Who in Chicago* (Chicago: A. N. Marquis, 1931), 705.

GEORGE CROLL NIMMONS
(1865-1947)

An architect, Nimmons, a native of Ohio, graduated from the University of Wooster. He later traveled and studied architecture in Europe, then attended the School of The Art Institute of Chicago. In 1887 he began his career as a draftsman in the Chicago office of D. H. Burnham & Co. Ten years later, in 1897, he left to form a partnership with William K. Fellows (Nimmons & Fellows), which continued until 1910. The firm was best known for the huge Sears, Roebuck & Co. plant in Chicago and for the branch buildings it designed for Sears, Roebuck in several midwestern states. Nimmons practiced alone from 1910 through 1917, when he organized George C. Nimmons & Company, which produced many loft structures for light manufacturing in

the Chicago area. Between 1933 and 1936 he was a senior partner in Nimmons, Carr & Wright.

Henry F. and Elsie Rathburn Withey, *Biographical Dictionary of American Architects (Deceased)* (Los Angeles: Hennessey & Ingalls, Inc., 1970), 442; *Book of Chicagoans* (Chicago: A. N. Marquis Company, 1911), 507; Obituary in Illinois Society of Architects *Bulletin* (July-August 1947); George C. Nimmons, "Skyscrapers in America," *Journal of the American Institute of Architects* 21 (September 1923), 370-372; *Who's Who in Chicago* (Chicago: A. N. Marquis & Company, 1926), 646.

BLANCHE OSTERTAG

An artist, Ostertag studied at The Saint Louis Art Museum before spending four years in Paris at the Julian and Delecluse academies. Moving to Chicago in 1896, she worked as an artist and illustrator. Her drawings appeared in *Brush and Pencil* and *Country Life in America* between 1898 and 1902. She illustrated calendars and books, and also provided interior designs for local architects. In 1903 three glass mosaic panels designed by Ostertag and executed by Orlando Giannini for the dining room of Frank Lloyd Wright's Joseph Husser house, Chicago, were displayed in the Chicago Architecture Club's annual exhibit. By 1899 she had a studio in the Fine Arts Building and, after 1901, at the Tree Studio Building. Ostertag moved to New York in 1911, where she is known to have painted the *Sailing of the Claremont* in the foyer of the New Amsterdam Theatre.

Blanche McDougall, "Blanche Ostertag," *Book Buyer* 25 (November 1902); "B. Ostertag," *Brush and Pencil* 1 (December 1897), 55-57; David A. Hanks, *The Decorative Designs of Frank Lloyd Wright* (New York: E. P. Dutton, 1979), 204; Jeannine Love, "Blanche Ostertag: Another Wright Collaborator," *The Frank Lloyd Wright Newsletter* 4 (Second Quarter 1981), 11-16.

KRISTIAN E. SCHNEIDER
(1864-1935)

A sculptor, Schneider left his native Norway at the age of nineteen to emigrate to Chicago, where he found work as a stonecutter. By 1888 he had been hired by James Legge to carve models for the plaster molds used in casting ornament for Adler & Sullivan's Auditorium Hotel and Theatre. Subsequently he executed the ornament for several other Adler & Sullivan projects, including the celebrated Golden Door on the Transportation Building at the 1893 World's Fair.

In 1893 Schneider became a modeler at the Northwestern Terra Cotta Company. He had risen to the rank of foreman by 1899, when he sculpted models for the intricate metal and terra cotta ornament on the Schlesinger & Mayer department store (now Carson Pirie Scott & Co.), Chicago. In 1906, he left Northwestern to open his own studio in partnership with Henry F. Erby, a fellow employee at Northwestern. In 1909 he joined the American Terra Cotta & Ceramic Company as chief modeler, a position he held until the firm closed in 1930. Eventually two of his sons, Trygve and Thorolf, were employed at American Terra Cotta; a third son, Roy, became a well-known photographer in Crystal Lake.

While at American Terra Cotta, Schneider modeled ornament for Sullivan's commissions and for numerous buildings designed by Purcell & Elmslie and other Prairie School architects. In 1910 he sculpted a series of panels for Lincoln Memorial Hall at the University of Illinois, Urbana. In 1919 he executed a handsome plaque in memory of Sgt. William Peterson, which was donated to the Crystal Lake High School by William D. Gates. (Note: models of the Lincoln plaques and the Peterson Memorial are now in the John L. Husmann School in Crystal Lake). In 1930, when American Terra Cotta closed, Schneider went to work for the Midland Terra Cotta Company in Chicago, where he was employed when he suffered a stroke. He died in Crystal Lake on August 11, 1935.

The author wishes to thank Martin A. Reinhart for sharing biographical material in his manuscript "Norwegian-Born Sculptor, Kristian Schneider: His Essential Contribution to the Development of Louis Sullivan's Ornamental Style" (1982). "A New Life of Lincoln," *The Clay-Worker* 57 (April 1912), 605-10; "An Artistic Model," *Crystal Lake Herald* (December 30, 1915); "K. Schneider with Terra Cotta Co.," *Crystal Lake Herald* (November 20, 1930); Larry Millett, *The Curve of the Arch* (St. Paul: Minnesota Historical Society Press, 1985), 88-93.

HOWARD VAN DOREN SHAW
(1869-1926)

An architect, Shaw was born in Chicago. He studied architecture at Yale University and the Massachusetts Institute of Technology before traveling in Europe and the Orient. Returning to Chicago in 1895, he became a draftsman in the office of Jenney & Mundie. Two years later he opened his own practice. Over the next three decades he designed a variety of structures, including the Donnelley Printing Co. plant in Chicago, a model steel town in Indiana, and numerous churches and clubs. He also designed the buildings comprising Market Square in Lake Forest, Illinois, and numerous country houses along Lake Michigan's north shore.

Obituary in *Architectural Record* (July 1926); Henry F. and Elsie Rathburn Withey, *Biographical Dictionary of American Architects (Deceased)* (Los Angeles: Hennessey & Ingalls, Inc., 1970), 548; Leonard K. Eaton, *Two Chicago Architects and Their Clients: Frank Lloyd Wright and Howard Van Doren Shaw* (Cambridge: Massachusetts Institute of Technology Press, 1969); H. Allen Brooks, *The Prairie School: Frank Lloyd Wright and His Midwest Contemporaries* (New York: W. W. Norton, 1972).

MELVILLE P. WHITE

White was listed as a draftsman in the Chicago city directories between 1899 and 1903.

FRANK LLOYD WRIGHT
(1867-1959)

An architect, Wright was born in Wisconsin. He had little formal education in architecture, although he attended a few courses at the University of Wisconsin. In 1887 he moved to Chicago, where he was employed by architect Joseph L. Silsbee before joining the firm of Adler & Sullivan. There he worked as a draftsman until 1893, when he opened his own practice.

For several years Wright maintained two offices, one adjacent to his home in Oak Park, and a second in Chicago. Among Wright's best-known works are his "prairie houses" designed between 1900 and 1909, when he left for Europe. Among the best known of these commissions were residences for Bradley and Hickox, Kankakee, Illinois (1900); Ward Willits, Highland Park, Illinois (1902); Susan Lawrence Dana, Springfield, Illinois (1902); Darwin D. Martin, Buffalo, New York (1903); Isabel Roberts, River Forest, Illinois (1908); Avery Coonley, Riverside, Illinois (1908); and Frederick Robie, Chicago (1908). Other structures included the Larkin Building, Buffalo, New York (1904), and Unity Temple, Oak Park, Illinois (1906).

After the Wasmuth portfolio — illustrating Wright's early work — was published in Germany in 1911, his international reputation spread rapidly. Returning to America in 1911, he moved to Spring Green, Wisconsin, and rebuilt his practice. He went on to design buildings of international renown like the Imperial Hotel in Tokyo (1915-1922) and the Johnson Company's Administration Building in Racine, Wisconsin (1936). By the 1930s Wright's designs reflected changing tastes and new geographical regions as he executed structures in the Southwest and on the West Coast. In 1932 he organized the Taliesin Fellowship, a residential program with idealistic principles for apprentice architects. He continued to produce bold designs until the end of his life, including the Guggenheim Museum, New York (1944-59).

During his seventy-year career Wright designed around 1,000 structures, of which some 400 were built. Many of his drawings and documents are preserved at Taliesin West, located near Scottsdale, Arizona. His Oak Park home and studio, restored to their 1909 appearance, are open to the public.

Literature detailing the life and work of Wright is extensive. See particularly, Frank Lloyd Wright, *An Autobiography* (New York: Longmans, Green and Company, 1932) and *The Future of Architecture* (New York: Horizon Press, 1953); David A. Hanks, *Decorative Designs of Frank Lloyd Wright* (New York, E. P. Dutton, 1979); Grant Carpenter Manson, *Frank Lloyd Wright to 1910: The First Golden Age* (New York: Van Nostrand Reinhold Company, 1958); Henry-Russell Hitchcock, *In the Nature of Materials, the Buildings of Frank Lloyd Wright, 1887-1941* (New York: DaCapo Press, 1979, reprint of 1942 edition); Brendan Gill, *Many Masks, A Life of Frank Lloyd Wright* (New York: G. P. Putnam's Sons, 1987); Adolph K. Placzek, *MacMillan Encyclopedia of Architecture* vol. 2 (New York: The Free Press, 1982), 434-48; H. Allen Brooks, *The Prairie School: Frank Lloyd Wright and His Midwest Contemporaries* (New York: W. W. Norton, 1972); Leonard K. Eaton, *Two Chicago Architects and Their Clients: Frank Lloyd Wright and Howard Van Doren Shaw* (Cambridge: Massachusetts Institute of Technology Press, 1969).

NOTES

1. William D. Gates, "Terra Cotta Clay," *Clay Record* (1892), 340.

2. For more about the Pauline Pottery and the art pottery movement in Chicago, see Sharon S. Darling, *Chicago Ceramics & Glass* (Chicago: Chicago Historical Society, 1979), 47-81.

3. For an overview of the architectural terra cotta industry in Chicago, see Darling (note 2), 161-204. See also Robert C. Mack, "The Manufacture and Use of Architectural Terra Cotta in the United States" in H. Ward Jandl, ed., *The Technology of Historical American Buildings* (Washington, D. C.: Foundation for Preservation Technology, 1983), 117-51.

4. "Terra Cotta," *Nunda Herald* (July 22, 1887). For other references to early pottery produced at the factory see "W. D. Gates Tells More of the Days 'Way Back When,'" *Crystal Lake Herald* (January 7, 1932), and the *Nunda Herald* (April 29, 1887; May 20, 1887; and June 3, 1887). For a discussion of the art pottery movement in Chicago, see Darling (note 2), 47-81.

5. Edward S. Orton, Jr., "An Idyll(er) in Terra Cotta," *The Clay-Worker* 28 (October 1897), 273. For biographies of Orton and E. E. Gorton see "Charter Members," *American Ceramic Society Journal* 6 (January 1923), 26, 30-31. Gorton was succeeded as head chemist by Ray R. Stull, who left to take charge of the department of ceramics at the University of Illinois around 1913. Stull's work is summarized in "Notes on the Production of Crystalline Glazes," *Transactions of the American Ceramic Society* 6 (1904), 186-97.

6. "Improvements at Terra Cotta," *Nunda Herald* (June 15, 1899).

7. The Gates Potteries, *Hints for Gifts and Home Decoration* (Terra Cotta, Illinois: The Gates Potteries, 1905), 7.

8. Susan Stuart Frackelton, "Our American Potteries, Teco Ware," *The Sketch Book* 5 (September 1905), 13.

9. For references to Teco Crystal, see "A New Uplift to American Pottery," *The World's Work Advertiser* 8 (August 1904), 5217; "Teco Ware," *Keramic Studio* 6 (February 1905), 219; and Jean Hamilton, "Arts and Crafts at the Exposition," *House Beautiful* 16 (October 1904), 44-46.

10. See Diana Stradling, "Teco Pottery and the Green Phenomenon," *Tiller* 1 (March-April 1983), 9-36.

11. Walter Ellsworth Gray, "Latter-day Developments in American Pottery — II," *Brush and Pencil* 9 (February 1902), 295-96.

12. Gray (note 11), 292. For a concise overview of American and European ceramics at the turn of the century, see Martin Eidelberg, "American Ceramics and International Styles, 1876-1916," in *Aspects of the Arts and Crafts Movement in America, Record of the Art Museum* (Princeton, N. J.: Princeton University Press, 1975), 13-19.

13. Discussion following "The Independence of Burned Clay as a Decorative Building Material," *Brick* 12 (1900), 272-73.

14. The Chicago Architectural Sketch Club was originally organized as a sketching club for draftsmen; it changed its name to the Chicago Architectural Club in 1895 when it admitted architects to membership. William D. Gates was an associate member of the club. See Wilbert R. Hasbrouck, "The Early Years of the Chicago Architectural Club," *Chicago Architectural Journal* 1 (1981), 7-14.

15. See microfilm copies of exhibition catalogues of the Chicago Architectural Club, The Art Institute of Chicago, Ryerson and Burnham Libraries.

16. See Charles Crosby, "The Work of American Potters, Article Four — How Teco Came To Be," *Arts and Decoration* 1 (March 1911), 214.

17. "A Remarkable Stein," *The Clay-Worker* 37 (January 1902), 25.

18. *Catalogue of the First Annual Exhibition of Original Designs for Decorations and Examples of Art Crafts Having Distinctive Artistic Merit* (Chicago: The Art Institute of Chicago, 1902); "Arts and Crafts Exhibition," *The Sketch Book* 11 (February 1903), 12-15.

19. "Crematory Vases," *The Clay-Worker* 59 (January 1903), 45. Beginning in the 1880s cremation was promoted as the most sanitary, inexpensive, and "poetic" way of disposing of the dead by those opposed to embalming and the health hazards associated with ground internment. See James A. Farrell, *Inventing the American Way of Death, 1830-1920* (Philadelphia: Temple University Press, 1980).

20. "List of Exhibits," *Sixteenth Annual Exhibition of the Chicago Architectural Club, March 26-April 17, 1903.*

21. Gates's terra cotta house, built in 1892-94, still stands in Hinsdale, Illinois. Nathan Herzog's residence, built in 1896, stood at what is now 3445 West Adams Street near Garfield Park in Chicago.

22. Illustrated in Frank Lloyd Wright, *Frank Lloyd Wright: The Early Work* (New York: Horizon Press, 1968), 101, 102, 103. Sketch identified as "Skyscraper Vase — Designed 1902," published in *Frank Lloyd Wright Monograph 1902-1906*, ed. Yukio Futagawa, text Bruce Brooks Pfeiffer (Tokyo, Japan: A.D.A. Edita Tokyo Co., Ltd., 1987), 93.

23. *The Flower in a Crannied Wall* terra cotta figure is illustrated in Wright (note 22), 5; *The Moon Children* is shown on page 37.

24. See Donald P. Hallmark, "Richard W. Bock, Sculptor for Frank Lloyd Wright and the Architects of the Chicago School," 2 volumes (Master's Thesis, University of Iowa, 1970). Chicago Historical Society.

25. For more about the Prairie School architects, see issues of *The Prairie School Review*, 1964-1975; also, H. Allen Brooks, *The Prairie School: Frank Lloyd Wright and His Midwest Contemporaries* (New York: W. W. Norton, 1972), and *Prairie School Architecture: Studies from "The Western Architect"* (Toronto: University of Toronto Press, 1975); and Brian A. Spencer and Victoria T. Hansen, eds., *The Prairie School Tradition* (New York: Whitney Library of Design, 1979); and Alan Gowans, *Images of American Living* (New York: Harper & Row, 1976), 389-418.

26. Thomas E. Tallmadge, "The 'Chicago School,'" *Architectural Review* 15 (April 1908), 73.

27. See Robert Judson Clark, ed., *The Arts and Crafts Movement in America, 1876-1916* (Princeton: Princeton University Press, 1972), and *Aspects of the Arts and Crafts Movement in America* in *Record of the Art Museum* (Princeton University Press, 1975); Eileen Boris, *Art and Labor: Ruskin, Morris, and the Craftsman Ideal in America, 1875* (Philadelphia: Temple University Press, 1986); and Wendy Kaplan, ed., *"The Art That Is Life:" The Arts and Crafts Movement in America, 1875-1920* (Boston: Museum of Fine Arts, 1987). For an overview of the movement in Chicago, see Richard Guy Wilson, "Chicago and the International Arts and Crafts Movements: Progressive and Conservative Tendencies" in *Chicago Architecture 1872-1922*, ed. John Zukowsky (Munich: Prestel-Verlag and The Art Institute of Chicago, 1987), 209-27.

28. "The Chicago Arts and Crafts Society," *Handicraft* 4 (July 1911), 143-45.

29. There are many misprinted initials in the Teco catalogues. Mrs. "F.R." Fuller may have been Mrs. L.E. Fuller, wife of Lucius E. Fuller, an associate member of the Chicago Architectural Club in 1899 who was listed in the Chicago city directory that year as associate editor of *The American Lumberman*.

30. See Jeannine Love, "Blanche Ostertag: Another Wright Collaborator," *The Frank Lloyd Wright Newsletter* 4 (Second Quarter 1981), 11-16.

31. See address by Gates in "Ceramics in Illinois," *The Clay-Worker* 64 (October 1914), 385.

32. See catalogue of exhibits of the Arts and Crafts Society in *Catalogue of the Eleventh Annual Exhibition of the Chicago Architectural Club* (Chicago: The Art Institute of Chicago, 1898); and reviews of the exhibit in George M. R. Twose, "The Chicago Arts and Crafts Society's Exhibition," *Brush and Pencil* 2 (May 1898), 74-79; "Arts and Crafts," *Arts for America* (1898), 491-92; "The Arts and Crafts Exhibition," *House Beautiful* 3 (May 1898), 201-205. Information regarding the Society's founding and early exhibits can be found in "Art Life in Chicago," *Chicago Inter-Ocean* (March 27, 1989).

33. Portfolios of *Dekorative Vorbilder, Eine Sammlung von Figurlichen Darstellungen*, (Stuttgart: Verlag von Julius Hoffmann) with dates ranging from 1890 through 1911 were found in the TC Industries, Inc. archives.

34. See *Teco Pottery/America* (Chicago: The Gates Potteries, 1906). A moralistic tone pervaded all the publications issued by the Gates Potteries.

35. "Gates and His Pottery," *The Clay-Worker* 57 (February 1912), 249.

36. The Gates Potteries, *Teco* (Chicago: Gates Potteries, c. 1910).

37. Evelyn Marie Stuart, "Teco Pottery and Faience Tile," *Fine Arts Journal* 25 (August 1911), 101.

38. Frackelton (note 8), 14.

39. "Factory Co. Reorganizes," *Nunda Herald* (January 22, 1903).

40. See Frackelton (note 8), 19, and William D. Gates, "Address of the Newly Elected President," *Transactions of the American Ceramic Society* 7 (1905), 41-46.

41. For a description of Maratta's work see Susan Stuart Frackelton, "Our American Potteries; Maratta's and Albert's Work at the Gates Potteries," *The Sketch Book* 5 (October 1905), 73-80; other references to Gates's exhibits at the 1904 Fair can be found in "A New Uplift" (note 9), 5216-17; "Collection of Teco Ware Exhibited at the World's Fair by the American Terra Cotta & Ceramic Company, Chicago," *The Clay-Worker* (1904), 345 (illustration); "American Pottery at the World's Fair," *The Clay-Worker* (November 1904), 476-78; Hamilton (note 9), 44-46; "Terra Cotta at the World's Fair," *The Clay-Worker* (1904), 140-41; and "Teco Ware," *Keramic Studio* 6 (February 1905), 219.

42. The author is indebted to Charles R. Steers for sharing biographical material contained in "Recollections of Fritz Albert," an unpublished interview with Esther Sheperd, 1980.

43. Frackelton (note 8), 14.

44. Advertisement, *House Beautiful* 23 (March 1908), 50.

45. Jonathan A. Rawson, Jr., "Teco and Robineau Pottery," *House Beautiful* 33 (April 1913), 151.

46. Efforts to achieve harmony between structure and landscape were discussed by Wilhelm Miller in *The Prairie Spirit in Landscape Gardening* (Urbana: University of Illinois Press, 1915). He wrote: "The

Middle West is just beginning to evolve a new style of architecture, interior decoration, and landscape gardening in an effort to create the perfect home amid the prairie states. The movement is founded on the fact that one of the greatest assets which any country or natural part of it can have is a strong national or regional character" (as quoted in Grant Carpenter Manson, *Frank Lloyd Wright to 1910: The First Golden Age* [New York: Van Nostrand Reinhold Company, 1958], 102).

47. Architectural terra cotta ornament and Teco jardinieres originally illustrated in *The Western Architect* between 1913 and 1915 can be seen in Brooks (note 25), 46-161.

48. Pledge signed by Gates in The Gates Potteries, *Teco* (Chicago: The Gates Potteries, c. 1910).

49. Advertisement, *House Beautiful* 18 (1905), 57.

50. "Teco Ware Made with Care by Gates & Mates," *Glass and Pottery World* 16 (May 1908), 24.

51. Martin W. Reinhart, "Norwegian-Born Sculptor, Kristian Schneider: His Essential Contribution to Development of Louis Sullivan's Ornamental Style." (Paper presented at the Norwegian American Life of Chicago Symposium, Norwegian American Historical Association, 1982).

52. For contemporary descriptions, see "Perfection in Architecture," *The Clay-Worker* 51(January 1909), 29-31; and Carl K. Bennett, "A Bank Built for Farmers: Louis Sullivan Designs a Building Which Marks a New Epoch in American Architecture," *The Craftsman* 15 (November 1908), 176-84. See also Larry Millet, *The Curve of the Arch* (St. Paul: Minnesota Historical Society Press, 1985); and Wim de Wit, "The Banks and the Image of Progressive Banking," in *Louis Sullivan, The Function of Ornament* (New York: W. W. Norton, 1986).

53. Willard Connely, *Louis Sullivan As He Lived* (New York: Horizon Press, 1960), 284-85.

54. The Chicago Architectural Club, as well as the Chicago Chapter of the American Institute of Architects and the Architect's Club of Chicago, all had offices in the Kimball House at 1801 South Prairie Avenue, a block south, from 1924 through 1939. See John Zukowsky, "The Chicago Architectural Club, 1895-1940," *Chicago Architectural Journal* 2 (1982), 170-74.

55. "Who's Who in the American Terra Cotta Co.," *Common Clay* (October 1920), 13.

56. See *Teco* (note 48).

57. Charles Crosby, "The Work of American Potters — Article Four — How Teco Came to Be," *Arts and Decoration* 1 (March 1911), 214.

58. Advertisement, *House Beautiful* (February 1911), vi.

59. Advertisement, *House Beautiful* (April 1911), vii.

60. Evelyn Marie Stuart, "About Teco Art Pottery," *Fine Arts Journal* 20 (June 1909), 110.

61. Stuart (note 37), 107.

62. "The Teco Inn," *The Clay-Worker* 59 (February 1913), 221-22.

63. "Gates and His Pottery," *The Clay-Worker* 57 (February 1912), 247.

64. By 1915 Lucas had become vice president and general manager of the Northwestern Terra Cotta Company, according to Walter Geer, *The Story of Terra Cotta* (New York: Tobias A. Wright, 1920), 285.

65. "Plant Reorganized," *Crystal Lake Herald* (March 27, 1913); "To Build More Kilns," *Crystal Lake Herald* (April 3, 1913).

66. Details of the crisis can be found in the following articles in the *Crystal Lake Herald*: "In Financial Straits" (July 22, 1915); "Meet Friday Night" (July 29, 1915); "No Action Taken" (August 5, 1915); "Factory Prospects are Discussed" (August 12, 1915); and "To Lose A.T.C. & C. Co." (September 2, 1915).

67. "A Trip Through the American Terra Cotta & Ceramic Company's Plant," *Crystal Lake Herald* (August 5, 1915).

68. "News of Interest at American Terra Cotta Plant," *Crystal Lake Herald* (January 8, 1920).

69. *Common Clay* 1 (July 1920), xiv.

70. "Terra Cotta Factory News," *Crystal Lake Herald* (December 16, 1920).

71. "Terra Cotta Factory News," *Crystal Lake Herald* (January 20, 1921).

72. Lilian H. Crowley, "It's Now the Potter's Turn," *International Studio* 75 (September 1922), 43.

73. "American Terra Cotta & Ceramic Co. Plant Hive of Industry," *Crystal Lake Herald* (March 8, 1928), 1, 8.

74. "Wm. Gates Ponders Treatment Accorded Men of Advanced Years," *Crystal Lake Herald* (November 29, 1934), 1.

75. Conversation with George A. Berry III, October 19, 1987.

76. American Terra Cotta Corp., *Teco Potteries* (Crystal Lake, Illinois: American Terra Cotta Corp., c. 1937).

77. Conversation with George A. Berry III, October 19, 1987.

SELECTED BIBLIOGRAPHY

The following sources discuss or illustrate Teco pottery, William D. Gates, and/or the American Terra Cotta & Ceramic Company.

"American Pottery at the World's Fair." *The Clay-Worker* (November 1904), 476-78.

American Terra Cotta Corp. *Teco Potteries*. Crystal Lake, Illinois: American Terra Cotta Corp., c. 1937.

_____. *Teco Potteries, Terra Cotta, Illinois*. Terra Cotta, Illinois: American Terra Cotta Co., n.d. Garden pottery pamphlet stamped "American Terra Cotta Co. Plant No. 2, Indianapolis, Indiana."

Chicago Architectural Club. Catalogues of annual exhibits. The Art Institute of Chicago, Ryerson and Burnham Libraries. Microfilm.

Clark, Robert Judson, ed. *The Arts and Crafts Movement in America, 1876-1916*. Princeton: Princeton University Press, 1972.

"Collection of Teco Ware Exhibited at the World's Fair by the American Terra Cotta & Ceramic Co., Chicago." *The Clay-Worker* (1904), 345. Illustration only.

Common Clay. Published 1920-1924. The Art Institute of Chicago, Ryerson and Burnham Libraries. Gift of Mrs. Price Williams.

Connely, Willard. *Louis Sullivan As He Lived*. New York: Horizon Press, 1960.

"Crematory Vases." *The Clay-Worker* 59 (January 1903), 45.

Crosby, Charles. "The Work of American Potters, Article Four — How Teco Came to Be." *Arts and Decoration* 1 (March 1911), 214-15.

Crowley, Lilian H. "It's Now the Potter's Turn." *International Studio* 75 (September 1922), 539-43, ill. 546.

Crystal Lake Herald. "A Trip Through the American Terra Cotta & Ceramic Company's Plant," (August 5, 1915); "School Makes Presentation," (April 21, 1927); "Teco Had Originality, Variety, and Mark of Quality. . ." (November 16, 1972); "Visitor to Terra Cotta Plant Finds Hive of Activity," (March 8, 1928).

Darling, Sharon S. *Chicago Ceramics & Glass, An Illustrated History, 1871-1933*. Chicago: Chicago Historical Society, 1979.

Edgar, William Harold. "The Teco Pottery." *International Studio* 36 (November 1908), xxviii-xxix.

Eidelberg, Martin, ed. *From Our Native Clay*. New York: American Ceramic Arts Society, 1987.

Evans, Paul. "Teco Pottery." In *Art Pottery of the United States*. New York: Charles Scribner's Sons, 1974, 278-81.

Frackelton, Susan Stuart. "Our American Potteries, Teco Ware." *The Sketch Book* 5 (September 1905), 13-19.

_____. "Our American Potteries; Maratta's and Albert's Work at the Gates Potteries." *The Sketch Book* 5 (October 1905), 73- 80.

"The Gates." *The Clay-Worker* (March 1928), 305-6.

"Gates and His Pottery." *The Clay-Worker* 57 (February 1912), 247-51.

The Gates Potteries Publications. *Garden Pottery.* Terra Cotta, Illinois: The Gates Potteries, c. 1906. Designed, engraved, and printed by The Franklin Company, Chicago. Private Collection.

_____. *Hints for Gifts and Home Decoration.* Terra Cotta, Illinois: The Gates Potteries, 1905. The Art Institute of Chicago, Ryerson and Burnham Libraries.

_____. *Suggestions for Gifts.* Chicago: The Gates Potteries, c. 1908.

_____. *Teco.* Chicago: The Gates Potteries, c. 1910. Designed, engraved, and printed by The Franklin Company, Chicago. Chicago Historical Society.

_____. *Teco Art Pottery.* Terra Cotta, Illinois: The Gates Potteries, 1904.

_____. *Teco Pottery/ America.* Chicago: The Gates Potteries, 1906. Collection of Erie Art Museum.

"Gates Turns Editor." *The Clay-Worker* 79 (September 1920), 232-33.

Gates, William Day. Address delivered at the dedication of the Department of Ceramic Engineering, University of Illinois, Champaign-Urbana, in "Ceramics in Illinois." *The Clay-Worker* 64 (October 1914), 384-85.

_____. "Address of the Newly Elected President." *Transactions of the American Ceramic Society* 7 (1905), 41-46.

_____. "Address of the Retiring President." *Transactions of the American Ceramic Society* 8 (1906), 37-41.

_____. "A Clean Front." *The Clay-Worker* 35 (May 1901), 467-69.

_____. "Fine and Applied Art at the St. Louis Exposition." *Brush and Pencil* 13 (October 1903), 55-62.

_____. "A Fitting Use for Terra Cotta." *The Clay-Worker* 30 (August 1898), 93-94.

_____. "The Influence of the American Ceramic Society in the Terra Cotta Industry." *American Ceramic Society Journal* 6 (January 1923), 231-32.

_____. "The Manufacturer's Dependence on Ceramic Research" in "Dedication of the Ceramics Building, University of Illinois." *The Clay-Worker* 66 (December 1916), 526-30.

_____. "The Revival of the Potter's Art." *The Clay-Worker* 28 (October 1897), 275-76.

_____. "Terra Cotta Clay." *Clay Record* (1892), 340.

_____. "A Terra Cotta Residence, Method of Construction." *The Clay-Worker* 21 (January 1894), 20.

_____. "There's Music in the Air at Terra Cotta." *The Clay-Worker* 40 (November 1903), 441.

_____. "A Tribute to George H. Lacey, (manager of the Indianapolis Terra Cotta Company). . ." *The Clay-Worker* 15 (May 1921), 557.

_____. Photographs donated by his family. Chicago Historical Society, Prints and Photographs Collection.

Geer, Walter. *The Story of Terra Cotta*. New York: Tobias A. Wright, printer and publisher, 1920.

Geijsbeck, S. "The Ceramics of the Louisiana Purchase Exposition." *Transactions of the American Ceramic Society* 7 (1905), 289-355.

Gray, Walter Ellsworth. "Latter-day Developments in American Pottery — II." *Brush and Pencil* 9 (February 1902), 289-96.

Hamilton, Jean. "Arts and Crafts at the Exposition." *House Beautiful* 16 (October 1904), 44-46.

"Home of Teco Pottery." *Brick and Clay Record* 39 (October 15, 1911), 283-85.

Industrial Chicago: The Building Interests. Chicago: The Goodspeed Publishing Company, 1891, 789.

Jenney, William LeBaron and William B. Mundie. "A New Departure in Terra Cotta Work: Will D. Gates's Beautiful Home." *The Clay-Worker* 21 (January 1894), 19-20.

Kaplan, Wendy, ed. *"The Art That is Life:" The Arts and Crafts Movement in America, 1875-1920*. Boston: Museum of Fine Arts, 1987.

Keane, Theodore J. *Friendly Libels*. Chicago: The Cliff Dwellers, 1924.

Kovel, Ralph and Terry Kovel. "Teco Gates." In *The Kovel's Collectors Guide to American Art Pottery*, 262-68. New York: Crown Publishers, 1974.

Little, Flora Townsend. "A Short Sketch of American Pottery." *Art and Archaeology* 15 (May 1923), 219-27.

"Lousiana Purchase Exposition Ceramics." *Keramic Studio* 6 (February 1905), 216-19.

Millett, Larry. *The Curve of the Arch: The Story of Louis Sullivan's Owatonna Bank*. St. Paul: Minnesota Historical Society Press, 1985.

Mitchell, Elmer C. "The Art Industries of America — II, The Making of Pottery." *Brush and Pencil* 5 (April 1905), 67-76.

"More on Teco Pottery by a Teco Collector." *Pottery Collectors Newsletter* (August 1972), 151-53. See also (December 1971), 31-32.

"A New Uplift to American Pottery." *The World's Work Advertiser* 8 (August 1904), 5216-18.

Nunda Herald. "Baked Clay" (March 19, 1896); "Terra Cotta, Its Manufactory" (July 24, 1885).

Nye, Lowell Albert, ed. *McHenry County, Illinois, 1832-1968*. Woodstock, Illinois: McHenry County Board of Supervisors, 1968.

Orton, Edward S., Jr. "An Idyll(er) in Terra Cotta," *The Clay-Worker* 28 (October 1897), 270-73.

Rawson, Jonathan A., Jr. "Teco and Robineau Pottery." *House Beautiful* 33 (April 1913), 151-52.

"A Remarkable Stein." *The Clay-Worker* 37 (January 1902), 25.

Ruge, Clara. "American Ceramics — A Brief Review of Progress." *International Studio* 28 (March 1906), xxi-xxviii.

Sheffield, Albert H. "To a Teco Vase." *The Clay-Worker* 61 (January 1914), 43.

Stradling, Diana. "Teco Pottery and the Green Phenomenon." *Tiller* 1 (March-April 1983), 9-36.

Stuart, Evelyn Marie. "About Teco Art Pottery." *Fine Arts Journal* 20 (June 1909), 338, 340-45.

_____. "Teco Pottery and Faience Tile." *Fine Arts Journal* 25 (August 1911), 99-111.

"The Teco Inn." *The Clay-Worker* 59 (February 1913), 221-22.

"Teco Pottery and the Holidays." *The Craftsman* 7 (November 1904), 234.

"Teco Ware." *Keramic Studio* 6 (February 1905), 219.

"Teco Ware Made with Care by Gates & Mates." *Glass and Pottery World* 16 (May 1908), 24-26.

"Terra Cotta at the World's Fair." *The Clay-Worker* (1904), 140-41.

"Terra Cotta Fronts." *The Clay-Worker* 30 (October 1898), 261-63.

"Terra Cotta in Architecture." *The Clay-Worker* 49 (January 1908), 30-35.

Transactions of the American Ceramic Society. 1899-1912.

Waid, D. Everett. "A Terra Cotta Residence." *The Brickbuilder* 3 (April 1894), 49-51.

Weidner, Ruth Irwin. *American Ceramics Before 1930: A Bibliography.* Westport, Conn.: Greenwood Press, 1982.

Waterbury, Ivan C. "Great Industries of the United States, Pottery." *Cosmopolitan* 38 (March 1905), 593-602.

Wright, Frank Lloyd. *Frank Lloyd Wright: The Early Work.* (New York: Horizon Press, 1968).

CONTRIBUTORS

SHARON S. DARLING has done pioneering research in the field of Chicago Arts and Crafts. She is the author of numerous essays and books, including *Chicago Metalsmiths, Chicago Ceramics & Glass,* and *Chicago Furniture: Art, Craft and Industry.* The curator of Decorative and Industrial Arts at the Chicago Historical Society from 1975-1986, she currently serves as Director of the Motorola Museum of Electronics, Motorola, Inc.

RICHARD ZAKIN is a working ceramist who has taught at the State University of New York, College at Oswego, since 1967. He has exhibited his work widely, and is the author of *Electric Kiln Ceramics,* as well as numerous articles dealing with the technical aspects of historical ceramics.

TOD M. VOLPE is an independent art dealer and consultant, and co-founder of the Jordan-Volpe Gallery in New York City, which pioneered the revival of interest in the American Arts and Crafts movement. A collector and authority in the field since 1970, he is currently building collections in Los Angeles and New York, and developing his first story for a feature film.

SHELLE LICHTENWALTER BARRON is an accomplished painter, printmaker, and graphic designer who has won over 20 regional and national awards. The recipient of a 1989 NEA Mid-Atlantic regional fellowship grant and a 1989 Visiting Artists fellowship to the Brandywine Printmaking Workshop, she has exhibited her work widely. She currently teaches graphic design at Mercyhurst College.

JOHN VANCO has served as Director of the Erie Art Museum since 1968. Under his leadership, the Museum has grown from a small volunteer-run gallery to its present status as a major force in the region's visual arts community. He has organized over 300 exhibitions, and coordinates the Museum's multifaceted operations, including the growing permanent collection, educational programs, jazz and new music offerings, alternative performances, and art historical research.

PHOTOGRAPHY CREDITS

Dave Bowers, *figs. 56, 57*

Mrs. Ronald M. Byrnes, *figs. 6, 34 (top), 71*

Brush and Pencil (April 1905), *figs. 76, 78*

Chicago Historical Society, *figs. 1, 4, 13, 25, 28, 34 (bottom), 35, 36, 60, 64, 70, 83; pgs. 13, 75*

Christie's, New York, *fig. 15*

Clay-Worker (January 1902), *fig. 14*

Common Clay (August 1920), *fig. 68;* (October 1920), *fig. 55;* (November 1920), *fig. 66;* (December 1920), *fig. 29;* (March 1921), *fig. 61;* (April 1921), *figs. 31, 59, 67;* (May 1921), *fig. 31;* (August 1921), *figs. 33, 58, 69*

Dana-Thomas House State Historical Site, *fig. 23 (top)*

Sharon and Mikell Darling, *figs. 7, 10, 65*

Erie Art Museum, *figs. 16, 23 (bottom), 53*

Fine Arts Journal (August 1911), *figs. 44, 63*

Michael Levitin and Meredith Mendes, *fig. 40*

Andrew Lopez, *fig. 53*

Robert Lowry, *colorplates 1-36, 39, 40; figs. 8, 12; cover*

Charles McMillen, *79*

Metropolitan Museum of Art, *fig. 19*

Missouri Historical Society, *fig. 38*

Motorola, Inc., *fig. 73*

National Center for the Study of Frank Lloyd Wright, *figs. 17, 20, 21, 26, 27*

The Newberry Library, Chicago, Ill., *fig. 24*

Norwest Corporation, Minneapolis, *fig. 11*

Nunda Herald (July 24, 1885), *figs. 2, 5;* (January 31, 1886), *fig. 3*

Rick Sferra, *colorplates 37, 38*

Sketch Book (October 1905), *figs. 39, 41, 42, 75, 77, 82;* (July 1906), *figs. 48, 81*

TC Industries, Inc., Crystal Lake, Ill., *figs. 9, 13, 30, 32, 33, 52, 58, 69, 72, 74; pgs. 129, 169*

John Vanco/Kathy Merski, *figs. 18, 22, 37, 49, 50, 51, 54, 80*

Western Architect (January 1913), *figs. 45, 46, 47;* (January 1915), *fig. 43*

INDEX

LENDERS TO THE EXHIBITION

Linda Balahoutis and Jerry Bruckheimer

Bruce Baker

Jairus B. Barnes

The Beck Family

Leonora J. Bierdeman

Chicago Historical Society

Dean Cunat

The Dillenberg/Espinar Collection

Ilene C. Edison

Erie Art Museum

Robert A. Furhoff

John and Nancy Glick

Stephen Gray

Barbara and Jack Hartog

William and Mary Hersh

John L. Husmann, McHenry, IL

Michael Levitin and Meredith Mendes

Andrew Lopez

James and Mary McWilliams

Jean and Martin Mensch

Norwest Corporation, Minneapolis

Private Collection

Mr. and Mrs. Timothy Samuelson

Jerome and Patricia Shaw

Joel Silver

Gary Struncius

TC Industries, Inc., Crystal Lake, IL

Governor and Mrs. James R. Thompson

Patsy and Steven Tisch

Kenneth R. Trapp

Toomey - Treadway Collection

Unity Temple: The Unitarian Universalist Church in Oak Park

Tod M. Volpe

Paul R. Ziegler, Atlanta, GA

GENUINE TECO

can be infallibly recognized by the presence of the
Teco sign delicately cut into the under side of each
piece. Persons who are not experienced in judging
pottery values are assured by the Teco Mark of
both material superfineness and artistic purity.
If you wish the Genuine, look for the Teco Mark.